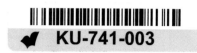
Tate Watercolour Manual
Lessons from the Great Masters

Tony Smibert and Joyce H. Townsend

Tate Publishing

First published 2014 by order of the Tate Trustees
by Tate Publishing, a division of Tate Enterprises Ltd,
Millbank, London SW1P 4RG
www.tate.org.uk/publishing

Reprinted 2015, 2017

A catalogue record for this book is available
from the British Library
ISBN 978 1 84976 088 1

Distributed in the United States and Canada by
ABRAMS, New York
Library of Congress Control Number applied for

Designed by Untitled
Colour reproduction by DL Imaging Ltd, London
Printed by Cambrian Printers UK

Measurements of artworks are given in centimetres,
height before width

Contents

Foreword
Nicholas Serota

The *Tate Watercolour Manual: Lessons from the Great Masters* is a unique addition to Tate's books on art and artists. An exciting fusion of painting practice and specialist knowledge, it focuses on a number of important British watercolours, many of them in Tate's collection, and gives practical insights into how they were created. The publication has developed from years of discussion, observation and collaboration by the authors over that key figure in British art history, Joseph Mallord William Turner, who transformed watercolour from a useful documentary medium to the expressive and beloved art form that it is today. The manual, however, also takes an in-depth look at great works by some of the other masters of the medium: Claude Lorrain, Alexander Cozens, Thomas Girtin, John Constable, John Sell Cotman, David Cox, Jean-Baptiste-Camille Corot and John Ruskin.

These great artists did not generally leave a legacy of writings, diaries or teaching manuals. Although many had pupils, the details of their teaching methods are largely lost. Their works alone speak to us today, and while it is easy to see and marvel at skill and effortless perfection, their messages on how to emulate the great masters, and develop painting skills directly derived from their various approaches, can be harder to appreciate. The *Tate Watercolour Manual* aims to give them voice once more. Written in the form of lessons and guided by an experienced contemporary practitioner, the resulting exercises demonstrate the essence of each artist's approach, without the complications that ensue when one attempts emulation of more complete and complex images. The book also provides a *modus operandi* for the fruitful study of other works and other artists, even perhaps, other paint media.

For historic works of art, an important part of the message can be found within the materials. Since we cannot watch the old masters at work, or turn to sources such as film and photographs as we so often do for contemporary artists, the best route towards recreating their approach is to use the same historic materials. Modern equivalent materials differ from their past counterparts in ways that radically affect their use. Hence it is not only necessary to know how the great masters painted, but also what they used. Without such understanding, paintings from previous centuries can appear almost technically impossible to emulate today and discussed here are traditional paints, brushes and papers, as well as advice on modern substitutes. Such information has been gleaned through a combination of materials analysis (this is particularly challenging for delicate watercolours on paper) and materials history. Tate is a world leader in these fields, with an emphasis on British artists and the period from early industrialisation at the end of the eighteenth century to the mid-twentieth century.

Historic materials are intractable and today difficult to obtain; many are hazardous and cannot lightly be used at home or in education, the very settings where many would seek to experiment with them. But once their capabilities are understood, it is then possible to recommend safer contemporary materials that work in the same way, as this publication does, and use them instead.

The aims of the book are to enable, to engage, to excite, to promote experiments in the use of watercolour materials, and to unlock artistic potential, even in people who would never previously have dared to describe themselves as painters. I am delighted that Tate and its collections is providing such a unique opportunity to appreciate some of our greatest artists and to draw inspiration from their achievements in watercolour.

I would like to thank all the contributors for their expertise and for sharing their insights and in particular Tony Smibert, Joyce Townsend and Nicola Moorby, as well as Alice Chasey, editor at Tate Publishing.

Nicholas Serota
Director, Tate

Introduction
Nicola Moorby

Why is it that so many people have such a special love for watercolour? Is it because it remains among the most accessible of the fine arts? Unlike more technologically demanding oil painting, sculpture or printmaking, even the least artistically minded may well have had a go with watercolour paints at some point in our lives while, outside the professional art world, legions of amateur devotees wrestle with its delights and frustrations on a daily basis. Similarly, if we purchase any artworks for our own homes they are perhaps more likely to be in the form of small-scale pictures to which watercolour is intrinsically suited. Watercolour has also traditionally been used to depict things which themselves have a wide, universal appeal, subjects such as flora and fauna, the countryside and exquisite natural phenomena like sunlight and reflections in water. People who like nature often like to see it depicted in watercolour. On the other hand, despite its everyman appeal, watercolour has also been wielded by some of the greatest artists to create enchanting, glowing images which never cease to dazzle us with their technical and visual brilliance. Above all it is perhaps the unique relationship between the nature of watercolour paint and how it can be applied which makes its results so seductive and satisfying. No other medium is so fundamentally defined by its physical properties and, as this manual aims to demonstrate, the key to truly understanding and appreciating watercolour is a basic understanding of how to use it.

Tate's collection is particularly rich in watercolours, reflecting the important role of the medium in the history of British art. Without a doubt the 'jewel in the crown' is the Turner Bequest, a unique gift to the nation comprised of thousands of works found in the studio of J.M.W. Turner after his death in 1851. Unsurprisingly from arguably the greatest watercolourist of all time, this treasure trove includes a multitude of watercolours ranging across Turner's career, many of which had never been seen before the late nineteenth century. From the briefest preparatory washes to finished exhibition pieces, and with every other working stage in between, the Bequest documents a lifetime of watercolour practice and shows how Turner evolved from accomplished beginner to exalted genius. Fabulous examples of his work can be found in many other public collections around the world, but it is only at Tate that you can trace the evolution of the master at work and see intimate, private studies looking as fresh and immediate as if they had just been painted.

Complementing the Turner Bequest is the Oppé Collection, a significant body of British drawings and watercolours acquired by Tate in 1996, as well as many other historic pictures dating from the so-called 'golden age' of British watercolour. This notable chapter in British art history is generally defined as 1750–1850, an era when watercolour assumed the status of a national art form. Traditionally seen as climaxing with the virtuosity and originality of Turner, the period saw the rise of a new aesthetic: the topographical landscape watercolour. British artists recognised that the fluid and transparent properties of watercolour lent themselves to the record of ephemeral phenomena such as the sea and rivers, sky, weather and light, and through this happy marriage of subject and materials they breathed new life into the landscape genre. First emerging in the work of eighteenth-century pioneer Paul Sandby (c.1730–1809), the so-called 'father of modern landscape painting in watercolours', a generation followed and invented new ways of applying and wielding wet washes, releasing the expressive potential of the medium and establishing new ways of picturing nature and the world. Tate's collection includes outstanding examples from this golden age, including works by Sandby, Francis Towne, Thomas Jones, John Robert Cozens, John Sell Cotman, Thomas Girtin, John Constable, David Cox, Peter de Wint, William Blake, Richard Parkes Bonington, and many others. These pioneering practitioners were Turner's predecessors, contemporaries and successors, and in their hands watercolour had its finest hour.

The *Tate Watercolour Manual: Lessons from the Great Masters* invites you to embark upon your own journey of discovery, aided and guided by artists and paintings mostly represented within the collection. Particularly for beginners this may at first seem a daunting standard to try to meet. However, this book is intended to make it seem less daunting. It is important to remember that the masters are there to teach you, not to compete with you. The aim is not to discourage you by showing you an unattainable level of perfection – on the contrary it invites you to take a seat in the best watercolour class in the world. Ultimately it doesn't matter if we can't all paint like Turner, Constable, Cotman or any of our watercolour heroes. The act of looking closely at their works is reward enough in itself so that simply by dipping your brush in paint and sweeping it across paper you have honoured their achievements and made your own contribution to the spirit of their legacy.

About this book
Tony Smibert

Art galleries are much more than places for the passive enjoyment of art. They also offer a unique opportunity for anyone interested in painting or drawing to learn from the wonderful originals of great masters, both historic and contemporary. The traditional way to do this is by copying. A great deal can be learned *while* working from a masterwork, so that the process becomes a virtual lesson from the artist.

As a painter myself, a connection with Tate grew out of studying the remarkable watercolours of J.M.W. Turner. Tate is the home of the national collection of British art, and therefore holds thousands of paintings from the golden age of British watercolour, 1750–1850. It is also the custodian of the

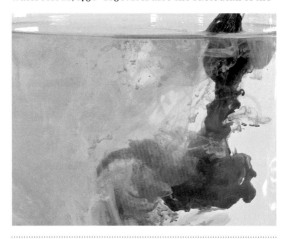

Natural principles at work: drawn down by gravity, colour tumbles from a brush dipped in water, then mingles slowly with colours added earlier.

Turner Bequest; a wonderful legacy comprising the contents of Turner's studio at his death in 1851. In addition to oil paintings and studies on canvas, this vast treasure trove includes some 37,000 sheets of paper, both loose and bound within sketchbooks, of which around 30,000 bear images in pencil and/or watercolour. Supplementing the riches of the Turner Collection, Tate also maintains a Conservation Archive that includes a range of historic paintboxes and other British artists' materials unique to this period. Study visits from my studio in Tasmania, Australia, finally led to work as a visiting artist researcher in collaboration with Dr Joyce Townsend, a Tate senior conservation scientist. For the past twenty-five years Joyce has carried out important documentary and practical research into nineteenth-century British artists' materials, their composition, the way they work in practice, and the ways in which they change over time. In particular she is the acknowledged scientific authority on Turner's painting techniques and materials. I was also impressed by the broad enthusiasm of Tate staff for finding new ways to help the public fully understand and engage with Turner as a *practical painter*, and was proud to be part of the 2010 publication *How to Paint Like Turner* (to which this book is a companion). *How to Paint Like Turner* made it possible for anyone, anywhere, to learn about Turner's painting methods by actually trying them out with guided assistance from curators and practising artists, with reference to works at Tate. But perhaps it does not sufficiently help the novice artist to take that first dip of the brush into water?

This new manual is designed to give anyone who has never lifted a brush before a broad understanding of how watercolour actually works. It starts with a short course on traditional watercolour, examining the very *nature* of the medium and the historic evolution of materials, tools and techniques. There are also fascinating insights into historic paints and their comparison with modern equivalents. If you've never painted before, it will help you to acquire some of the classic painting skills along with a practical understanding of how to combine them and create a small landscape using methods that would once have been known and used by almost all professional artists. Along the way you'll also be acquiring a working vocabulary of watercolour terms to assist you in closely examining and appreciating great masterpieces.

For those ready to paint at a more advanced level we have then included a series of practical painting exercises based on the works of some of the greatest masters in watercolour history. These later exercises are largely based on the assumption that you already know the basics of how to use watercolour (so if you don't, please work through the introductory course first). Although there is a focus on the golden age of British watercolour, the manual also mentions works by other artists from outside Britain, without whom it could not present a comprehensive overview. The result is both an introduction and a guidebook, rather than a definitive guide to watercolour. Artists and their works are selected solely to illustrate key principles, and then demonstrate ways through which anyone can acquire a practical understanding

of their achievements. At the heart of the manual is the belief that important and inspiring lessons can be learnt by looking to the past, through the basic structured techniques underpinning watercolour practice and the limitless possibilities of free creative experimentation.

One of the things the book aims to do is to offer clear instruction in watercolour processes. All nine artists covered are illustrated by examples of their own work accompanied by relatively simple painting exercises designed to help the reader (whether student, artist or researcher) to apply the same methods. These are, I hope, very clear due to removal of all the things you won't need to be challenged by at the same time. Each small picture you will paint is based upon a very significant concept, and in each instance a single principle is all you have to address. These exercises may not leave you feeling you have painted complex, 'finished' pictures but they will give you a practical understanding of how many of the great masters worked, as well as offering ideas to introduce into your own artistic approach. I was trained as an artist and art educator myself, and I've always felt that my own artistic development could have been different if I had received a little more formal and structured information on painting techniques. The material we present here – including access to Tate masterworks – is something like the sort of practical course I wish I'd had access to myself.

Readers will notice that all the historical examples feature representational landscapes. This is not because watercolour is exclusively used to paint landscape (it isn't), but because many of the most significant artists who helped to evolve the medium as an expressive art form during the eighteenth and nineteenth centuries had a great interest in painting nature. Pioneers such as Turner used watercolour to meet the challenge of capturing the essence of 'romantic' landscape (meaning mighty and awe-inspiring), dramatic weather, lofty mountains and wild seas, and depicting them for the many who would never experience such scenes in real life. Landscape became a key subject for watercolourists, and many of the fundamental constructs remain relevant today. We can, for example, learn about abstract creativity by studying the landscape 'blots' of Alexander Cozens or gain valuable observations into colour harmony from Turner's so-called 'colour beginnings'. Similarly we can also find a guide to painting directly from nature in the sky studies of John Constable or derive models for classical composition from the earlier sepia, woodland studies of Claude Lorrain.

In order to fully appreciate the potential of watercolour as a mode of artistic expression it is important to set aside a number of incorrect notions and prejudices which have long tended to act against it being taken seriously by many in the wider art world. Firstly, that it is a 'weak' medium in terms of both colour and force of expression, and secondly that it is difficult to acquire the necessary skills. Thirdly, and because it has long been a popular medium for hobby painters and amateurs, watercolour is frequently dismissed as unsuitable for serious works of art. (Joseph Wright of Derby, for example, famously damned it in 1795 as 'Better adapted to the amusement of ladies than the pursuit of an artist'.) Finally, despite the fact that splendid original works are being created by contemporary artists, watercolour is still indelibly associated with traditional subjects and a somewhat 'dated' approach to visual practice. Within some of the great watercolour societies, where the highest levels of passion and skill are maintained, the primary focus does tend to remain fixed on conventional subjects so that, ironically, the passion to protect 'high traditional standards' may also be holding the medium back from its full potential as a powerful modern vehicle.

Watercolour is in fact a splendid choice for contemporary painters. There are subtle qualities *within the physical properties of the paint* that need to be appreciated, but these lead to unique possibilities for creative expression. Less suited to works on a large scale than oil or acrylic, watercolour is nonetheless equipped to deliver a whole range of effects that other media cannot. It may seem a 'quiet' medium but 'big-bold-and-new' is not necessarily better or more profound. After all, who would claim that loud music played by a band is of more significance than a solo on violin or flute? And those who dismiss watercolour because of its popularity do so in complete ignorance of the reality and genius of Turner, Constable and others – all of whom confronted and challenged the established order and, through commitment to watercolour practice, engaged deeply in *the experience of nature* as a means for producing extraordinary and transcendent artworks.

So although the *Tate Watercolour Manual* seeks inspiration from the past, it very much aims to forge a path for the future. The creative achievements of painters from a bygone era actually reveal how

important it is to encourage artists today to take watercolour seriously, but *in their own way*. Certainly we can learn a great deal from the masters, while the future for contemporary watercolour lies in responding to the challenges of our own era.

We were very aware that the audience for this book is wide ranging: from complete beginners to skilled artists of various ages. We hope it will also inform and inspire art historians and museum educators who are more than familiar with art historical terminology but may never have painted themselves and with teachers of art who may not habitually use watercolour as their medium of choice. The processes explained here will cast fresh light

Understanding the natural processes that govern the behaviour of pigment in water is vital to mastering watercolour technique.

upon any understanding of historic watercolour and suggest ways to bring greater personal insights into teaching and explaining art. No-one should be put off from trying out watercolour by the notion that it is inherently 'difficult' to use. It isn't! While learning how to paint 'like an expert' does require time, taken in bite-sized chunks a modest skill can soon be acquired, with fun and creativity at every turn.

Then there are the legions of gallery visitors who enjoy looking at watercolours even though they may not have picked up a paintbrush since their own school days. Watercolour is an art form which lends itself to the joyous appreciation of its physical properties. It can be enjoyed as a *medium* even by people who have never actually had the pleasure of painting with it. The (usually) small scale of paintings in watercolour automatically encourages people to move in for close examination, so that many viewers of exhibitions can be seen moving their hands to imitate the brushstrokes, exclaiming aloud in wonder, and discussing with companions how a breathtaking effect might have been achieved. This may just reflect the fact that so many people have at least tried or 'dabbled' with water-based paint at some point in their lives, or it may hint at something else – perhaps a special quality of intimacy and tactual presence that makes watercolour an alluring yet approachable medium.

We hope this manual will encourage you to make your own investigations, studies and discoveries, taking what you will from the great painters of the past and using their achievements to inspire your own creativity.

Enjoy your exploration!

The nature of watercolour

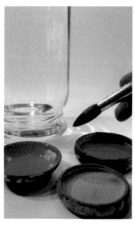
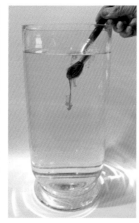
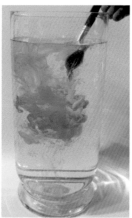
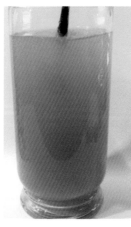

The Jar Experiment: revealing how pigments added to water will generally retain their purity unless forcefully stirred together – at which time they will lose their brilliance (as at lower right).

Watercolour can be a very unpredictable medium. Many first-time painters are confounded by the seemingly random movement of wet wash, leaving them to conclude that it is simply too difficult to manage. In fact it is not uncommon to hear people claim that watercolour simply 'won't go or stay where you want it to'.

So the best place to start is with an understanding of the very nature of watercolour as paint – and the natural principles that dictate its behaviour. Once armed with such knowledge, all of the traditional techniques, tools and materials that have been evolved over the centuries will start to make perfect sense.

The key mechanics of watercolour involve the way colour settles, dries and hardens, with opportunities for painters to create different effects at each stage. If you were to mix up separate dishes of red, yellow and blue watercolour and then take a jar of clean water and dip brushes loaded with those colours into it one after another, there you would see the natural principles that govern watercolour clearly revealed. Even when the brush is held still, gravity will cause the colour to tumble from it and dive towards the bottom of the jar. When introduced to the jar separately and then left undisturbed, these tumbling streams of colour normally retain their independence, brilliance and transparency *despite* any slight currents that may affect them. The effect is wonderful. However, if the water is stirred, the individual hues will rapidly disappear, leaving a uniform cloud of muddy brown or grey. This is why 'overworked' watercolours so often seem 'dull' and 'colourless' *and* why the glowing colours of a masterpiece may be so admired by those who understand the medium and the need to avoid 'overwork'.

Finally, over time (even in a jar) the pigments will settle – as would mud in a pond – and eventually harden when the water has evaporated away. A finished watercolour on paper is very like a dried-out, clay-rich soil in the summer. The pigment will normally remain where it has settled – whether glowing or muddy – unless again wetted or scraped away.

When studying the masters it is worth remembering that every technique in every watercolour painting has depended on the artist's ability to work with these very logical natural principles. It is fundamental to *understanding* the techniques of watercolour – and the key to learning them by assimilating this understanding into one's own practice. A clear appreciation of how watercolour actually works will help you to use the methods applied by painters who largely worked *with* the medium rather than 'against' it. Our short course will show you how to make use of these natural processes yourself.

From the beginning, study your materials. Here in a saucer a pool of of wash has settled, dried and finally hardened, just as it would have on paper.

It is possible to create all the tones of autumn foliage with simple blending of just a few colours on a plate.

Understanding that paint behaves more or less like mud in a pond can be the key to unlocking its mysteries *and* understanding traditional technique.

Tonal values, a few colours and interesting marks are all that is needed for many historic approaches.

What is watercolour?

What we call 'watercolour' is basically finely-ground coloured solids mixed with a binder (known as the paint medium) and then diluted with water. Mixing with a binder is key to making a 'paint' rather than coloured water. The earliest examples of watercolour paintings were arguably cave-paintings which used colourful mud or coloured minerals mixed perhaps with water from a stream. Although the resulting mixture could be used to paint an image onto a surface, such colours would stick only lightly and could easily have been disturbed or brushed away. The crucial leap towards producing a true paint was the inclusion of a binder or paint medium, a water-soluble one in this case that would cause the colours to hold together as a layer, and adhere to the surface when the water had evaporated. The earliest known, primitive binders included plant juices and possibly blood. Using a binder also prevented the solid component – the coloured pigments – from settling onto the rock surface so fast that painting had to be rapid. Even today, once a true watercolour paint is applied to a surface, the water begins to evaporate and the binder forms a film that encapsulates and protects the pigment. Then, after the paint has dried, the colours will remain reasonably impervious unless re-wetted (whereupon they will turn into wet paint again) or scraped away with a tool.

Although it is not essential for painters to know all about the science of binders, a basic understanding helps to explain how the greatest masters worked their magic. A binder should be colourless, so that it will not affect the appearance of the colorants, and it should not acquire colour in itself as it ages. Neither should it grow cloudy or crack over time. And it should form an increasingly strong bond to the application surface, in preference to an ever-weaker one. The binders used by Western artists over recent centuries are usually plant gums, which meet all these requirements. The most common binder, and the one used almost exclusively in paint manufacture today, is gum Arabic, a water-soluble substance derived from the sap of the acacia tree. A small proportion of powdered gum (under 5% by weight) in cold water, shaken occasionally over the course of a day, will provide a basic watercolour binder. Two or three times as much gum will make this a thicker binder, viscous like white of egg, that can be applied to previously-dried paint to give a locally glossy area that sits proud of the surface. One of the advantages of gum Arabic is that it can always be readily re-dissolved – a property entirely desirable if you want to introduce highlights by washing-out or sponging away areas of darker colour.

Other types of gum can also be used. Some artists for example like to build up thick layers of paint without disturbing the earlier applications, to arrive at a glassy effect. In this case it is necessary to use a mixture of gums, or at least, not gum Arabic on its own. William Blake, for example, combined gum Arabic and gum tragacanth (which has lower water solubility) with cane sugar or honey to make his thick dried paint flexible and less liable to crack. Historically, artists were able to purchase different binders blended from varying combinations of gums according to the individual recipes of their commercial suppliers. The twenty-first century expectation of a product that is always the same whenever you buy a new supply (obviously more important for a professional painter than for a beginner) has only developed since the nineteenth century. Back then, professional artists were far more accustomed to variation within the

Close-up of leaves in a tree painted by J.M.W. Turner, showing how the artist has added gum to make the paint locally thick. The actual width of this area is 1 cm.

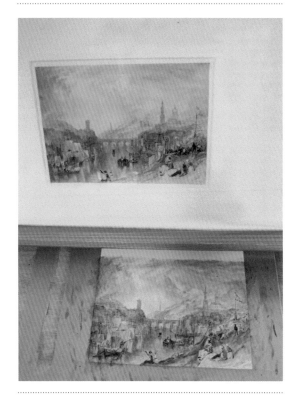

Historically inspired reconstruction made darker than the present appearance of *Newcastle-on-Tyne* c.1823, Tate D18144 by J.M.W. Turner to compensate for slight fading, using tiny amounts of Turner's Prussian blue pigment. (Photo: Charlotte Caspers)

Historically accurate reconstructions being painted in the Prints and Drawings Room at Tate by intern Charlotte Caspers, using tiny amounts of paint from an 1860s Rowney watercolour box. Her paper is stretched and taped onto a board. (Photo: Charlotte Caspers)

Winsor & Newton mould for a watercolour block, Winsor & Newton, London. (Photo: Charlotte Caspers)

products they bought, and to the need to concoct and modify their painting materials themselves, indoors in the studio. They were, as suggested at the beginning of this chapter, therefore fully engaged in working *with* the nature and properties of watercolour, which in turn assisted them in exploiting its creative potential.

In order for a contemporary painter to begin to work according to historically accurate principles, it is necessary to have a basic knowledge of materials history, and some understanding of the key economic and industrial developments during the period. This helps to explain how both the watercolour medium and artists' techniques evolved. A painter who is also undertaking museum-based research will need a willingness to think laterally, and a resistance to taking reported facts solely at face value, as well as the skill and patience to experiment with creating materials from unusual raw ingredients, then using them. Many contemporary products are too pure or too much modified or 'improved' to replicate the challenging feel of historic materials. Nevertheless it is a rewarding exercise to make historically accurate reconstructions from published recipes for artists' materials, either to match the analytical findings on the materials used by a particular artist, or those known (through the artist's letters or notes, for example) to be used in a specific work. The use of historic materials by a painter provides many insights into *why* individual artists worked in certain ways, and increases our respect for the images they created. Private painters with a deep interest in understanding the methods of a master may also find this a fascinating process.

The experience of handling historic paints would have been quite different from using modern paints and would have required rather more physical labour and preparation. One of the necessary preparatory tasks was that of grinding the raw pigments, and different materials required different degrees of effort. For example, the more colourful (and expensive) mineral pigments such as bright red vermilion were difficult to prepare and to work with. This was in contrast to gritty and coarse-grained earth colours such as yellow and brown ochres, or red ochre (made by heating yellow ochre), which are very easy to reduce to a fine powder with minimum effort, by grinding with a mortar and pestle, or on a glass plate with a flat-bottomed glass grinding device known as a muller. Most of the laborious grinding would have been done by suppliers known as artists' colourmen, who would then have added an appropriate gum mixture (specific to each colour but generally including some gum Arabic), and made little cakes of watercolour for sale.

Although these simple mixtures known as 'hard' watercolour were visually similar to modern 'soft' watercolour blocks, their properties were actually quite different, and 'hard' watercolours took a lot of soaking in water and scrubbing with a brush before they were ready for use in painting. The flow properties and solubility of the paint (perceived as the time it took to 'work up' a useable brushload of paint from the hard block) could be improved by the addition during manufacture of bile or ox gall, added as a liquid. These acted as surfactants: that is, they kept the large particles characteristic of those mineral pigments which require effortful grinding in suspension in the gum binder. These products are particularly useful for the smaller group of very hard mineral colours such as ultramarine made from lapis lazuli, which look less brilliant and intense when they are ground finely, yet are prone to settle out to leave a gritty appearance on the paper if ground coarsely. Consumer products today, such as shampoo and cleaning agents, are so full of surfactants and dispersants to keep everything in suspension, well mixed and ready for use, that we are unaccustomed to having to shake anything liquid to

counteract settling. Historically, most products settled and separated rapidly, and it took some effort to make them ready for use, every time. Professional painters would all have had small glass plates and glass mullers in their studios, for re-grinding dried-up or poorly mixed pigments.

From the early nineteenth century 'soft' commercial watercolour blocks pre-mixed with honey and sugar began to be produced. These were far more practical to use outdoors, because a wet brush was enough to work up colour rapidly, so that painting could begin. A further advance occurred during the 1830s when the addition of glycerine created 'moist' watercolours, the type of product most universally used today. However, it was only after the 1840s with the production of metal paint tubes with pre-mixed contents, that conveniently stored watercolours became available. Then, as wider ranges of colours were produced for tubes over following decades, painting became much easier for the beginner and overwhelmingly less messy and time-consuming. Until tube paints largely supplanted 'hard' watercolours, colouring *indoors* after a day of pencil sketching in wild weather was both practical and an efficient use of one's time, especially when travelling, and more productive than struggling out of doors with demanding blocks of hard watercolour.

Eighteenth- and nineteenth-century artists purchased their materials from suppliers known as colourmen. London had many small colourmen's shops centred in the Covent Garden area, while the provinces were served by mail-order services from the larger suppliers. British manufacturers exported watercolour equipment empire-wide and the market didn't just serve artists. Sailors, explorers, military personnel, scientists, botanists, and increasing numbers of travellers or tourists all employed watercolour for professional purposes (very much in the way that digital photography and mobile devices are used today for both business and leisure). Reeves was one of the earliest colourmen to produce watercolour materials. Reeves and Winsor & Newton remain well-known suppliers today, while other nineteenth-century colourmen, once equally well-known to professional artists, are no longer trading.

Chrome yellow from Turner's studio pigments, on a glass plate ready for grinding.

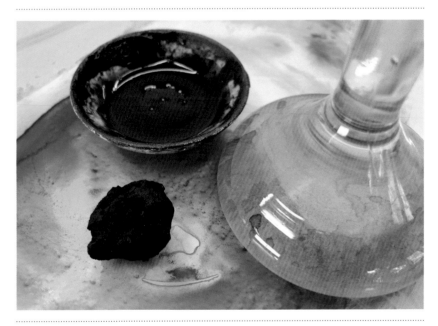

Prussian blue from Turner's studio pigments, being ground with a muller, 6–8 cm wide at its flat base, to make paint for historically accurate reconstructions of Turner's watercolours.

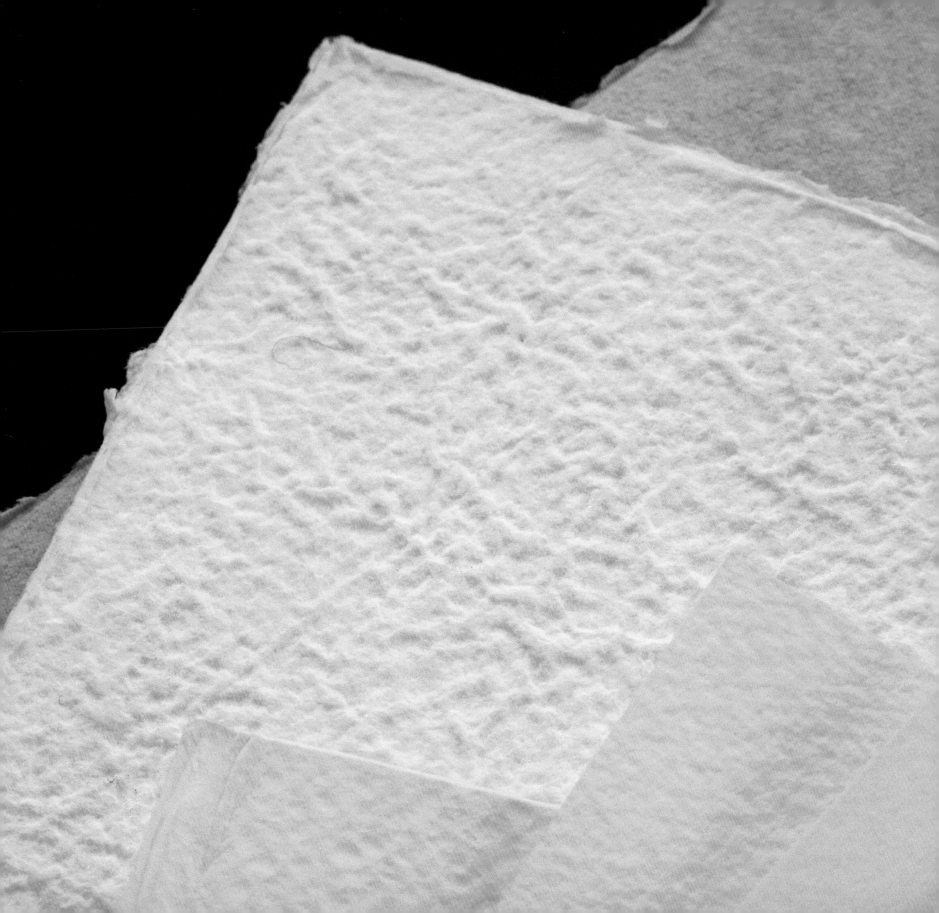

The nature of paper

Just as important to the final appearance of a watercolour image is the support onto which it is painted. In Western art and in recent centuries this has usually meant paper. To the painter, the most important qualities of a watercolour paper are its colour, its relative absorbancy, and its strength as a surface to work on. Stated in the broadest terms, suitable paper is critical to the success of every painting.

Those who simply want to paint, but without first looking at the technology of paper, will be wise to remember the following: while almost any paper might be used to carry a watercolour, some will work better than others. Where the finest results are achieved, they will almost always be painted onto *artist-quality, acid-free papers* with *a strength and surface appropriate to watercolour* and to *the task planned*.

However please note that, while the watercolour course you'll find later does discuss quality paper *manufactured for watercolour*, most of the studies in the sections after the short course were actually painted onto cheap sketchbook (cartridge) paper.

Unlike the machine-made paper that is common today, historic paper was all handmade. The best high-quality papers were expensive products that took between three and six months to produce. Intended for writing with ink, these sheets had to be strong enough to cope with the scratching of a pen, smooth enough to permit fine pen strokes, and also resistant to the absorption of ink which would otherwise smear out, and cause swelling and wrinkling of the paper as it dried. The latter property was achieved by applying a heavy coating of a range of materials known as 'size' (applied as a liquid agent and, in the nineteenth century, predominantly made from high-quality animal glue similar to modern gelatine). The degree of sizing varied according to the function. Map-makers and printers, for example, required strong, well-sized paper in large sheets with no joins. By contrast, unsized paper, known as waterleaf, absorbed water like blotting paper and was used for precisely that purpose. Lightly sized papers readily absorbed some moisture, which made them ideal for wrapping and protecting goods such as flour and sugar, keeping them dry and ready for use. One such product was roughly textured 'cartridge' paper, designed to preserve cartridges containing gunpowder, so that the ammunition would work successfully and at the first attempt when firing a gun. The colour of these common wrapping papers was unimportant, and they tended to be brown, due to the mainly yellow/brown materials used during the paper-making process. Writing paper on the other hand was made white by removing these impurities at some expense, or was coloured light blue by including some blue colorants to compensate for any yellowish colour cast.

Today, as in the past, the manufacture of paper for watercolour involves creating a pulp made from fibres in water. Eighteenth-century papers were predominantly made from linen rags, while during the early nineteenth century cotton was often added to the mix, or less commonly straw or hemp. These components were often derived from recycled textiles or rags and, in a seafaring nation, two types of material discarded in abundance were blue navy uniforms, fibres from which produced blue papers, and old rope made from hemp. Linen and linen/cotton mixes made good and durable papers, as opposed to low-quality

A selection of modern handmade papers with different textures and colours. Contemporary machine-made paper for artists offers fewer choices of texture.

hemp papers which soon turned yellow.

Whatever the type of raw material, the separated fibres were mixed with water and some animal glue to create a slurry or pulp which was then allowed to settle evenly onto a paper mould and dry. Various factors established the final characteristics of the paper sheets. Additional glue known as 'internal sizing' affected both the strength of the paper and the final degree of absorbency, although further, surface-only, sizing could also be applied at a later stage, by dipping the paper in a solution of gelatine. Strength was also influenced by the tendency of such fibres to attach to each other during the drying process. Surface texture, meanwhile, was dictated by whatever the pulp was laid to dry upon, i.e. whether upon something rough or smooth. The thickness and strength of the final product was pre-determined by the amount or weight of pulp used, so that paper sheets came to be known (as they are today) by their 'weight'. As stated earlier, these three factors – strength, surface texture and absorbency – remain to this day, critical elements shaping how individual watercolourists work.

Although there were many different types of historic handmade paper, what was not available before the 1780s or 1790s was paper intended for artists alone. Watercolour painters chose their papers from a very varied, never exactly repeated, range of products, often making their selections based upon their financial situation. Most serious artists opted for durable, high-quality papers bought in bulk. If necessary, they economised in other areas, for example by only purchasing their pigments in small quantities at a time. Each artist selected papers according to his or her individual needs and personal painting styles or subject matter.

One of the most fundamental choices for each subject painted was whether to opt for paper that was 'laid' or 'wove'. Prior to the mid-eighteenth century, all papers had a 'laid' texture where the sheet was made by dipping a paper-making mould shaped like a large tray into the slurry of paper fibres and animal glue, then lifting it out and manipulating it until the water drained out through its porous base. The base was crossed with fine horizontal wires stitched round vertical supporting wires. Each mould was the size of the finished sheet and it transferred a grid-like pattern of closely spaced lines onto the paper surface,

with 'wire lines' running in the opposite direction. (Not unlike the weave on a very fine basket.) However, even when the paper had been dried completely and flattened in a screw press, these lines still remained visible on the surface of the final product. This was commonly a problem when painting a watercolour, because the lines affected the way the paint settled, and therefore disrupted the integrity of the image.

In 1757, Kent papermaker James Whatman the Elder (1702–59) pioneered a new invention – substituting the grid of wires with a fine woven mesh. This new 'wove' paper resulted in a more uniform, smoother and less textured surface, though it was not made in quantity until the 1780s. External sizing by dipping the sheet in gelatine, as mentioned earlier, then pressing the paper in a heavy press (a manufacturing process which is called glazing), can make a wove paper smooth enough to appear perfectly flat from most angles of view. Although in fact the two sides of the sheet will feel different to the experienced painter, the 'wire' side (the one that lay on the wired surface of the mould) has more texture than the opposite 'felt' side, both look virtually identical to the general viewer and neither side is likely to interfere with the appearance of a painted composition. Many artists regularly and indiscriminately used either side, particularly in the case of a bound sketchbook, where a painting that spans both sides of the binding necessarily uses *adjacent* sheets. This usually means *opposite* sides of the paper, and therefore a change of surface that may disrupt the continuity of the image. Laid paper nonetheless continued to be produced into the nineteenth century and some artists continued to use it, while others used both laid and wove papers at different times. Those who preferred a very coarse paper tended to use thick, non-glazed wove paper.

Once an artist has selected his or her preferred type of paper it is also possible to customise its properties. For example, dipping sized and/or glazed paper in water, or repeatedly applying watercolour wash, dilutes or removes the size, thereby making the paper more absorbent. The watercolour paint can then spread out further, and it will never form a hard outline as it dries. This gives an experienced artist tremendous scope to respond to the characteristics of that paper, making it follow his/her will through manipulation of its water exposure. S/he might even capitalise on

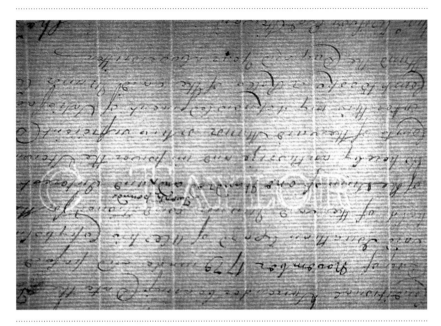

Laid paper from a document, x2 magnified image lit from behind, to show the lines and the maker's countermark. The actual width of this area is 11 cm.

Detail of J.M.W. Turner, *Study of Two Men in Academical Caps* ... 1796, Tate D00836. It shows the surface of a middle-weight off-white wove linen paper, with charcoal drawing. The actual width of this area is 2 cm.

A selection of handmade wove papers made to simulate those used by Turner (blue, white and off-white) and Cox (brown).

Detail of J.M.W. Turner, *A Family Seen from Behind* ... 1796, Tate D00824. Turner has used a heavy wove linen paper, this example being coloured light blue with blue fibres. The actual width of this area is 1.5 cm.

uneven sizing common at the start and end of a batch obtained from the same paper mill. Turner is the best example of an artist who instinctively understood his paper. He used many types within his work, although these were mostly purchased from a small and carefully chosen group of suppliers, in batches that sometimes lasted him for decades. Another visual characteristic of gelatine-sized papers is the granulation, or visible settling of large pigment particles between the paper fibres. David Cox, for example, used surface-sized papers in order to achieve this very effect.

Traditional, handmade, glue-sized papers were generally wetted and 'stretched' before use by artists. This could be done by laying the sheet onto a heavy wooden sketching board, and taping the edges (illustrated on p.12), or pasting them down with animal glue, using a 12–20 mm adhered strip on each side. The paper would then be wetted all over with a sponge and left to dry. Although it would 'cockle' and shrink, breaking free if the adhered strip was too narrow, it would not respond so violently to water again. Painting could then be carried out on the same board without releasing the paper.

Thinner papers could be brushed down onto a flat surface with a large wet brush or a wet sponge, and they would stay satisfactorily flat without taping *so long as they were wet*. This meant that the artist could start painting immediately and without the need to prepare the board days ahead.

Aside from special orders, modern artists' paper is very different in its characteristics from historic paper. Good-quality products are mostly made from cotton fibres, with the commonest internal sizes now being a synthetic material rather than gelatine. Additional surface sizing as found in historic papers is nearly always absent. These papers absorb more water from the brush, and cockle and wrinkle less as they dry. Unfortunately though, art suppliers provide little information on fibre or size type. Paper for etching or printing is the most heavily externally sized product on offer today. The contemporary artist who seeks out surface-sized and glue-sized papers comparable to historic equivalents has real difficulties in finding them. It is possible to source them from very specialist suppliers, or an alternative is to resort to old rolls of household lining paper (commonly applied over old, uneven or damaged plastered walls to prepare them for wallpapering) or else supplies of 'archive quality' paper for preserving printed documents, or, if it can be found, printing paper from the mid-twentieth century or earlier.

Modern papers come in a range of weights, colours and textures. Coloured paper tends to come in single sheets and is more expensive than white (while the opposite was true in the past). Sketchbooks today tend to have bright white papers. These are visually distinct from the creamier or off-white papers produced by the traditional processes in use in Britain until just after the Second World War (and up to the 1960s or later in some countries). Some artists in search of authentic-looking supports therefore seek out old papers, such as the blank pages at either end of second-hand or antiquarian books, as J.A.M. Whistler did for printing his etchings. Today, handmade paper is much more expensive than the machine-made paper that is on sale from artists' suppliers, and handmade papers can be recognised by the wavy-looking deckle edge, created by the edge of the mould that made each sheet.

Beginners are once again advised to start out with a *medium-weight, cold-pressed, acid-free* paper. We further advise that this has a *medium* surface and is clearly marked as 'made for watercolour' by a reputable manufacturer. A good art-materials supplier will be able to assist and advise you on specific types, just as did the artists' colourmen of earlier times.

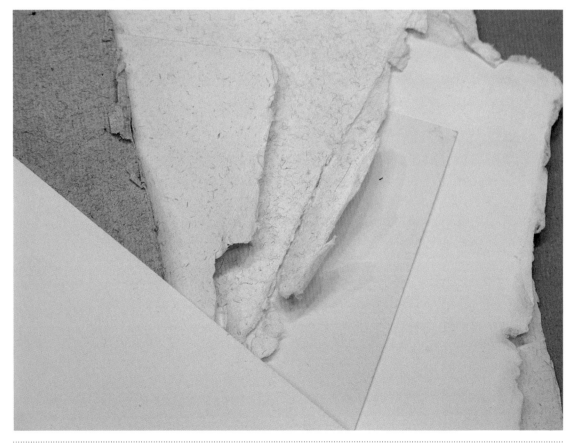

A selection of historically accurate handmade papers of the colours and textures often used by Turner.

The nature of brushes

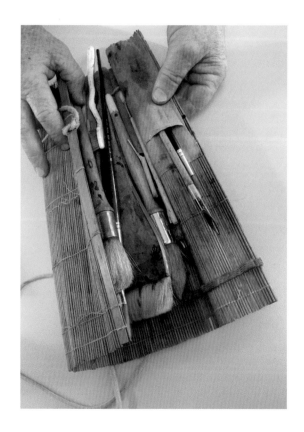

Protecting brushes in transit: the very practical brush-roll of painter and wilderness bushwalker, Hugh Mackinnon.

Brushes are certainly the most critical hand-tool of most watercolourists, so that with them the great masters were able to coax watercolour to portray not only the massive forms of clouds building before a storm, but also the finest details of dew upon a leaf or the tiniest of figures in the far distance. Your own choice and use of brushes will greatly determine not only the marks you can make in watercolour, but also how successfully you manage the *amounts* of it required for even the most basic of processes. Most obviously brushes can be used to pick up, carry and deposit paint *onto* the painting and move it around once it is there, but they can also be used to lift colour *off* the painting too. Choosing between these will determine the types of marks made by the paint, which is affected by factors including how much paint the brush is carrying, whether the paper is wet (and how wet), and so on. A good brush has 'spring' and can hold a lot of water. Its broadest brushstroke is the length of its hairs (about 20–25 mm for the largest artists' brushes). Modern brushes can be found in a range of sizes, and they make a great variety of marks even when used conventionally. But when used *unconventionally* the painter may soon discover how brushes can play their part in the almost unlimited potential of watercolour for original and creative self-expression.

In the past, traditional brushes for watercolour were known as 'pencils'. It is possible today to find makers of traditional brushes, though they are rare. The type of hair obtainable today for brush-making is mainly squirrel, but once included camel, hog and cattle hair. The correct number of hairs was selected, graded, trimmed to length, tied together, dipped in animal glue and pulled through a pre-softened quill from a bird's flight feather (from the wing or tail). The stub of the quill was then tied round with fine string and placed onto a wooden handle. Handles came in different lengths, including short ones that could be fitted into a travelling watercolour box. Brush-heads could be replaced as necessary, and were probably bought in multiple packs. In fact, many historic watercolour boxes include only the handles, looking like blunt-ended sticks, without any attached brush-heads.

All quills produce round brushes. Historically, swans and geese provided the largest quills (about 8mm in diameter) and sizes ranged down through ducks and crows to larks (the last with a diameter of about 1 mm). The smallest sizes would have been used for fine details by manuscript illustrators, and of course by watercolourists, although these ranges are unobtainable today. However, even the largest of these brushes would seem quite small and puny for covering a large sheet of paper with watercolour wash today. In the past, cloths, rags and sponges could have been used to do this instead, or larger brushes of the type required by decorators or for varnishing large surfaces, which were made by tying the hairs to a thick stick or dowel, meaning they were also round in shape, or by embedding many small brushes into a wooden handle, to give a rectangular brush (mostly with gaps between each small head). Flat brushes with dense hairs along their length are a modern invention in the West. The metal ferrule or crimping device that holds the hairs in both modern artists' and decorators' brushes did not become available to watercolourists until the later nineteenth century. There is some

Different types and qualities of hairs for making brushes.

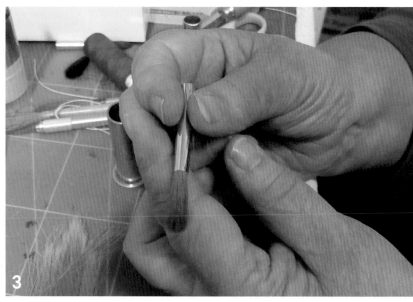

The hairs bunched, glued together and inserted into a quill.

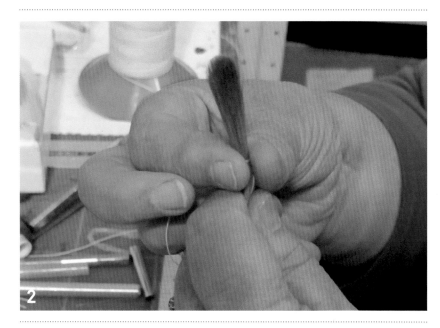

Tying the hairs together before dipping them in animal glue.

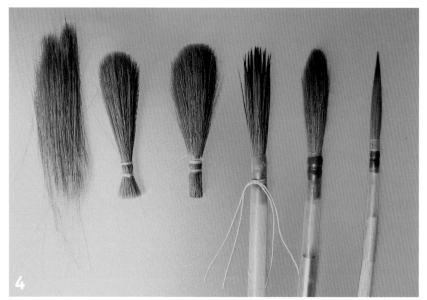

The brush-making process. The authors sincerely thank Cath Geheran of Handover Brushes and Paints, London, for her generous demonstration of this historic craft.

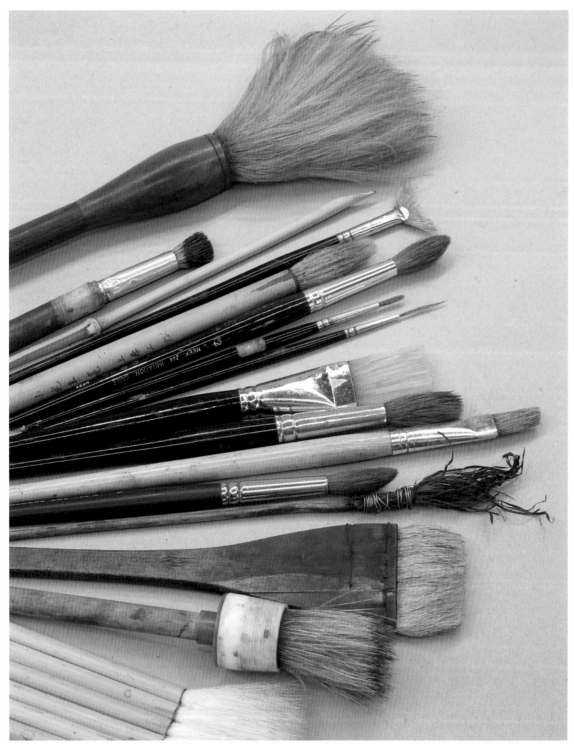

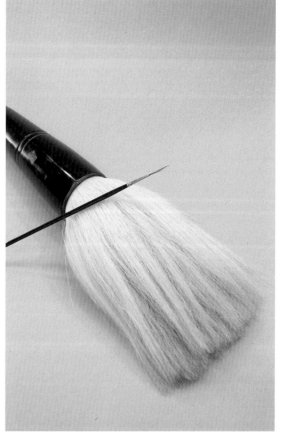

Selections of modern brushes: from small to large, including commercial, art and handmade brushes. The variety of marks that can be made is virtually limitless.

evidence to suggest that at least some Western artists were able to acquire brushes from southeast Asia earlier (possibly much larger and even flatter brushes of the type now known world-wide as 'hake' brushes or made by joining numbers of quill brushes side by side). Fan-shaped blending brushes, common today, would have been very difficult to fashion from quill brushes. Although it would have been possible to trim the hairs of a round brush, there is in fact little brushstroke variety to be achieved by such an exercise. Using the 'heel' of the brush, i.e. the part where the hairs are bound together, gives some of the effects obtainable today with a fan-shaped brush, or a flat one that has been trimmed with scissors. John Glover (1767–1849), a well-known watercolourist and teacher during the early nineteenth century, was known to encourage his students to splay the hairs of a single brush to create massed foliage effects at a time when most watercolourists still used the end of a tiny brush to place each single leaf carefully, with a separate mark. You *will* notice, however, that most of the many and varied marks made in the lessons and exercises provided in this book are also made with a single brush.

Brushes today might be made from sable, nylon, horsehair, goat hair, hog bristles or dried grass bound to a handle. They range from expensive artist-quality brushes down to much cheaper brushes bought for kitchen use – and even toothbrushes. Interesting-looking brushes tend to make interesting marks – and these can be the stimulus for creativity and freshness. Rolling them up in a reed or bamboo mat is a common way to protect them when heading out to work in the open air, or for travelling generally.

You will only need a few brushes in order to work from this book. The most important is a size 10 or 12 imitation-sable 'round' (that is, it will come to a fine point when wet). The brush used in most of the illustrations is a very inexpensive example made of two-thirds pony hair and one-third goat hair, and it imitates the performance of a really 'tired' old sable or squirrel brush. Such a brush – seen on top (with a red handle) in the image of portable gear for working out of doors – enables even a beginner to work with it as if it has been in service for years. It proved to be the perfect tool when creating historically accurate reconstructions of Turner's watercolours, for example.

Next, a 2–5 cm-wide hake makes life easier for laying flat and/or graded washes, and is useful for pre-wetting when required. Three more are useful: a small nylon flat brush); and a number of hog-bristle oil brushes for mixing paint.

A basic range of inexpensive brushes is all you will need to get started.

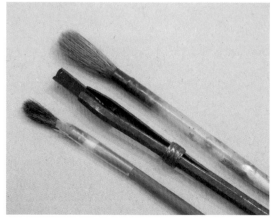

Historic materials: a wooden-handled quill brush from the 1880s (left), a possibly much earlier brush made from a quill (right) and, in the middle, a *porte-crayon* holding a hand-cut graphite stick.

The nature of drawing materials

Details of J.M.W. Turner, *Bridge and Cows* c.1806–7, Tate D08102 (shown on the following page), showing paint removed with water to create the reflection of the cows in the river. The actual width of this area is 1 cm.

Drawing is often used prior to the application of watercolour washes, and was commonly used to sketch or define the subject in some detail. For many uses of watercolour, including map-making and topographic sketching by military draughtsmen, detailed drawing was vital, and paint was applied simply to aid comprehension and use of the image.

The earliest material used for drawing was probably charred wood. A more controlled version of this simple process is used to create sticks of charcoal as sold today. On a very simple level, charcoal can be made by leaving a twig to burn down in a cooling fire, surrounded by others so that the oxygen supply is low. Charcoal sticks could always be made at home, or bought from an artists' colourman. Although good for creating bold tonal drawings, it is not the easiest material to use with watercolour since the sticks come in only one colour – namely black, it is not suited for making very light sketching marks, and it tends to leave wide grey smudges on the paper when attempts are made to rub it out. Charcoal also has a tendency to repel watercolour washes, and hence is better used for sketches not intended to be worked up later with colour. Oil painters find it a more useful material if they paint thickly from choice, because oil paint 'takes' to charcoal (and also graphite pencil).

So-called chalks (including black, red and white varieties), and other soft minerals based on earth pigments, have been used for drawing since the Renaissance, and various holders were designed to make the most of a sliver of material (one is shown on the opposite page, with the two quill brushes, holding a piece of shaped natural graphite). Genuine chalk is white or cream in colour, and therefore useless for drawing on white or off-white paper. Natural graphite, a soft, non-toxic black mineral, is more suited to this, hand-cut and clamped into a special holder with an adjustable jaw, known as a *porte-crayon* which held it firmly by one end so that almost all of it could be used for drawing. By the mid-eighteenth century, graphite was ground up and combined with clay to create a material known as 'black lead' (today we call it graphite pencil), enabling different 'hardnesses' of pencil to be produced. Later, round pencil leads were made for insertion into hexagonal wooden holders and, by the mid-nineteenth century, were often machine-made, labelled and colour-coded according to their quality and hardness. David Cox recommended using a 'hard black lead' pencil for fine light marks to represent distant elements in landscape, and a soft one to make thicker marks in the foreground. J.M.W. Turner and many others often followed this well-known precept.

Another useful drawing implement in a watercolourist's paint box was a pen. Pens designed for dipping into ink for writing could equally be dipped into watercolour paint when delineating very fine detail. Ink itself was also used for drawing: both Indian ink made from lamp black, which can be diluted to make grey wash; and the more everyday irongall ink, blue/black when applied, which turns brown on ageing and also has the unfortunate long-term consequence of making paper deteriorate. Today it tends to look like a brown wash, sometimes quite light in tone.

Almost as important as materials for making positive marks are strategies for ways of removing

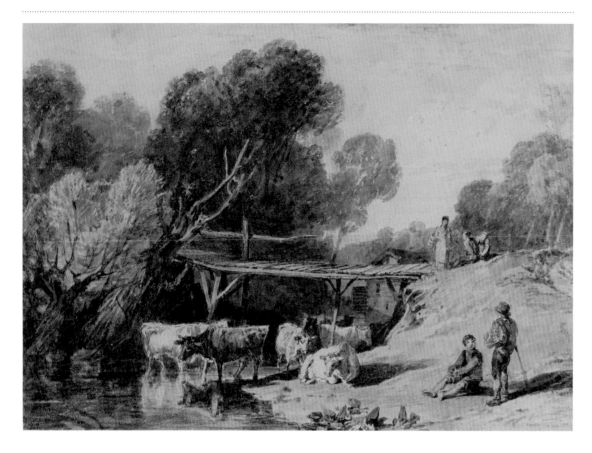

J.M.W. Turner, *Bridge and Cows* c.1806–7, Watercolour and graphite on paper, 18.5 x 25.8, Tate D80102.

them or for making negative ones – that is, marks or washes that emphasise a patch of non-painted paper and cause it to be perceived as a light area within the composition. For a golden age artist, carrying two pencils, a hard and a soft, and a small bottle of diluted watercolour (often brown or grey, for shadows) and/or a small bottle of thick white watercolour (known today as gouache), gave many more options than simple pencil sketching when working outdoors. At home or in the studio, however, away from wind and rain, it was possible to employ a range of implements and techniques designed to lift off dried paint or to create highlights without painting them on. One method involves a brush full of clean water, used to re-wet the area to be lifted, and then squeezed out and touched to the wetted paint, to draw up the colour. Another is to use a sharp-ended tool such as a knife, pin, needle or thumbnail to scratch down to white paper, as Turner regularly did when he had a need to lift off colour. Sometimes he left curved marks corresponding to the sweep of his right thumbnail. Finger-tips, rags and handkerchiefs obviously work too – and (rare) images of Turner at work show rags stuffed into every pocket. (Images of other well-known artists actually at work are even less easy to find.) Feathers and raw sheep's wool would have been readily available to many, and could serve the same purpose.

A versatile precursor of the modern eraser could be created by taking a pinch out of each successive day's loaf of bread, and leaving the doughy lumps to go stale in the studio. After a few days this generated a range of 'erasers' of varying hardness, which would leave no greasy trace, or cause damage to the paper (which was a disadvantage of too much scraping away with a sharp or pointed tool). Contemporary manuals recommended this procedure, but since the use of bread as an eraser leaves no trace we cannot tell now how widely it was adopted or which artists regularly used the method.

All of these techniques could be used on dry paint, and also on areas which were just drying, which in combination gave an even greater variety of effects. For example, scraping into wet watercolour paint will leave a darker mark than when the same tool and pressure is applied to dried paint (so that, by scraping the paint away from the surface, a lighter mark much closer to the original colour of the paper will result).

The nature of colorants (pigments)

Hillside effect created from a mix of yellow ochre into which a little Hooker's green was added to make a single green that was then variegated with other colours and finally gradated with clear water.

Any practical painter (or serious materials researcher) who aims to emulate the greatest past masters of watercolour, needs to be mindful of not only the *physical* properties of paint (i.e. how it behaves as a liquid medium), but also its intrinsic material properties – and how these have been understood and exploited by previous generations of artists.

Early watercolours, known as 'stained' or 'tinted drawings', made use of colours created from animal and plant materials. Their function was to add colour to a usually pre-defined patch on a print or drawing, and their typically fine particle size meant that washes were easy to apply evenly. However, these materials also have low tinting strength (i.e. the visual impact of the colour is never intense), which meant they could not be applied as opaque washes, and their quality and resistance to fading in light varied hugely. Durability and actual appearance were influenced by particle size and by the way the pigment had been prepared (in the case of plant-derived colorants this meant the health of the plant, and the weather as it grew). Indigo, red lake and gamboge were all made from various parts of different plants, while Prussian blue (discovered in the early eighteenth century but only adopted gradually) was made from animal products, originally blood or other discarded parts from the meat trade. Indian yellow was derived from the urine of cows undernourished on a particular plant and fed little else. (Today the shade is replicated by a completely different process and ingredients, since the method was banned long ago.) The other colours noted above are today synthesised industrially, but have the same chemical composition as the historic equivalent.

These organic colorants were popular throughout the eighteenth century and into the first decades of the following century, not least because they were mostly cheap. Before watercolour painting really developed as an expressive art form, many other craftsmen and professions used the medium as part of their working practice, and in fact 'stained drawing' had its roots in map-making, documenting scenes outdoors (for example by the military, in planning manoeuvres) and the making of preparatory designs by low-income craftsmen. Earth colours were also inexpensive, so that raw and burnt sienna, raw and burnt umber, light red, Indian red and yellow ochre were also commonly used. All earth colours have the advantages of being somewhat transparent, and they have good permanence. The plant-derived colorants were even more transparent when used in watercolour paint, so that the two groups of materials used together were ideal for 'staining' paper. Bone black and lamp black also share the advantage of permanence, and were sometimes used as monochrome washes.

Oil painters traditionally used brighter and more expensive pigments made from minerals that were broken up, before being ground down and washed to extract colourless impurities, and then ground again more finely. Some are not intrinsically very colourful and need to be used with huge particle sizes if they are to look brilliantly bright in paint. This posed a problem for watercolourists using the same materials to make use of their intensity of colour and greater opacity. Such materials had a tendency to 'settle out' in watercolour, and therefore create granulated

washes, with the grittiness obvious to the viewer. However, by the early nineteenth century increasingly more pigments were being industrially manufactured and the processes were gradually optimised, resulting in better, brightly coloured products with naturally smaller particles, which made good watercolour paints. Many of the paints were toxic, and virtually all the production processes were dangerous.

Today, very few artists make their own watercolours (though some make their own pastel sticks using similar materials). Commercially produced tube watercolour paints are very popular for studio work, while semi-moist pans are probably the best choice for portability and convenience when out of doors.

Most of the demonstrations in this book were painted from artist-quality tube paints mixed in inexpensive saucers and using a very limited range of colours. This mimics the process and reduced palette that a watercolourist of the golden age might have used on a day-to-day basis. Certainly, research has revealed that many of the greatest watercolours of that age were created with very few colours, especially those of the eighteenth century. Some masters (for example, Tom Girtin) used a slightly wider range of pigments, while Turner (uniquely) used a much wider range over a long career but used a lesser number in individual works.

With practical precautions and rigorous avoidance of skin contact with historic materials (which means never touching, stirring or manipulating the paint with a finger, nor breathing in particles if pouring or shaking dry pigments out of a container), most of the traditional pigments can be used safely by artists, or for public demonstrations to adults (but never children) who have been warned not to handle them.

Green is intentionally not on this list. Historically it was commonly made by mixing blue and brown for a dull green, and for brighter greens a blue and a yellow, or a black and a yellow, which is still easy to do. A process known as 'variegation' can be used to suggest the countless variants of green that might be seen on a hillside. Most neutral greys, slate colours and purplish greys were also mixed in the period of the golden age, from a blue and a red. Truly purple pigments were not available at all until after 1850, and even after this date they were not immediately adopted by those artists who were already skilled in mixing a range of subtle purplish tones.

Colours for the exercises	Modern palette	Golden age palette
Red	Light red or cadmium red	Vermilion (which is toxic)
Yellow	Yellow ochre or cadmium yellow	Yellow ochre or chrome yellow (which is toxic)
Blue	Cobalt blue	Genuine ultramarine, or later cobalt blue or synthetic ultramarine
Dark blue or black	Phthalocyanine blue or lamp black	Prussian blue or bone black or lamp black
Light brown	Raw umber	Raw umber
Dark brown	Burnt umber	Burnt umber
Transparent brown	'Sepia' which will not be genuine	Genuine sepia
Transparent grey	'Payne's grey' which is a neutral grey	Mixture of blue indigo and light red or a red lake, perhaps with yellow gamboge or Indian yellow, but not made from lamp black
White for highlights	Chinese white	Chalk or dolomite, lead white (which is very toxic) or Chinese white at the end of the period
Bright opaque red	Cadmium red	Vermilion (which is toxic)

Turner was one of the few artists who used a genuine green pigment in watercolour, and he set a trend which others would soon follow. He regularly used emerald green, as brilliant and intense as its name suggests. However, it is important to note that it is fully as toxic as lead white. Anyone using emerald green and/or lead white for historic reconstructions should have the resources of a proper laboratory to handle them safely, must comply with national health and safety procedures and be able to show written evidence of risk assessments. (Fortunately such colours are no longer commonly used by artists, and indeed are not obtainable in many countries today.) Some other toxic historic pigments are less problematic in practice, because they are insoluble in water and/or cannot be absorbed by the human body even if they are used unsafely. Vermilion is an example, and it can still be bought today in tube watercolours, while other more toxic materials cannot.

Paint boxes and other equipment

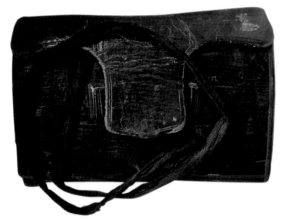

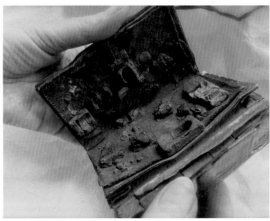

Turner's travelling watercolour palette, closed and open.
(Private Collection)

It is often the more luxurious historic watercolour boxes which survive, having been considered too good to be used by their owners. Some may have been given as school prizes or as gifts. The Ackermann box on this page includes: a removable tray with enough space for eighteen replaceable blocks of colour; a slot for holding many brushes of a reasonable length; a dish for water; another slot for charcoal, erasers, knives, needles and other tools; a sliding drawer of white porcelain dishes for mixing and retaining tints for re-use, and space for small sheets of paper for studies. Similar boxes for oil painting had slotted grooves in the base for holding small panels with still-wet paint. Stiff cartridge paper could be stored in the same way after an outdoor painting session, or thinner and wetter paper could be supported by the same sketching panels until it dried. The box itself provided a good surface for working outdoors, and most are lockable with carrying handles. Many examples held ten blocks of the more traditional colours, some a generous twenty-four including the brighter and newly invented ones, while later nineteenth-century sample products made for trade exhibitions are even larger.

The professional artist adapted his own gear for his own convenience. Turner's travelling watercolour palettes were small enough to push into an inner pocket in bad weather, and one was made from re-purposed leather, waterproofed canvas and a succession of watercolour blocks stuck down. In another example (not illustrated here) the blocks are all well-used, and he may even have stuck down old ones that already had a hollow made by the brush: this could be topped up with water at an inn before he had dinner, and

used afterwards when the paint had softened. All his surviving palettes, more likely from the end of his life, include the more challenging 'hard' watercolour blocks of his youth (see 'The nature of watercolour').

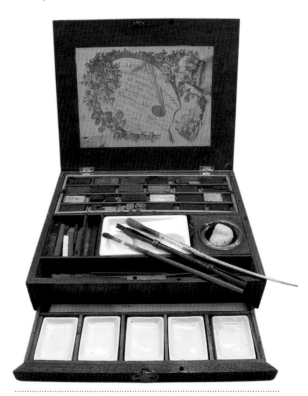

Late eighteenth- or early nineteenth-century Georgian watercolour box by R. Ackermann of London. (Tony Smibert Collection)

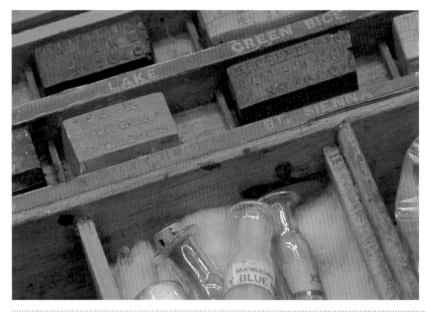

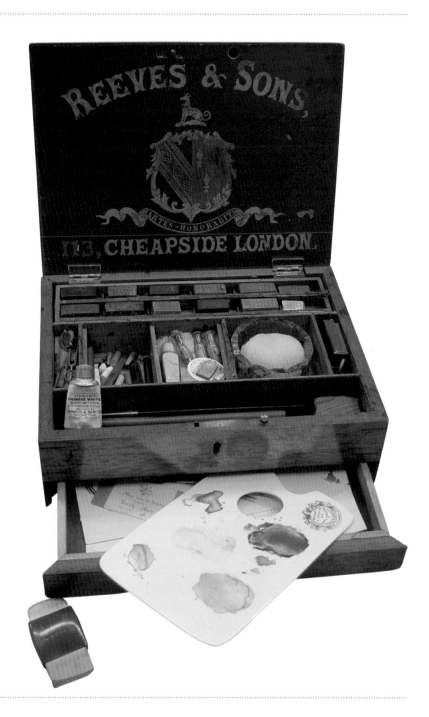

Nineteenth-century watercolour box by Reeves and Sons of London. The watercolour blocks were stamped on one side with the maker's name and the equivalent of a present-day logo, and with the name of the colour on the other. A mixture of makers indicates either non-original contents or realistic use and replacement of favourite colours by the original user of the box. (Tony Smibert Collection)

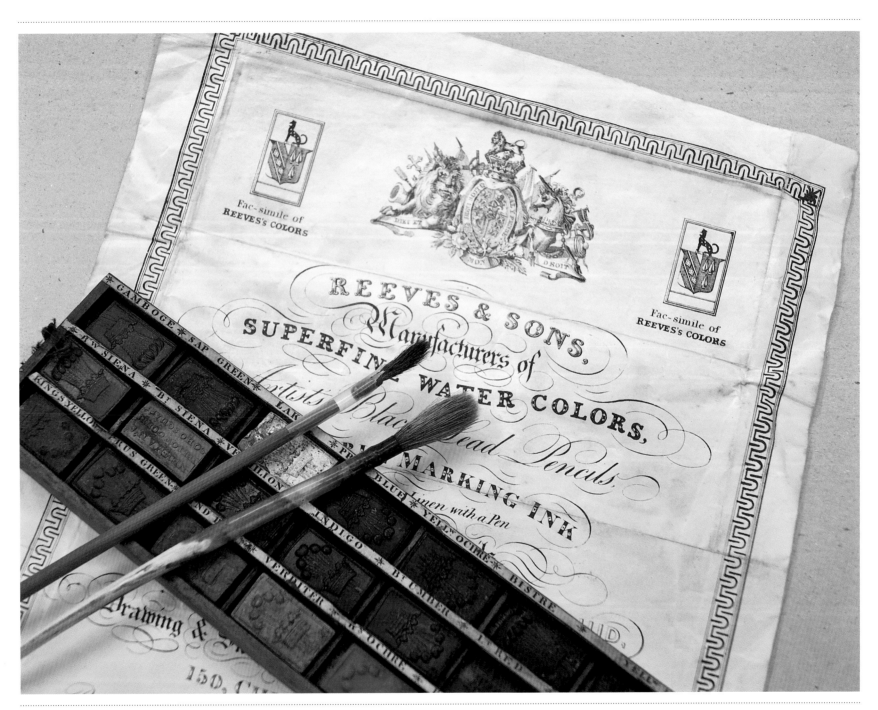

Advertisement from the first half of the nineteenth century for watercolours from Reeves & Sons of London, with Reeves paints and brushes. (Mountford Granary Collection)

Advice for schools

'School-grade' paint

While this book was not specifically written for schools, it should be expected that many young people will certainly be interested and many art teachers will want advice on how to help their students to understand, relate to and possibly emulate the sorts of watercolour effects achieved by the great masters of the past. While school paints today are normally water-based, for health and safety reasons, this does not make them suitable for traditional watercolour painting. So one of the greatest challenges facing schoolteachers wanting to give students a meaningful experience of true watercolour is the limited capacity of most schools to provide the materials. Artist-quality watercolour paints, for example, are expensive and some include toxic pigments (mainly vermilion, discussed previously). Brushes for watercolour painting, especially sable, are very expensive and easily damaged, and quality watercolour paper may also be well beyond the budget for an entire class.

These challenges aside, it is still possible to offer a hands-on experience based on watercolour by modifying the exercises in this book and adapting school-quality materials to the task. Then where there are students who show real interest or aptitude, it may be worthwhile to invest in smaller quantities of at least student-quality materials (intermediate in price, they will not include toxic pigments) purchased from reputable manufacturers of artists' materials, and allow those enthusiasts to explore the medium privately or under teacher supervision. One of the authors, Tony Smibert, originally graduated as a secondary art teacher and sums up his own experience with this problem as 'looking out for students who really want to learn watercolour and can be trusted with access to real materials and professional advice'. Depending on reading age and maturity, such interested student/s should find no difficulty in understanding the purpose, guidance and practical instruction offered throughout this manual – subject to timetabling and a space for them to work.

The broader aim should probably be to help all students to see that watercolour, though it requires focus and application to achieve high levels of skill, is nonetheless readily accessible to all. While hoping that, by trying their hands and learning to recognise the techniques of traditional watercolour, school pupils who are aspiring artists will come to appreciate and deeply enjoy the achievements of the many great artists who have worked with it, we should also expect that children of any age at a secondary level with an interest in painting can also benefit. Therefore many of the watercolour exercises explained here can also be re-interpreted to adapt to classroom paint, paper and brushes.

Paint

Typical school colour paints are mostly opaque and come ready-mixed and thinned in bottles. Therefore the heavier textural applications of paint won't be possible, but thinning the paint to make somewhat 'transparent' washes will.

Paper

The trick is to use better-quality paper than 'newsprint', which will not prove suitable for classical watercolour effects (it is less heavily sized than traditional papers, highly absorbent, prone to buckling and easily torn when wet). Cartridge paper may prove sufficient to your needs, or the 'matt' side of litho paper. Ideally, the purchase of economically priced watercolour paper (of a grade known as *not*) of medium weight may prove to be the best possible investment and worth the extra cost for students who are genuinely interested.

We recommend encouraging students to start out by working small. Although many will want to work boldly and on a large scale, a *small sheet, large brush, strong paint* model aimed at creating numbers of smaller pictures is advisable, rather than its alternative (i.e. large sheet, small brush and weak paint). Boldness can still be achieved, and beginners can learn to appreciate this with reference to the small scale of many incredible watercolours in public collections. Turner's work in particular is a great example of this.

Another great technique to draw from the visual evidence sometimes remaining on watercolours by Turner is the highly efficient way that he likely stretched relatively thin papers when travelling, which provides a nice introduction to the use of broad wet-in-wet effects. A similar mode of working is achieved by thoroughly wetting cartridge paper (even photocopying paper will work for this) and pressing it out onto a smooth surface such as a board, sheet of plastic or hardboard, or even directly onto a desk or table. The sheet can then be washed and charged with colour right up to its edges as Turner sometimes did, working wet into wet with expressive

and exploratory purpose in order to move colour around and establish effects. The sheet can then be gently peeled from the board or table and hung up to dry. When dry (and possibly pressed flat under a weighted board), they can then be painted with details using dry-brush technique. This is far more immediate than taping, glueing or pinning the paper to a board before wetting it, and the aim of this manual has been to focus on techniques that are readily applicable to *un-stretched* paper and sketchbooks.

Brushes

The notion that watercolour requires expensive sable brushes has to be put aside at school level. It is simply not true anyway. Anecdotes and surviving materials suggest that the great artists used a whole range of cheaper alternatives alongside the more expensive brushes.

Most of the exercises in this manual were created using very inexpensive and 'imitation sable' brushes (mostly pony hair) that had already been proved to have a reasonable capacity to take up wash, yet deposit lots of wash on application to paper, *and* hold their shape for expressive mark-making. It might seem obvious but many artificial brushes (nylon, for example), although capable of forming a great point, cannot take up wash sufficiently for most washing-in processes and often won't release the limited amount of colour they *have* taken up. If you give children those brushes they will have difficulty in laying any sort of traditional wash.

Children will always punish brushes, but this won't be such a problem if you pay heed to the exercises given earlier in the manual and allow them to explore fully

and appreciate the creative potential of whatever tools you may give them.

Teacher preparation time is vital. We suggest that art teachers play around with the processes and exercises from the manual that they might want to build into classroom lessons. With experimentation they should prove readily adaptable to different levels of students.

Here are a few of my own, adapted for classroom use, from within the later sections devoted to individual artists.

- Stained drawing (lake, mountain, sky) which J.S. Cotman developed
- Abstract colour harmony using Turner's method
- Sky studies using Constable's method
- Blotting using Cozens' system
- Tree studies with reference to Claude and Corot

Teachers will no doubt be well aware that Tate and most other great galleries are very committed to assisting teachers to help students gain access to and inspiration from the works in their collections.

Many galleries run school-term and holiday programmes for all ages and might well be interested in helping the practising classroom teacher with ways and ideas to extend those presented here. Good luck!

Preserving watercolour-based artworks

Most professional artists use good-quality materials to promote the long-term preservation of their artworks – so that the images they create and sell will not only *survive*, but continue to look the same over time. The greatest enemy of a work on paper is a lack of proper care. Even if the highest quality of materials available was used it will still be damaged by over-exposure to light, damp, inappropriate chemicals used to clean it and even accidents.

But first: since in this book watercolour is correctly described as a 'painting' medium, why is it that most public collections including Tate, classify, store and preserve watercolours within their departments of 'prints and drawings'? This derives from an historic context whereby watercolour was largely used either by artisans and craftsmen as a means to develop their designs, or artistically for adding tonal values and local colour in between the lines of a drawing in pencil or ink. Furthermore, drawings were not regarded as 'finished' works of art on the same level as paintings in oil which were perceived as better imitating reality, and being far more capable of conveying complex ideas and emotions. (When watercolour was used by artists, it was most commonly to do preliminary studies for the real work to follow, so that it wasn't until the mid-eighteenth century that watercolour gradually came to be placed on something of an intellectual and aesthetic par with oil painting. The formal and *historic* definition of watercolours remains the same in galleries because, like prints and drawings in other media, they are works on paper. All these types of artwork require a special type of care and conservation, since they are much more fragile and light-sensitive than a typical oil painting, and therefore less durable.

Most important for durability, paper is both flexible and responsive to moisture (the latter is a key reason why it is used for watercolours). However, the textured surface has also proved to be good at trapping dirt and soot, which are very difficult to remove. Up until the early twentieth century, British houses were heated with coal fires and historically they were lit with candles, or sometimes gas or oil lamps, all of which created a sootier and dustier environment than we experience now. The cheaper and nastier varieties of such lighting and heating created gaseous pollutants, as did horse-drawn transport and inadequate sewerage systems. All these gases not only affected public health but also led to the loss of colour in dyed textiles and many other materials, including watercolours. An early strategy for the care of collections was to keep watercolours and prints hidden away in portfolios, except when the owner took them out to admire them, which provided good protection from the hazards of the historic indoor environment.

When watercolours were hung on walls they were often framed for protection. Glass was expensive in the nineteenth century – more so than gilded frames – and until the mid-twentieth century it was difficult to make large, flat sheets free of ripples. Eighteenth-century watercolours would have been displayed in a frame that exactly fitted the image, a practice known as 'close framing'. Most watercolours and prints from that period were sold without frame or glass, but with a narrow 'window mount' made from thick paper or card, with several coloured 'wash lines' painted on all four sides just beyond the extent of the image. Many collectors had a uniform set of frames and mounts made for their entire collection, or at least for all that they displayed

in the principal rooms in their houses – spaces which would have been seen by their friends and sometimes made available to artists for study. Where truly wealthy collectors owned several properties, in common with the rest of the interior furnishings, works of art would be covered and protected from light, dust and soot when the family was not at home and the house was closed. This was a traditional housekeeping practice.

Influential thinkers such as John Ruskin sought to improve the living conditions of the masses through education and expansion of the mind. One outcome was that large numbers of works on paper from public art collections were framed and sent on nationwide tours to the provinces where they were then displayed for long periods of time. However, the traditional coloured pigments used for 'stained drawing' were not lightfast, as Ruskin (but not everyone) appreciated, and were far more readily faded than the same pigments when bound in oil. Adding to the problem, from the end of the eighteenth century through to the later nineteenth century, many new pigments had been invented and were soon used on an industrial scale before their lack of stability was appreciated. Some of the best examples of Turner's art were toured and displayed continuously for up to twenty years, with the result that many have faded badly. Museums today limit display times for works on paper and call the practice 'preventive conservation'.

The drastic and sad deterioration of the Turner watercolours did lead to some eventual good. Two well-informed gentlemen were commissioned by the British government to undertake investigations into the effect of light on watercolours. Their Russell and Abney report produced in 1888 is a model of its kind:

thorough, comprehensive, well-reasoned and influential to this day, since they identified many factors in the deterioration of paper-based artworks that even in the twenty-first century are still being elucidated. Russell and Abney were in effect the first conservation scientists, though even the term 'scientist' belongs to the century after their publication. We now know that in a typical domestic situation, the length of time before historic watercolour materials show noticeable fading can be as short as 10–20 years (even when placed so as to avoid direct sunlight). If they do encounter sunlight, some traditional pigments will lose colour within a season. This is why all public collections display watercolours for limited periods, and in low lighting conditions. Institutions have to balance access now against the expected needs of future generations.

In the past, some public-spirited collectors tried to ensure the longevity of the works they donated to public collections by, for example, stipulating display only in January when the hours of daylight are few (the Vaughan bequests to the National Galleries of Ireland and Scotland), or else not in heavily polluted city centres (The Burrell Collection given to the city of Glasgow, Scotland). Today such gifts or bequests can be maintained safely through conservation framing and lighting, and good display design, thus meeting the donor's objectives while giving wider access for study and enjoyment.

The private collector or artist is well advised today to employ preventive conservation methods. Frame your works using good-quality archival materials – which is not as simple as it sounds. It can be daunting and confusing to try and navigate the bewildering array of advertising and internet resources, and not all art suppliers are aware of conservation issues. However, professional conservators, conservation suppliers and large and reputable framing companies can provide help where necessary. Owners ought to assume that the cheapest framing materials are likely to cause damage in the long term, either by failing to prevent colour change to the extent that conservation-grade or archival-quality material could, or by themselves deteriorating and thereby accelerating loss of colour in the most sensitive materials. Always ensure that works on paper are not exposed to direct sunlight by strategically placing them within your house: on the same wall as the single window in the room (ideally at least one metre away from that window); in hallways without windows; or on walls where the daylight is weakest (ie. directly north-facing walls in the northern hemisphere, and south-facing ones in the southern hemisphere). Use glass or acrylic sheet to glaze the frame. If a good product is used, this should not affect the appearance of your picture. Seal the frame well against the entry of dust and pollutant gases. Very valuable or sensitive works could also benefit from conservation framing that excludes ultraviolet light and in some cases even oxygen.

It is all too easy to be unaware of the gradual colour changes that are taking place within a framed watercolour. This is particularly true for hues that have been created *by mixing* because *often only one component of the mixture will lose colour*. Historically, for example, watercolourists commonly mixed green tints from blue and yellow pigments and these most often shift in tone towards blue when gamboge or yellow lake – both of which have poor lightfastness – have been used.

One traditional pictorial convention was to depict distant landscape with more blue in the mixture than in the paint mixed for the foreground – which is simply depicting nature as we see it – but this had the effect of making the middle distance even more light-sensitive, since pale washes of most pigments (there being *less yellow* in the middle ground in this case) will fade faster than a dense wash made of the same material. It is now commonplace, therefore, for faded examples of historic landscapes in watercolour to look extremely 'blue' overall, which heightens the effects of distant blue haze to a point far beyond that which was first intended (often misunderstood or unappreciated by the contemporary viewer).

Watercolour artists often mixed greys for skies and clouds, from red and blue or red and black. Less often they used a thin wash of black pigment, which would have been more lightfast, but whose uniform hue offered fewer creative possibilities. The loss of the blue component of a mixture in a sky, leaving red clouds, is usually very noticeable once it has occurred. The peachy 'sunset' effects seen in some works by Peter de Wint, however, which are actually due to loss of blue, illustrate this point, but are sometimes interpreted as effects intended by the artist. Sometimes loss of red from purplish or slate-coloured clouds can be the first change to occur, especially if the artist chose a stable blue pigment such as Prussian blue, or black, but mixed this with a red lake that was less lightfast. The absence of once-dramatic red and/or yellow tones in sunsets might not be obvious to the modern eye, whereas a soldier of the Napoleonic era portrayed in a seemingly white uniform rather than the expected red one would be more likely to be noticed as a visual oddity.

Learning watercolour

If you had wanted to learn watercolour in Britain around two hundred years ago, you might well have been advised to seek out a drawing master for one-to-one lessons. For the upper classes this would probably mean employing a painter to tutor you (and many artists depended for their livelihood upon the patronage of wealthy families). But for those of lesser means – especially if they aspired to life as a professional artist – the established route usually involved apprenticeship to an established master with whom they would learn their craft from the ground up, through a ritual of hard work based on colour-mixing, studio chores, and the washing in of more-simple areas of a composition created by the master. At the core of a traditional master–pupil relationship was the expectation that the sound and proven way to learn was by *reproducing pictures* painted or provided by the teacher. In other words: copying. Technical skills could best be learned and embedded through attentiveness, close observation and hard work – slowly acquiring the master's methods until finally the young artist could progress independently. Skill and confidence would be grounded on regular practice.

Hard work, close observation, copying and innate talent could also create a world-class artist without formal apprenticeship. Those who aspired to the highest branches of art were able to work towards this in the national art schools by drawing 'from the antique' (i.e. from sculptures or casts of classical statues), before progressing to drawing from the live model. Prior to the establishment of public museums and art galleries (the first of its kind in Britain was Dulwich Picture Gallery founded in 1811), keen students also seized every opportunity to visit private art collections (and teaching drawing to the children of wealthy families might well provide a welcome entrance to such households).

Turner is a great example of how well the latter system worked for some. He was neither apprentice nor pupil for any length of time, but did attend excellent life-drawing classes. The transition from his earliest works, largely dependent on monochrome tonal values, to his later harmonies in glorious colour, was also marked by a wonderful capacity to work hard and mature his talents throughout life, using watercolour as a way to see, record, experiment and capture his experience of the world. By comparison, today's beginner has access to a much wider variety of study aids, with books, tutorials and online lessons available from skilled painters world-wide. Yet the most important part of Turner's own regime of learning was that he drew and painted all the time. It was the focus he applied to *the task of skill acquisition* that still applies even today if you hope to service a great ambition in watercolour (and Turner, of course, was *very* ambitious).

The next part of this book introduces you to a way of working that even Turner might have identified with: a step-by-step course that starts with a short introduction to the basics of watercolour, then progresses to working from the masters.

Although the amount of time you will spend on it is tiny compared to what would be required if you wanted to acquire high-level skills, the process will certainly give you a general start along with a hint of what it might have been like to study watercolour painting two centuries ago.

A serious study of historic watercolour technique involves a combination of science and art: the science of art materials and the practice of painting.

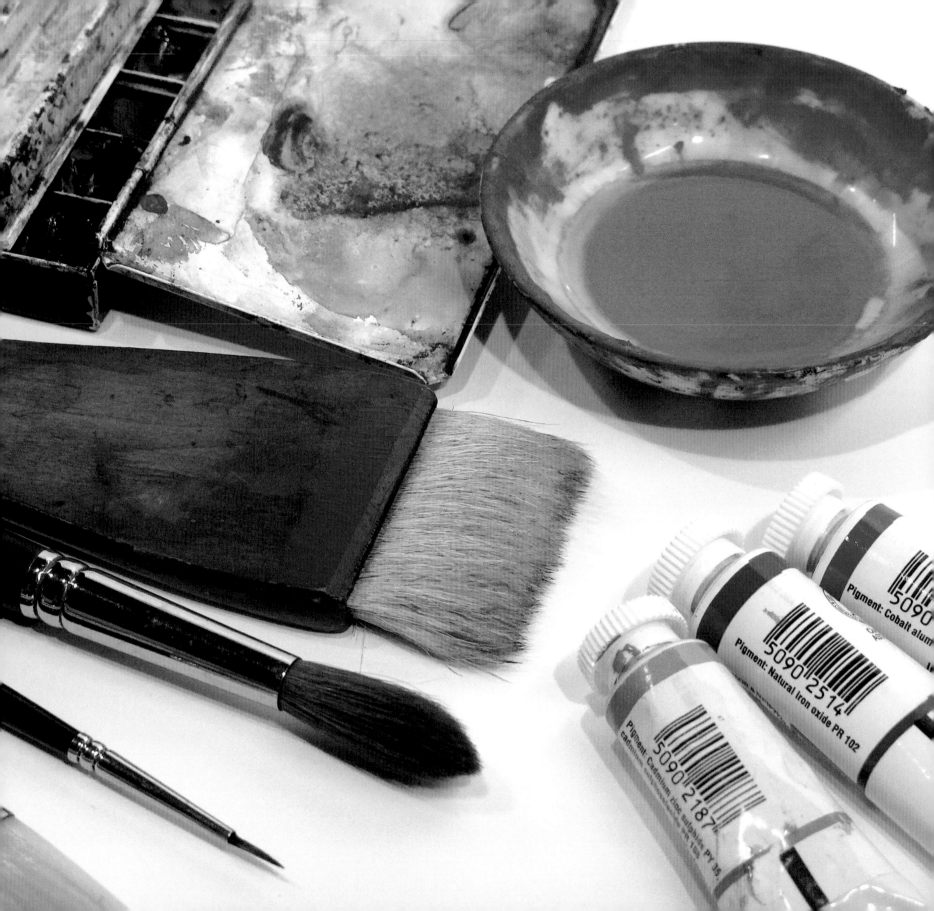

The short introductory course: understanding and preparation

Above: Tony Smibert explaining the use of charts during a course at Mountford Granary, Mountford, Tasmania.

Getting started

If this is your first experience of watercolour, you may be anxious to start straight away. The course commences by reminding you of the nature of watercolour, before explaining what can be called 'the pathway to mastery': introducing you to the materials; showing you the most important technical processes; and finally, how to combine them in a single 'traditional' watercolour.

Mastery is more than skill

One of the signs of a truly skilled watercolourist is the apparent ease with which s/he achieves wonderful effects.

Watercolour mastery involves more than diligent practice; it also has to do with accepting and working in harmony with the natural principles that govern the way that watercolour behaves. It requires a level of *matured* skill well beyond the merely technical so that, to an observer, it may look deceptively easy to do or even chaotic. This would certainly be true of Turner, whose talents were legendary and seemed to transcend mere technique.

The pathway to mastery

In Japan, the traditional pathway to mastery is sometimes described as *shu-ha-ri*: meaning the three stages of development that a student within a traditional master–pupil relationship should aspire to achieve. Although the following explanation of *shu-ha-ri* is *not* a strictly literal explanation of the Japanese words, it serves to illustrate the idea behind the term, and help a contemporary student to understand the stages of learning in a master–pupil relationship – even in the West.

The first term – *shu* – refers to an initial period of mimicry where the student might be expected to observe and copy the works and even the specific techniques of the master or school of painting. During this stage everything is unfamiliar and may even seem unnatural to the hand. Then, *shu* passes into a higher phase of learning.

This second stage is called *ha*, when what was unfamiliar has now become familiar and what might have seemed unnatural to the hand now seems quite natural to it. (Like learning to drive, where at first the vehicle seems a thing apart from you, but later becomes an 'extension of the body' so that we drive it almost unconsciously. That is *exactly* the feeling of connection attainable in watercolour through a structured beginning and ongoing practice.) At *shu*, the student might be cautioned against complacency and encouraged to study with greatly heightened awareness and effort, because *ha* is not the highest level of attainment. It is merely a stage of maturity leading towards eventual separation from the master or school. The evolving painter may now begin to discover possibilities and processes that *no one ever taught him or her* and may begin to experience a surge of creative confidence based on the ongoing process of *learning-by-doing* so that the *process of painting* is the primary *learning experience*.

Finally, the third of the levels – called *ri* – occurs if and when the maturing artist, having fully absorbed the techniques learned can at last apply them with immense confidence. He or she has become 'one'

with the medium and can now take it in any direction chosen. This is the stage where 'mastery' implies far more than merely expert skill. It is a level of profound understanding and even wisdom within the medium. It is the level of mastery – so that at the highest level we might observe that the artist seems to be in virtual harmony with the medium and able to achieve the most wonderful effects without effort.

To many contemporary artists, grounded in the notion that talented people can simply pick up any medium and use it with complete freedom of self-expression, *shu-ha-ri* may seem a strange notion. Yet a similar process played an important part in the history of Western watercolour. Many of the artists featured within this book served apprenticeships very like the Japanese *shu-ha-ri* model, working under skilled topographical artists or drawing masters. Students were expected to assist their masters, to watch carefully, copy and finally absorb and make use of the full range of the teacher's techniques. In many cases this process involved simply copying from works available in the collections of wealthy patrons. A famous example is the 'academy' of Dr Thomas Monro (1759–1833), a successful physician and amateur painter who invited young artists to attend his London home once a week in order to copy the masterworks he had collected. There, budding talents including the young Turner, Girtin and Cotman encountered and copied works by earlier painters such as John Robert Cozens.

Remember how watercolour works

Following this three-stage principle, the very best way to learn watercolour is first to understand *how it works*, and observe for yourself how this affects every technique. This will help you recognise and understand the sorts of things that occur on your own sheet of paper, including the accidents (which may prove to give you the greatest opportunities for learning and creativity). It will also equip you to identify the very logical processes to be seen within the works of the great masters and to make your own discoveries.

The goal in this short introductory course is to give you a sound understanding of why things happen the way they do, starting with how watercolour actually works – its very nature – upon which you can build

your own development. With a solid footing you can approach the historic masterworks that follow and start to analyse and extract the information needed to build higher skills and understanding of your own. Failure to understand the natural processes that apply to watercolour paint explains why so many people write off the medium as being far too unpredictable, rather than embracing its creative opportunities. And incidentally, while this course can get you started, actual practice will prove to be the greatest teacher.

About the exercises

These introductory exercises eliminate the pressure of trying to learn too much at once. The aim is not to end up with great art, or even finished pictures – only a clear understanding of how to apply traditional skills. Then, when you have learned these truly classic processes, there is an opportunity to bring them together within a 'traditional' landscape watercolour.

Please don't race through. Do consider trying each of them *a number of times* and then, in the future, returning to repeat them again as practice 'drills' – as a musician would return to scales – to acquire co-ordination of mind and body within a given skill-set.

Suggested equipment

Contemporary watercolour equipment needn't be costly or deluxe – it's what you do with it that matters most! Items for these exercises include only a few brushes, tubes or semi-moist pans of colour, and vessels for mixing. Soy sauce dishes are great for studio work, being white like paper, but, for working out of doors, tins or jars with a lid for mixing are more practical (see the later section covering work *en plein air*).

Studio space

You will also need somewhere to work plus a number of other items:

- A suitable table (no need for an easel at first) which is flat, clean, clear and 'splashable' (so it won't matter if you spill water on it)
- At least three jars or other water containers
- Box of tissues or a roll of paper towel
- Metal-edged ruler
- Cutting blade
- Pocket knife
- Water sprayer

Watercolour gear need not be expensive. Plates make wonderful studio palettes just as good as the delicately formed porcelain palettes of the nineteenth century, and plastic palettes are perfect for outdoor work.

Materials: artist, student and school quality

Today we have access to a wide range of materials, all readily available from art suppliers, photo and printing shops, online and even many supermarkets.

Fortunately, you won't need a great deal of equipment to start with. But you will need *good* gear. The best paint is 'artist quality', which can be expensive but will reward you with better handling, more consistent results and longer life for your finished works. You may note that the illustrations reproduced here reveal my preferences but this is only because, like many professionals, I have stuck with materials that I *know from experience* are first-class. This is not to endorse a brand, but makes the point that high-quality materials make a worthwhile investment. Normally the same would be true of paper, because, as already said, nothing is more important to watercolourists than the surface onto which they lay their colours. While the techniques illustrated within the introductory course have certainly been painted onto high-quality watercolour paper, you may well be surprised that many of the exercises later in the book can be done onto the *cheapest* of papers and may be best effected with brushes of a very inexpensive type. (So please take careful note of any advice on equipment accompanying an exercise.)

Full-time art students may well find the purchase of the full range of artist-quality materials is too expensive to contemplate and have to make do with student quality. But if this is you, don't worry about it – your focus, time, effort and enthusiasm will make up for the difference and you can then make the transition to artist quality if/when you start to work professionally and when you will need to consider the longevity of your work and find real value in achieving more consistent effects. While you can only access student quality now, it won't make a *great deal* of difference once you come to understand the medium.

Working small and using charts

Most of the demonstrations here were painted onto quite small pieces of medium- to heavy-weight contemporary watercolour paper cut down from much larger pieces and simply taped (dry) onto a board. From the beginner's point of view, contemporary paper 'behaves' better than historic equivalents, and the simple tape application gives all the benefits of stretching and pre-wetting a more historic product, without the laborious preparation.

Alternatively, another way to proceed is to use 'charts' as a way to work through the exercises – and particularly the introductory course.

Overleaf is what a completed 'chart' looks like, made by laying a grid of transparent Magic® tape (available at most stationers, as a 'removable', fairly see-through, good-quality and durable tape) onto a sheet of watercolour paper to create a series of smaller painting surfaces. When these are individually wetted, worked and dried, expansion and cockling is less than it would be on larger pieces of paper and certainly when compared to wetting a whole sheet at once. Then, after all the surfaces have been used and the paint has dried, the tape is removed so that each is left with a surrounding border of clean paper. These borders additionally provide a space to make notes, either to record the step-by-step processes used or to jot down other observations. Hence, a chart is a neat way to work through the introductory course and end up with the whole thing on a single sheet for later reference. (We use see-through tape rather than 'masking tape' because we find great advantage in being able to see and reference the white paper through the tape as the values of colours are built up within the painting bordered by it – and certainly better than complete masking by the dull, yellow/brown of traditional masking tape and/or gummed tape.)

Charting is also a great way to revise and drill individual skills – for example, respectively repeating flat, gradated or variegated wash– so that you duplicate the processes in successive panels *on a single sheet* (our 'scale practice' again). The charts illustrated nearby show developmental practice working in monochrome and colour. Practice and repetition are the soundest way to build your understanding of the basic skills for, without them, advanced development may not be possible (and this certainly applies to using classic painting methods covered later in the manual).

As mentioned in the section 'For Schools', if there is one other piece of advice we thoroughly recommend, it is to *start out working small*, using a *large brush* and *generous quantities of rich paint*.

The grid of tape on each chart makes brushstrokes reaching beyond each small picture easy to cope with. Wiping the tape will ensure paint doesn't bleed back and spoil the drying wash.

Once the tape is off, the effect of each process can be easily appreciated and reviewed.

The opposite approach – of working on large pictures, using a tiny brush and using small quantities of paler paint – is a sure way to slow down your acquisition of understanding and skill. In this manual we shall always start out by simplifying, so that in most cases you will be able to create a satisfying result every time, with no pressure to impress yourself or anyone else, and with modest expenditure on materials. You will then move on to the next small study, and so on. It is an approach grounded in the traditional teaching method where repetition was fundamental to acquiring the basics.

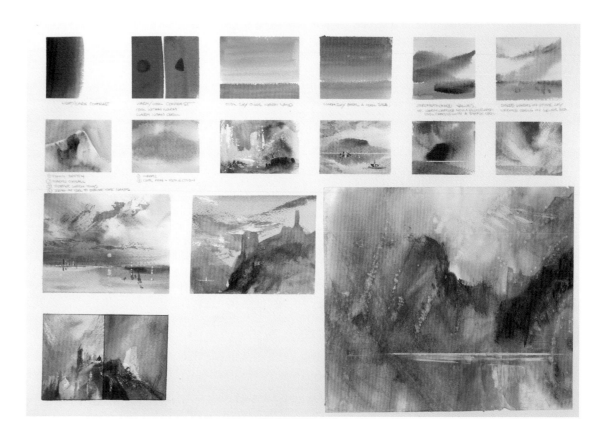

Tape applied as a grid on a sheet will create a chart ready for painting a series of small pictures and is ideal for student exercises.

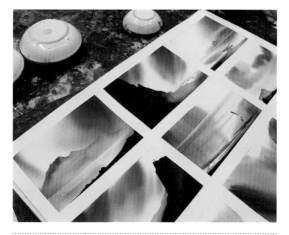

This is a 'developmental' chart tracking a monochromatic (i.e. single colour) approach within a variety of compositions. Working with tonal values this way was commonly called 'scale practice' during earlier times.

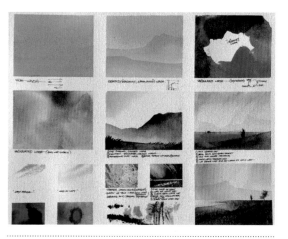

This is a developmental lesson chart – tracking each of the lessons in a Mountford Granary course. You may recognise some of them from this manual. The larger chart above is exploring Turner's use of warm and cool colours.

Mixing paint

Preparing paint is a fundamental skill and one that the traditional artist-apprentice had to learn well.

You will need a clean saucer, dish or palette for each colour, with two brushes, a sable or imitation sable to paint with and a much tougher hog-bristle brush to do the actual mixing. You will be working reasonably fast through a series of stages (so once you start painting you may need quite a lot of wash). Start by squeezing a dollop of paint onto the edge of the saucer and then pour in a (very) little water. Use the bristle brush to smear a small portion from the edge of the main dollop and then mix it with the water. When it is mixed (no lumps), test it on paper using the other brush. You may notice that the paint *looks* stronger in the dish than it does on the paper. This is because it forms a thicker layer in the dish. Watercolour paint always dries lighter so that even a well-balanced wash will eventually seem paler when it finally dries.

Continue this process until you have finally mixed all of the dollop. Along the way you will notice with more paint the wash has gradually become stronger and darker. Managing the strength (and 'darkness') of your colour mixes is an important skill to develop, because great watercolours very often make use of strong passages of colour alongside the palest of subtle tones. Use this process to mix strong washes of each of the primary colours – a blue, a red and a yellow. We suggest cobalt blue, light red and yellow ochre.

Small soy-sauce dishes from a Chinese supermarket make excellent mixing bowls for watercolour. You'll soon notice that paint mixed in dishes settles after even a short while and will have to be regenerated with stirring. When left alone for a longer period water will always evaporate, with the natural consequence that your prepared wash becomes stronger and darker. Then, when completely dried, it will of course harden. However, you can always add a little water and stir it back to life. Resurrecting dried-out wash is hard work for a brush and will soon ruin a good sable. We recommend using a cheap hog's-hair brush instead.

Mixing secondary washes

Secondary mixes arise when you blend two of your straight-from-the-tube colours together to create something new. Here, when light red is added to cobalt blue, the result is a warm grey. Alternatively, when cobalt blue is added to yellow ochre the result is a muted green. In this introductory course the emphasis is not on arriving at perfect colours but much more focused on *how to blend pigments* and *lay wash* in order to start painting.

When creating a secondary mix, the trick will be to maintain the purity of the original colours by pouring *from* them into a *further* dish. For our purposes, the only secondary wash you will need right now is grey, so create some by pouring some of your blue wash from its dish into a clean dish and then adding light red into it. You will notice as you experiment that some colours are more powerful than others so that, in the case of cobalt blue and light red, it is light red that dominates. Consequently, it is safer to add light red to cobalt blue, rather than the other way round, and it is also best to use very small quantities (carefully pouring in a little at a time), mixing and testing on paper between each addition. As you learn about your chosen colours and how they work best, the process of mixing becomes almost second nature.

Don't worry if you find that your first mixes prove too weak for the exercises. There are two easy ways to strengthen them that don't require squeezing out more paint or throwing the mix away and starting again. You can either let the sediment in the saucer settle, then pour off some of the surface water, or leave the dish in a warm place and allow time for an amount of water to evaporate. In both cases, when you stir the wash again it will be stronger. Almost any problem you encounter in watercolour can be solved if you refer back to the natural principles seen in our early experiment with the jar – in this case, the time it takes for settling of pigment and evaporation of water.

Professional painters tend to develop their own preferences for ways to mix paint – whether on a dinner plate, or in saucers, or as here, on the painting table itself. The table allows for a whole range of colours, strengths and degrees of wetness, as dried paint can always be picked up again with a wet brush. What might seem chaos at first is actually very practical, especially when there is careful management of cool colours on one side and warm on the other.

One final suggestion: consider mixing the pools of colour in your dishes *stronger and darker* than you think the work requires. Then use your brush to transfer some of it to a white tile, plate or table surface where you can add more water and dilute it. Use *this* as your reservoir for painting and varying the strength required for each task.

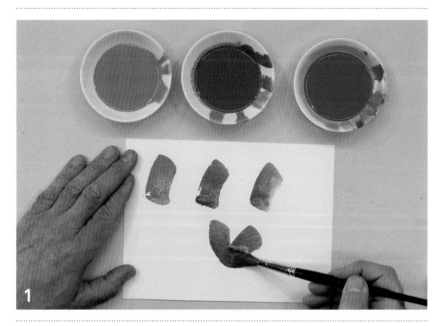

Mixing can be done on the paper itself. Here, the three basic colours from our short course are tested for strength.

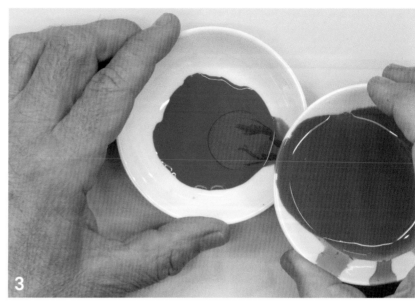

Preparing a grey paint from light red added into cobalt blue in a new saucer.

Secondary mixes occur when you blend colours – and the results are often beautiful and surprising. Here, yellow ochre, light red and cobalt blue create a beautiful 'grey' and 'green'.

Here's the resulting warm grey mixed from light red and cobalt blue. Make sure that all the pigment is thoroughly blended.

This white studio table-top functions as a mixing surface, along with various types of ceramic dishes including white dinner plates, soy-sauce dishes, stackable palettes and a tin box with palette lid.

The short introductory course: basic painting techniques

Painting in watercolour mostly involves ways to lay wash *onto* paper or remove it *from* the paper. Obviously this normally involves brushwork and the making of marks. For this you will need a large sable, camel-hair or imitation sable brush and four colours: yellow ochre, light red, cobalt blue and the mixed grey prepared earlier. (As previously discussed, this is made by adding a small amount of light red wash to a prepared dish of cobalt blue wash.) You will also need to prepare a chart from one sheet of watercolour paper, divided into nine small painting areas by Magic® tape.

Dry-brush
Painting onto a dry surface is called 'dry-brush'. To try this, load a brush with cobalt blue and make a couple of diagonal sweeps across the first little window.

Wet-in-wet
'Wet-in-wet' means painting onto a wet surface. Use clean water and the hake brush to wet the surface of the second picture and then again load the brush and make a couple of diagonal sweeps.

Flat wash

Historic watercolour was founded on the capacity of painters to lay various types of wash onto paper. The first is called 'flat wash'. Here's one of the traditional ways to lay flat wash by using gravity to pull an even amount of colour down over the surface of the paper. First: angle the paper and lay a band of blue across the top.

1

3

Continue the process, trying to keep to a speed that allows paint to flow evenly from the brush.

2

Immediately reload your brush and make a second sweep just below the first so that you pick up any wet pigment pooling at the bottom of the previous stroke.

4

Repeat the process with successive reloadings and sweeps across the picture until you reach the bottom.

Lay the picture flat and wipe around the outside to pick up any excess paint (use a tissue or squeeze out your brush to act as a sponge).

Just as 'mingling' occurs at a party when people are left alone to mix naturally, it also occurs when any two or more wet colours meet on the surface of a watercolour. Here's how to make it happen.

There's no need to pre-wet the page. Just take any two colours (cobalt blue and light red here) so that they just touch. They will mingle naturally along the meeting line.

Allow to dry. Achieving an even wash (without imperfections) is often made easier if the surface of the paper is damp.

'Charging' creates a kind of surprise effect when an amount of one colour is dropped or introduced into a passage of another. Start by painting the next unpainted rectangle with an amount of cool colour (the cobalt blue you've already mixed is fine). Then place an amount of another colour into it (light red makes a great effect). The result looks something like an explosion.

Gradated wash
(also known as 'graded' or 'graduated')

1

This is a way to lay a wash that will result in a graduation of tone – in this case it will fade from dark to light as you move down the page. Again, angle the board and begin as with the previous 'flat' wash except, after the first pass of full-strength colour, you should dip the brush into clean water (not paint) which will dilute the second stroke and make it paler.

3

Lay the picture down and mop up the edges as before.

2

As you continue the process, loading with clean water each time, each stroke will be lighter. The result should be a gradation of tone – from the darkest at the top to the lightest at the bottom of the page.

4

Carefully clean the tape of excess paint, wiping away from, not towards, the small picture.

5

When it has dried completely (you can use a hairdryer to hurry things along, but only if you make sure that the picture dries evenly), reload with full-strength wash of the same colour and paint in the ridgeline of a distant mountain range, then quickly gradate it right to the bottom of the page using the previous process (successively loading with clean water).

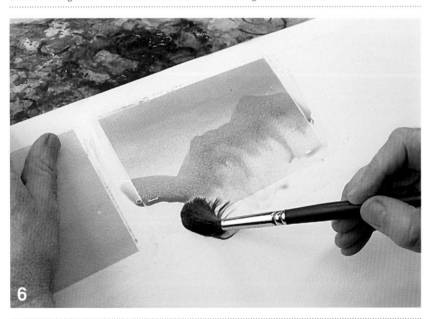

6

Note that although the gradation of the sky involved careful horizontal strokes, the gradation of the mountain was much less formal and was created by simply flooding with clean water beneath a passage of stronger wash to let nature and gravity take their course. The result is a less even but more organic variation in tone, giving the impression of cloud breaking up.

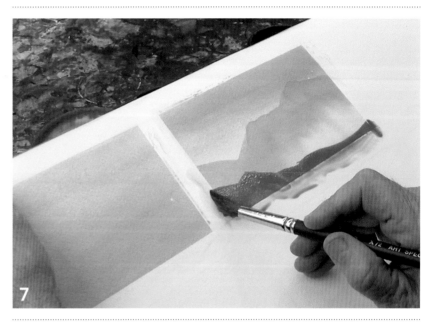

7

Finally, load with full-strength wash and paint in a nearby slope with a flat wash.

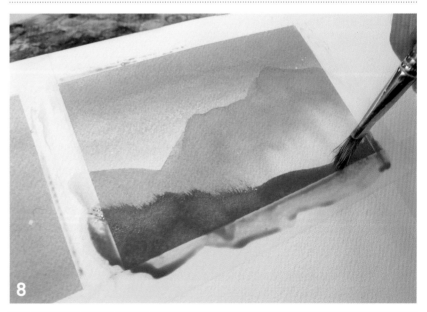

8

While the slope is still wet, use the tip of your mixing brush to tease up paint from the upper edge to create the effect of crisp grass.

Dry-brushed variegated wash with reserved white

Wet-in-wet variegated wash

Working onto dry paper, load your brush with yellow ochre and wash in some part of the picture, then quickly rinse the brush clean in a jar of water, squeeze out the excess, load with light red and continue on from where the other colour finished – so that it seems to be a single brush stroke, notwithstanding the fact that it is changing colour.

This time the paper is wetted with clear water first so that the same variegation process (and reserved white) is more subtle to the eye – with fewer imperfections and less aggressive mingling.

Continue with cobalt blue and finally the grey until they meet on the other side. There is no formal way to do this – just so long as any wash area to be extended is still wet. The area deliberately left unpainted in the middle is called a reserved white, the fundamental way to achieve pure white in a watercolour (literally 'reserved for a purpose' like a seat in a restaurant).

Apply some light red, yellow ochre, cobalt blue and mixed grey to each corner, with little overlap. The wet paper will cause the colours to mingle wherever they meet.

3

Tony Smibert, *Into the Light* 2012, Watercolour on paper, 38 x 29. Many artists work creatively with variegated wash – Turner was probably the greatest exponent. Here, using a 'Turnerian' approach, a landscape has been found within an abstract variation. Working creatively with basic processes has a sound historical basis, and was the core of an approach pioneered in watercolour by Alexander Cozens and explained later in the manual.

Working with the drying process

From wet-in-wet beginning to dry-brushed finish

A wet-in-wet beginning will eventually dry. Many watercolourists take advantage of every stage of this natural process, starting out with soft minglings and chargings while the paint is wet, before moving on to crisp-edged, dry-brushed passages when it is dry. Wet-in-wet variegation can be used from the beginning to establish the overall colour values and harmonies of the entire composition, in this case a lake and mountain.

Many of Turner's works began with a preliminary variegated wash that was then strengthened with dry-brush to both add *and* remove paint. Generally Turner began with warm wash but defined his shapes with cooler tones. He then added the darker values and lifted out lighter areas, creating sharp dark details and crisp lights. (See 'Lifting, scraping back and washing out' in this introductory course, for ways to do so throughout the drying process.)

Turner's colour studies and so-called 'colour beginnings' formed the basis of the sophisticated and highly creative approach to watercolour for which he was famous. His approach equipped him to make studies from memory and imagination at will to supplement his observations and studies on location. Even today, his remarkable watercolours portraying the accidental burning of the Houses of Parliament remain the subject of debate among art historians, painters and researchers – divided as to whether any of them were painted on location. See pages 92–3 for some of his sketches that may represent very rapid colour studies of the same event. Such a momentous event would certainly have stirred the Romantic imagination. This particular example is a studio work created later as a result of his own observations, reports from witnesses or, most likely, imagination. It includes many scratches to remove colour (and depict streams of water) after the paper was fully dry, and some washing out of dried washes (to show the light of the fire).

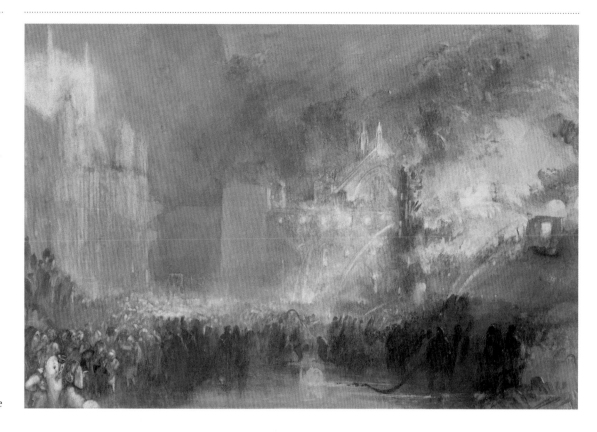

J.M.W. Turner, *The Burning of the Houses of Parliament* 1834–5, Watercolour and gouache on paper, 30.2 x 44.4, Tate D36235. Turner would produce two finished oil paintings of the event, both from views across the river, towards the back of these buildings.

Working from a variegated colour beginning

You can at any stage step aside from the course. Here is a typical way to start with a variegated beginning, which you may notice was not abstract but clearly intended to lay the foundation for the landscape that followed. In the first stage the paper was kept wet as each colour was added.

After the paper has dried, the blue sky has been washed in to create a crisp edge above the mountains, light has been 'lifted' from the surface of the lake, and the first suggestion of a castle has been added.

Dry-brushed trees and grasses

Using a bristle brush (hog hair is perfect), create the appearance of trees on a grassy slope.

This is easy to achieve with simple vertical, horizontal and diagonal strokes using the *tip of the brush* on dry paper.

Spatter and other marks

1

After taping, use a toothbrush to spatter different colours onto some parts of the sheet. (Remember, this is definitely a creative process.)

2

Then use the toothbrush to drag some interesting marks across the surface. (Obviously any brush can be used for watercolour – though many people never experiment beyond a traditional sable brush.)

3

Experiment with different colours and quantities of paint.

4

As the paper is drying, dab and wipe with a tissue. This takes out some paint and will create a variety of effects.

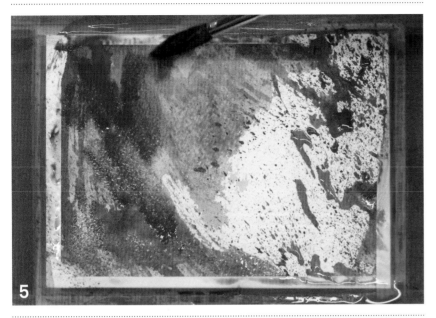

5

When the previous stage has dried, lay further wash over some parts (remember to reserve some areas of pure white). Alternatively, try washing with a brush loaded with clean water, so that colour is carried from previously dried areas of pigment.

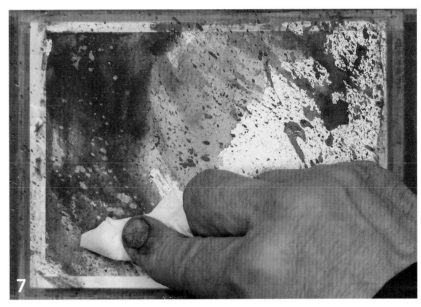

7

Spatter clean water onto the dried paint and wipe away the wetted areas with clean tissue. When dry, peel away the tape. You may be surprised at the result!

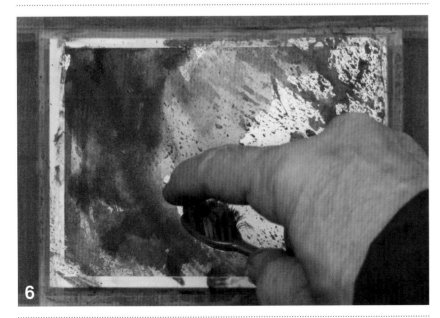

6

Spatter another colour while the paper is wet.

Lifting, scraping back and washing out

This next exercise is one of the most important, where you will meet a variety of ways to remove paint while it is at different stages of drying, and then after it is dry. Start by washing in with grey.

Rinse, then squeeze out the brush. Use it to soak up paint and create a lighter area.

Dab with a tissue to take paint from the painting.

Use a knife blade to scrape out paint while it is wet, to create a range of effects, which vary at different points throughout drying. Note the interesting marks that occur when paint is scraped from a wet area into a dry one. These sorts of marks are very significant in *The Challenge* by David Cox, where he used scraping, wiping and a variety of rather harsh processes.

5 Use a sprayer to squirt away some of the wet paint. If necessary, angle the board so that the paint is washed away from the surface of the picture. This can also be done when the painting has dried. Then wipe the soaked area with a tissue.

6 When the paint is nearly dry, try wiping away the lowest corner. Wiping it hard with a very dry, very clean tissue will slightly abrade the surface, and may even create a sparkle of white paper beneath the wash.

7 The next process is a modern variant on the traditional masking of an area of paper with thick gum water to protect it from both painting over and paint removal. Lay two strips of Magic® tape across the dry surface, but leave a thin line of exposed paper. The exposed strip can then be wetted by brushing water along it, and the paint can then be lifted by wiping with a dry tissue.

8 Now scratch a crisply defined horizontal line against a ruler. A razor in a safety guard, a pocket knife or a small tool like a flat screwdriver will work. The resulting sheet not only records your experimentation with different ways to remove paint (while it is still wet from application, as it dries, and when it has dried), but it also suggests innovative ways to create dramatic landscapes.

Fast drying

Fast drying with a hairdryer or other device *will* affect your wash. However, issues of convenience, along with the creative effects made possible through controlled *uneven* drying, means that many contemporary painters often choose to hurry things up this way (though when working out of doors, or for genuinely traditional processes, electric drying is not an option). When using a hairdryer, airflow and heat should normally be evenly distributed over the *entire* work. The easiest way is to keep it at a distance and to wave your arm back and forth, carefully looking *all the time* to see that the drying is even.

Use of a hairdryer or similar device is *not* cheating. While certainly the great masterworks that inspired this book were all created by artists who lived long before electric hairdryers, there is plenty of evidence to suggest that they would have incorporated any drying process they could, including, like Turner, hanging their paintings out to dry in a warm room. Even today, outdoor painters working in near-freezing conditions can sometimes be seen holding their paintings right up next to a campfire to hurry the drying process, just as desert painters working in extreme heat find ways to keep their works moist for as long as they need to.

The basic rule in watercolour is that there are no rules – only consequences. Whatever you do or don't do will have an effect, so that every decision on process at any stage in a painting has the potential to impact greatly on the final result. Where drying is concerned, don't be afraid to use an artificial dryer if and when you have access to it, bearing in mind that the result is likely to differ from work dried naturally. While many contemporary painters rely on drying with heat to achieve signature effects and certainly incorporate them into their day-to-day work, others find that subtle effects within the wash are only possible when settling and drying are allowed to take their own time with natural drying.

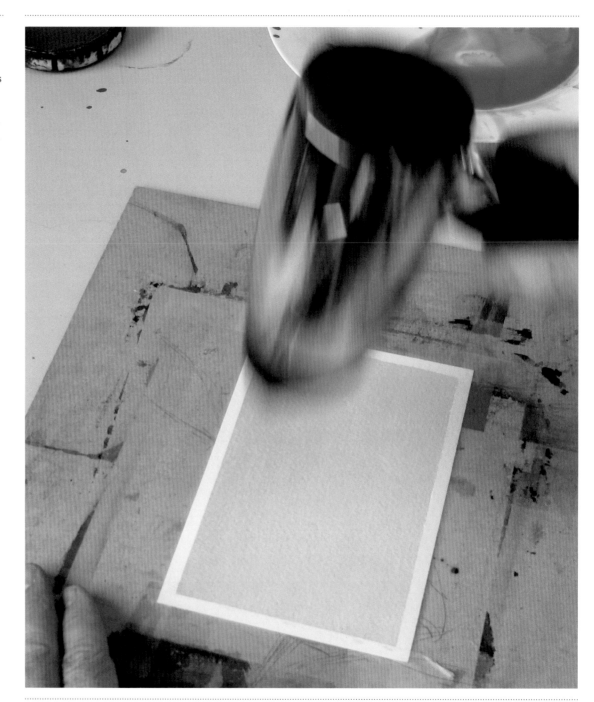

Drying a flat wash evenly with a hairdryer requires you to keep moving the dryer back and forth at speed. That said, uneven drying can also create wonderful effects.

Finished example

Tony Smibert, *Journey Series III* 2012, Watercolour on paper, 38 x 29. We hope the basic exercises will give you ideas and also help you start to 'read' techniques in the works you are studying. This more advanced version of the previous exercise was started with a coloured variegation. Light has been brought back through paint removal using many of the methods outlined: wiping the nearly dry wash with a tissue (upper cliff at left); upending the painting and washing out with sprayed water (in the sky); then with a damp brush and scraping out with a blade on the surface of the water and on the far cliffs; and finally, the birds and the touch of light on the upper edge of the nearby rock were created using opaque white gouache or body-colour applied with the tip of a very fine brush.

Bringing together traditional processes to paint a simple landscape

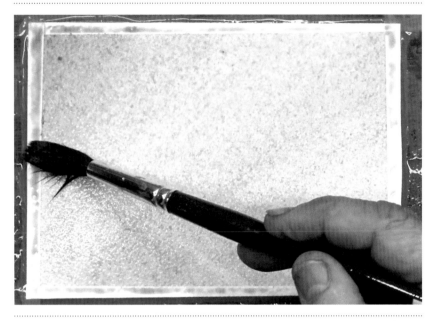

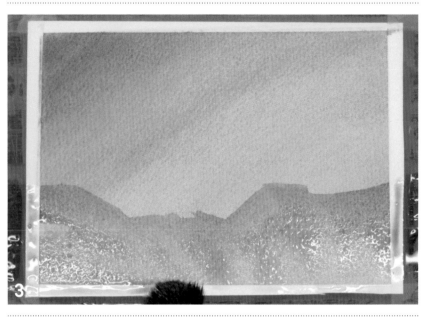

Earlier, you created a flat wash onto a *dry* sheet. This time, wet the sheet with clean water, load the brush with yellow ochre wash and sweep the brush back and forth to even out the paint over the entire picture. You can do this working flat or with the board angled and it gives you another way to achieve a virtually flat wash.

After this sky has dried, create a distant range of hazy, gradated mountains using a very pale strength of grey wash. You will probably have to thin the grey you mixed earlier (easily done by using your brush to decant a little onto the surface of your table or a plate, then adding water).

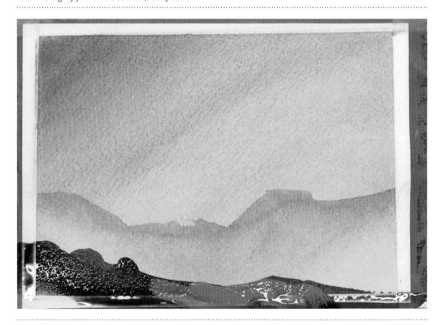

Variegate *and* gradate this by introducing blue into the upper left corner of the sky and blending it downwards, again sweeping the brush back and forth across the sheet. Work quickly and accept the result, which will be a warm, rather streaky sky. Don't fuss with it. Enjoy the effect. Allow this to dry (or dry it very evenly using a hairdryer held at a distance).

Dry completely, then variegate the foreground using all of your colours, teasing up grass or pressing the brush down to suggest the dark shapes of trees silhouetted against the distant mountains.

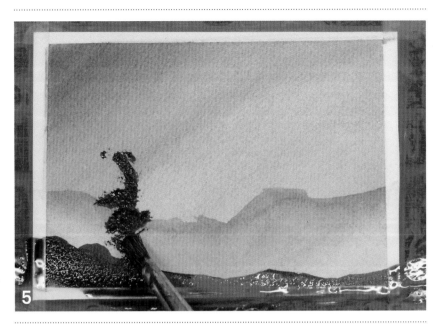

5

Alternatively, suggest a tree with flicks of dry-brush and perhaps wipe back the upper edge of the darkened foreground using a sheet of tissue, and then charge it here and there with colour. Remember, you don't have to paint a masterpiece, just get the processes to work together.

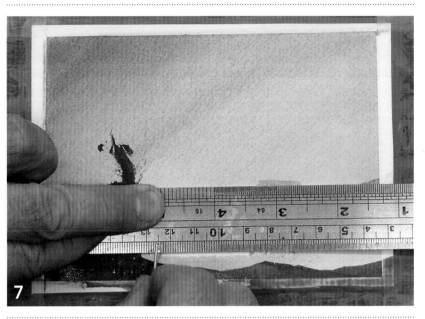

7

Next, scrape out a distant lake by scratching across the dry paper with the edge of a blade.

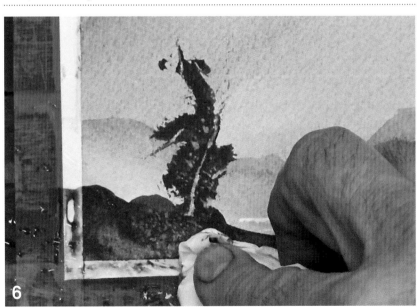

6

If you have established a tree, a very easy way to suggest a wavy trunk is to scrape the side of the tip of a blade up through the foliage. If you take it beyond the tree it may also drag some pigment with it, giving you a branch silhouetted against the sky. Finally, spray (or spatter) the foreground with a little clean water and wipe it firmly with a tissue to create some texture there.

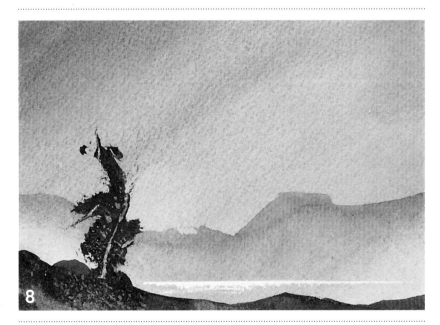

8

The final picture will be both simple *and* complex in that you have successfully brought together a number of techniques and processes to create a single work.

Experimentation and creativity

If you really want to benefit from this course, create a number of versions of the last landscape – but vary the elements. For example, paint tiny distant mountains seen over a low horizon, or towering grey mountains looming over the foreground. The challenge is to use traditional processes to create paintings, while giving you a chance to become familiar with these techniques, and to discover and create working methods of your own.

The result is a picture that combines and makes use of a large number of traditional processes: flat, gradated and variegated wash, dry-brush, wet-in-wet, charging and mingling, wiping out, scraping back, dry-brush work. It also uses historical devices such as aerial perspective, tonal gradation and composition. All of these were managed through a systematic process of wetting and drying, allowing time for pigments to harden and making use of different stages within that process. The result may not be a masterpiece you want to frame, but the act of following through the stages has given you an introduction to the logic, material, tools and techniques of watercolour, and a working vocabulary to use in your future discussions and study.

This larger study makes use of the same approach but varies the method for sky, mountain and foreground. The sky was swept in first, with a wet-in-wet variegated wash. The mountain was also variegated while the sky was still damp (not wet). The foreground was also variegated by charging into the wet surface below the mountain – and then strengthened with darker washes and worked with the brush while it dried. As with the smaller exercise, the trees were added after the paper had dried completely. The trunks were scraped back and the lake was lifted by wetting then wiping away paint with absorbent tissue. Finally, the whitest line on the far surface of the lake was scraped back with a blade and the white birds and a few blades of grass added with opaque white in a process traditionally known as 'heightening with body colour' or 'heightening with gouache'.

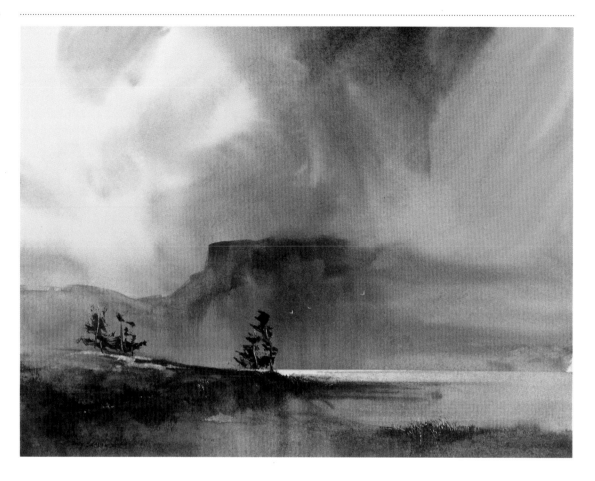

Tony Smibert, *Distant Guardian* 2013, Watercolour on paper, 38 x 29. You should feel free to extend, experiment with, dismiss or vary any of the techniques and processes shown in this book. Your watercolour approach should be based on what you find exciting.

A sound way to start is to apply the techniques shown as simple applications in previous pages to more complex subjects – as here in an imagined landscape based on the last exercise.

Great masters at work

Some of the most creative works in watercolour are based more on simplicity than complexity. So now, armed with some understanding of the principles and basic techniques, you are ready to start looking to the great masters of the medium for inspiration and instruction.

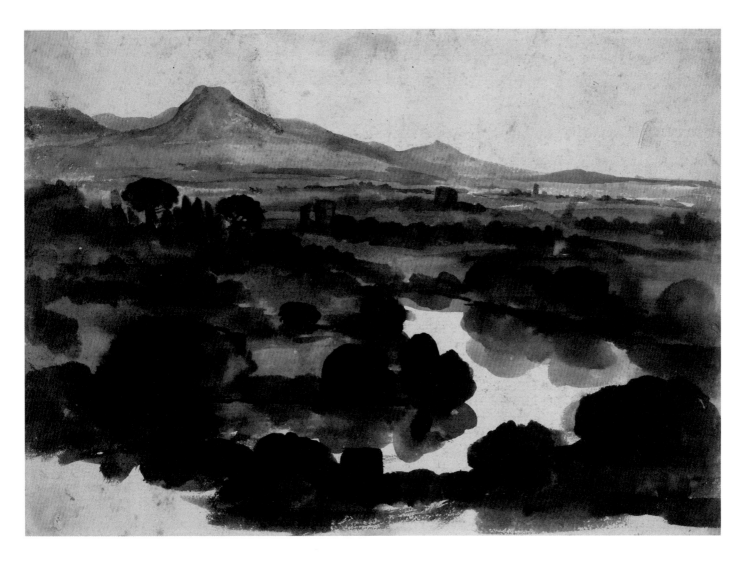

Claude Lorrain: composition studies using trees in a landscape

The French master, Claude Lorrain (c.1604/5–82) was arguably the most important artist to influence the development of British landscape painting. Like many of his contemporaries he served a traditional apprenticeship as a studio assistant, and broadened his artistic education by travelling in Italy. He is best known for the luminous golden lighting and harmonious compositions of his idealised classical landscapes, which became very popular with aristocratic tourists on the traditional Grand Tour. Consequently, many examples of his oil paintings made their way into British collections. The *Liber Veritatis* (*Book of Truth*) is an extremely useful book assembled by the artist: it contained hundreds of monochrome pen-and-wash drawings reproducing his most finished paintings, possibly as a precaution against misattribution or fraudulent use of his images. During the early eighteenth century it was purchased by the Duke of Devonshire (it is now in the British Museum, London). Then, in 1777, a British publisher reproduced the drawings in a two-volume printed edition of etchings and mezzotints, the circulation of which made Claude's landscapes very well known.

Claude's influence is most easily seen in his approach to composition, which was admired and copied by successive generations of British artists. John Constable, for example, described him as 'the most perfect painter of landscape the world ever saw' and used Claudian pictures as the basis for some of his own compositions. In his youth, Turner was found weeping in front of an oil painting by Claude because he felt he could never expect to paint something so fine, and throughout his life he used the French master's work as a model for the depiction of pastoral landscape. Even today, Claude impacts on painting, film, television and design, and in the world of amateur watercolour he remains a powerful, if unconsciously applied, element in the way that many painters idealise landscape and the natural world.

Claude's studies in watercolour – mostly sepia wash – reveal a great deal about his approach to composition, and within them we may find a key to his more finished great works. They provide a useful example of how to paint watercolours from the natural world, either sketching in the open air *from* nature, or by making creative studies *based upon* nature. Any painter can use Claude's method to do either: by making monochromatic studies *en plein air*, or by producing imaginative landscapes in the studio. The principles are not complex to understand and are straightforward to implement at a basic level. They can also be understood in conjunction with two works by the much later artist Corot, who was himself profoundly influenced by Claude.

Although very simple, *The Tiber from Monte Mario* is a masterly piece of composition. The most notable characteristic is that it is painted in very broad terms, with flat washes, and no attempt at unnecessary detail. Light from the sky is reflected in the river, offset by the darkest shapes of trees along the banks, conveying a tranquil landscape and a sense of deep calm.

Claude Lorrain, *The Tiber from Monte Mario*, c.1640–50, Dark brown wash on paper, 18.5 x 26.8, British Museum, London.

Here the focus is not on composition alone, but rather the wonderful possibilities of tonal sketching, by steadily building up tonal values. The most important thing is to start out using clearly defined values: with dark, medium and very light tones working in harmony with each other.

Proficiency in this method will come rapidly if you practise and apply the principle again and again. The trick is to work fast and repeat the process in further studies. These examples took around five minutes each. Working rapidly will also free up your hand to work intuitively in response to both your eyes and your inspiration.

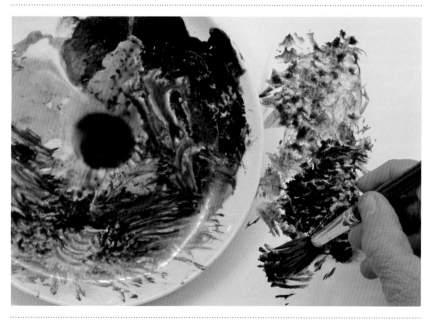

This method can be used for easy sketching *en plein air*. Notice the use of flat washes, very simplified shapes in the far distance and sharper, darker details in the foreground.

Squeeze a little sepia or Payne's grey onto one side of a dish. Use this to prepare and maintain both dark and light tones – or use the table surface to mix and test both values and marks.

Basic tonal study

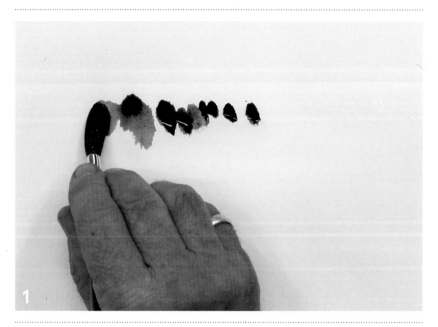

1 Using a very light tone of wash, sweep in the silhouette of distant hills. Now load your brush with a darker tone and sweep in the middle ground.

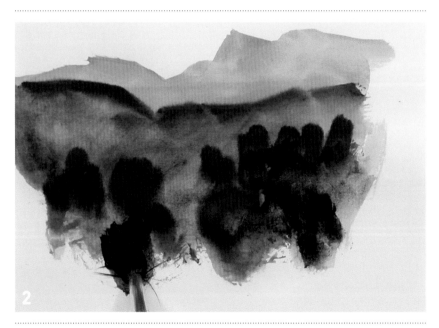

2 Finish by loading your brush with the darkest tone and suggest the shapes of trees in the foreground.

Trees receding into a hilly landscape

1 Use the tip and/or side of the brush to suggest the shapes of trees in the middle distance.

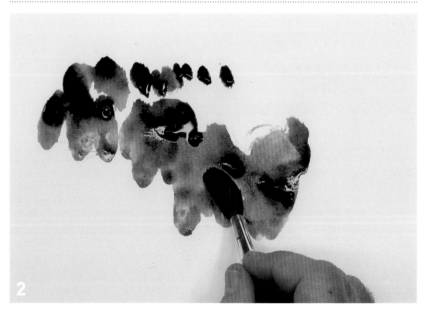

2 Then continue the process, imagining that your brush is travelling across the surface of a sloping hill and leaving the shapes of groups of trees behind. Trees in the foreground will be larger.

Allow the brush to create foreground masses, as well as individual trees.

River valley

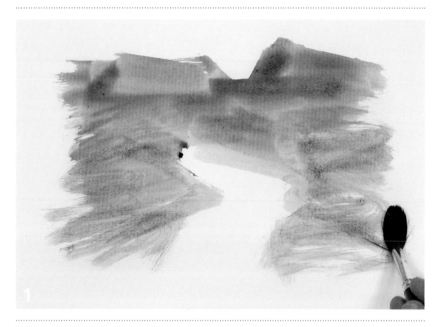

Now try a simplified version of Claude's own study shown on page 64. Start by washing in the distant hills and the river flats. Reserve (leave as white paper) both the river and sky.

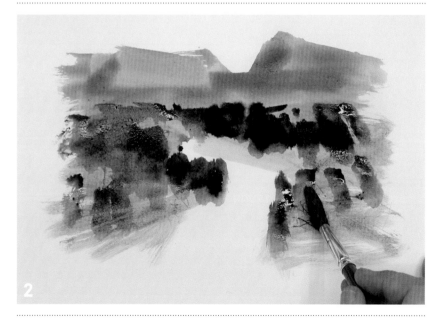

Use dark wash to suggest the massed shapes of trees receding into the distance and clustered along the river. (Notice how their shapes help to define the river.)

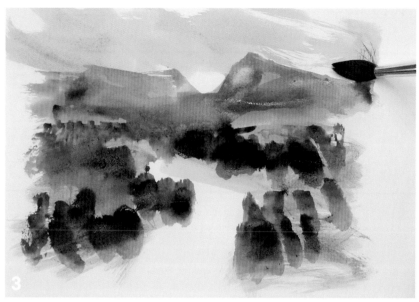

Use some mid-toned wash to apply the shadow on the mountain and to indicate the various shadows, i.e. where the sunlight isn't falling: those cast by the mountain and those on the mountain coming from cloud cover. Use a very light toning of wash to sweep in some suggestion of cloud cover. This will help to unify the composition.

Tonal analysis

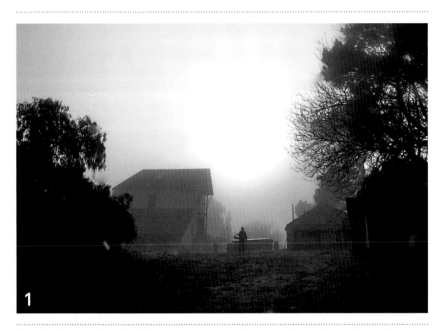

1

Mountford Granary, Mountford, Tasmania.
This digital photograph was taken under
foggy conditions, then further processed
to a monchrome (i.e. single colour) image
with exaggerated tonal values. The next
sketch simplifies it further as an exercise in
tonal painting.

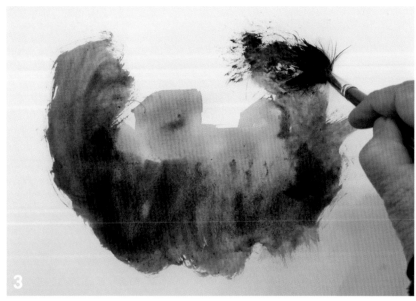

3

Then load your brush with darker wash and
suggest the shadowed foreground and foliage to
the left and right. Keep working while the sketch
is drying (and it will dry quickly if you are working
on cartridge paper in a sketchbook), showing
textured foliage with darker passages of wash
pressed in with the 'heel' of the brush, or perhaps
dotted in with the tip splayed ('broken brush').

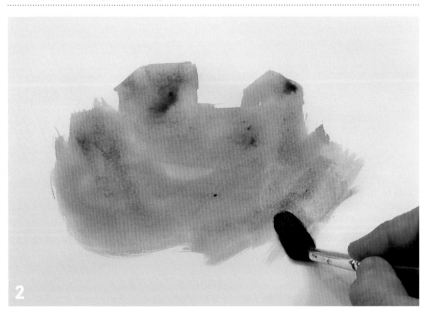

2

Start with light-toned wash to suggest the
broad silhouettes of the buildings rising out of –
and connected to – the foreground.

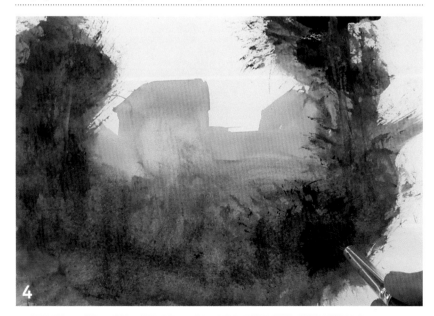

4

Build up darker values here and there and notice
how, by keeping the darkest tones and any
detailing largely confined to one side (as on the
right in this sketch), it suggests that this area is
closest to the viewer. Time to stop!

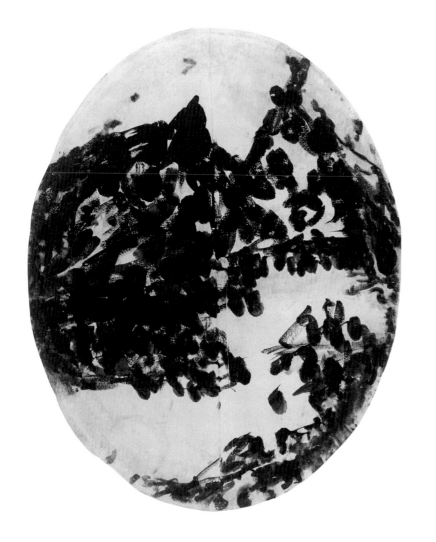

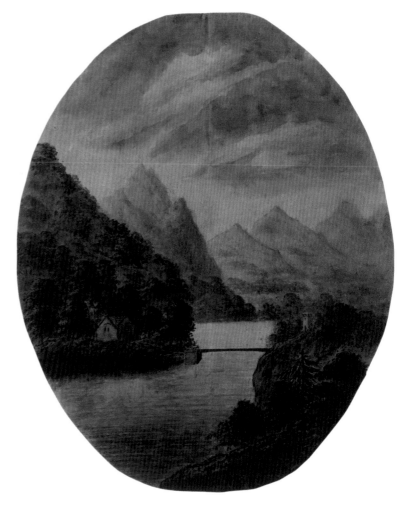

Alexander Cozens and a pupil, *A Blot, Based on New Method, Plate 10. Verso: A Clumsier Blot*, Ink on paper, 48 x 38.2, Tate T08197.

Alexander Cozens and a pupil, *The Pupil's Interpretation of a Blot, Based on New Method, Plate 10*, Graphite, ink and watercolour on paper, 48.5 x 39.1, Tate T08198.

Both from Cozens' *A New Method of Assisting the Invention in Drawing Original Compositions of Landscape* (1786).

Alexander Cozens: creative landscape blots

Alexander Cozens (1717–86) was born in Russia but was educated in England, and also lived in Italy for two years during which time he worked in the studio of the French landscape painter Claude-Joseph Vernet (1714–1789). He later became a celebrated drawing master, working in prestigious public schools such as Eton College, and he also acquired some wealthy private clients, including Sir George Beaumont who would go on to become an important connoisseur and patron of the arts. A successful professional artist, he participated in the earliest organised public exhibitions of watercolours at the Society of Arts and also showed his work at the Royal Academy. He was the father of another important watercolour pioneer, John Robert Cozens (1752–97).

His materials have not been analysed scientifically. Visual examination suggests he used the typical watercolour palette for the period, with an emphasis on earth colours, and use of plant-based colorants such as indigo for his skies, but less use of red plant-based lakes.

Alexander Cozens' ideas, methods and publications had enormous influence on the evolution of watercolour as a creative medium, as well as on the way that painters came to approach landscape. Referring to a treatise by the Renaissance master Leonardo da Vinci (1452–1519), in which artists were recommended to find inspiration in stains or marks on old stone walls, Cozens devised a system for inventing landscape using abstract blots as a starting point. His full system was complex and not particularly easy to follow, but in essence his theories offered simplification of the fundamental elements of landscape when sketching and a way of creating original pictures from imagination by elaborating upon semi-accidental arrangement of marks, or 'blots'.

Although this may not seem a radical idea today, it was very different from the topographical methods used by most watercolourists of his era, and it led to Cozens being derided by some as 'Blotmaster General to the Town'.

Here is how you can experiment with Cozens' system. Remember, his blots were largely *informal* marks made by the brush. The key lies in *not trying to draw accurately* but simply to use the brush to build up masses in a very direct fashion. Think of the way that a toddler might make impulsive 'splodges' with a brush. Picasso would observe some two hundred years later, 'It takes a lifetime to learn to paint like a child'. The urge to control what you are trying to draw is a strong one, and has to be put aside here, so that you end up with marks that help you to imagine an *entirely invented landscape*.

Preparing to make blots

In watercolour painting, brushes have two broad tasks. The first is to pick up, deliver and carry paint, and the second is to make marks. Though you may be able to guess how much paint a brush can carry and the marks it is likely to make by looking at it, the only way to really learn what a brush can do is to experiment with it.

Even a flat nylon brush will make an interesting mark if unevenly loaded with wash.

This brush, handmade by artist Ian Bell (wood shavings wired to a stick), makes wonderful marks that suggest any number of natural textures and living plants.

The flat nylon brush unevenly loaded with wash and then moved around – for example by pressing, dragging sideways and so on – can make many other marks too.

Dot, dab, drag, roll

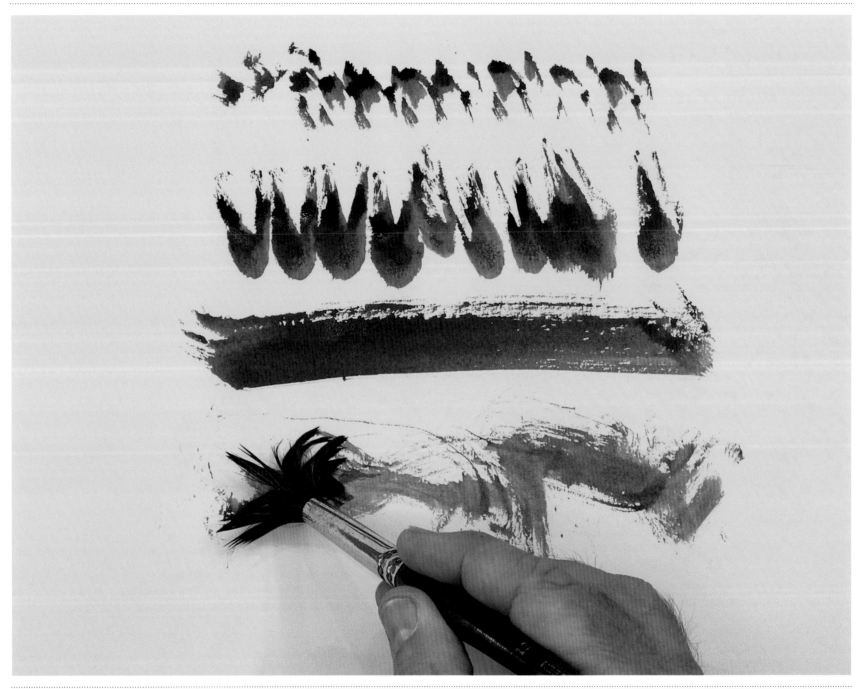

An exercise like the following 'dot, dab, drag, roll' process will help you to explore the possibilities for making interesting marks that just one brush can offer. The result will be a range of exploratory marks all made with a single brush.

- Start by making *dot*-like marks using the very tip of the brush (top)
- Then try *dabbing* by patting the page with the side of the brush (second from top)
- Next *dragging*, by laying the brush on its side and making a broad sweep sideways (second from bottom)
- And finally *roll* the brush while *pushing* it along so that the hairs fold back (bottom)

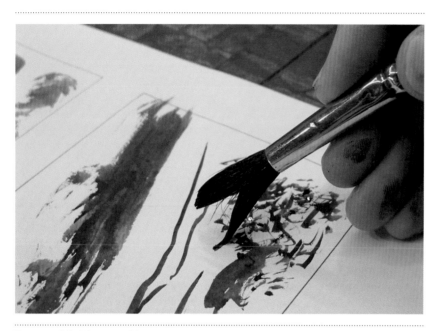

Tree compositions from blots

In this first simplified exercise in blotting you do have something in mind – the massed foliage of trees. Later on, in your own practice, you might try to make entirely free, random marks and use them to create complete landscapes or indeed any other subject they might suggest.

Historical link for blotting
A colour sketch or colour beginning by Turner can be regarded as a kind of creative blot – conceivably owing a great deal to his study of Cozens – and partly representing what the artist may have seen, partly experimenting with colour and composition, and sometimes acting as a preparatory start from which a finished painting might be built. Such studies, while complete in themselves, represented a crucial stage in Turner's ongoing creative process.

You may well find that some of the most interesting marks can only be made with a brush that is splayed into an irregular shape. Historically this is called *split-brush* and was used by painters to depict foliage. In the next exercise you will be using the brush splayed, to create almost random marks.

Note that a brush when fully loaded will make a very different mark from the same brush when nearly empty.

Start with mid-toned values: load your brush with sepia or Payne's grey and rapidly splodge down a number of irregular shapes suggesting tree foliage. Don't try to form trees, just build up splodges.

Darker values: now you need to allow your eye to start to see the shapes you've created as being massed foliage, then use a much darker toning to build up the shadows (respectively underneath the foliage, on the ground and perhaps to one side).

Try the process a number of times and in different ways. These blots were created very quickly and with much freer and drier brushwork, and then the trunks simply brushed up through the foliage. After a while this may help you to see *real* foliage in terms of the blotting technique and so implement it as a useful way to sketch *en plein air* as well.

Details: this is the easy part: use a knife blade or fingernail to drag out the basic shapes of tree trunks. The result is a copse of trees created from a series of random blots.

Repeat the exercise with a variety of brushes. Here a very old and worn-out 'fan' brush has been used.

Creative blotting

Ideas for creative blotting

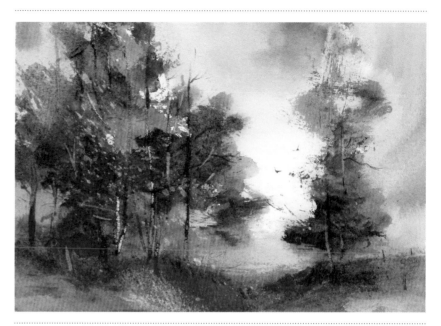

Genuinely abstract blots can be made using almost anything to press and smear paint. (Cozens himself recommended crumpling the paper to increase the haphazard potential of marks.)

A wet-in-wet landscape charged with 'blots' as the basis for trees.

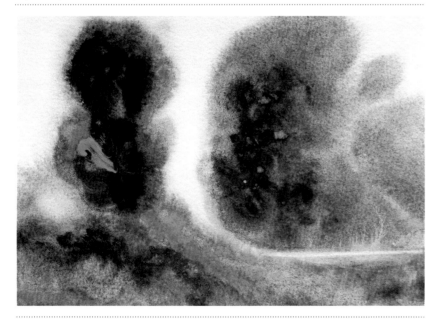

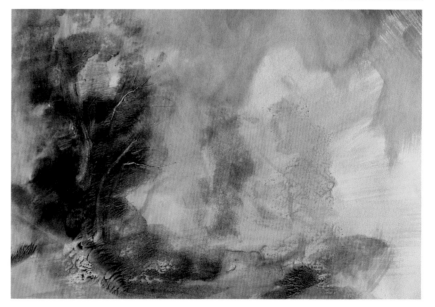

Wet-into-wet charging of colours prone to granulation (including raw umber and burnt umber) with wiping out during the drying process, then lifting by wetting and wiping. Final dry-brushed accent in bright blue.

Watercolour monoprint created by applying wet paint to a sheet of glass (painting onto the glass forms the foliage into the desired Corot-like composition) then pressing a sheet of wet paper onto it to create the blot. Tree trunks were then suggested by scraping out while wet.

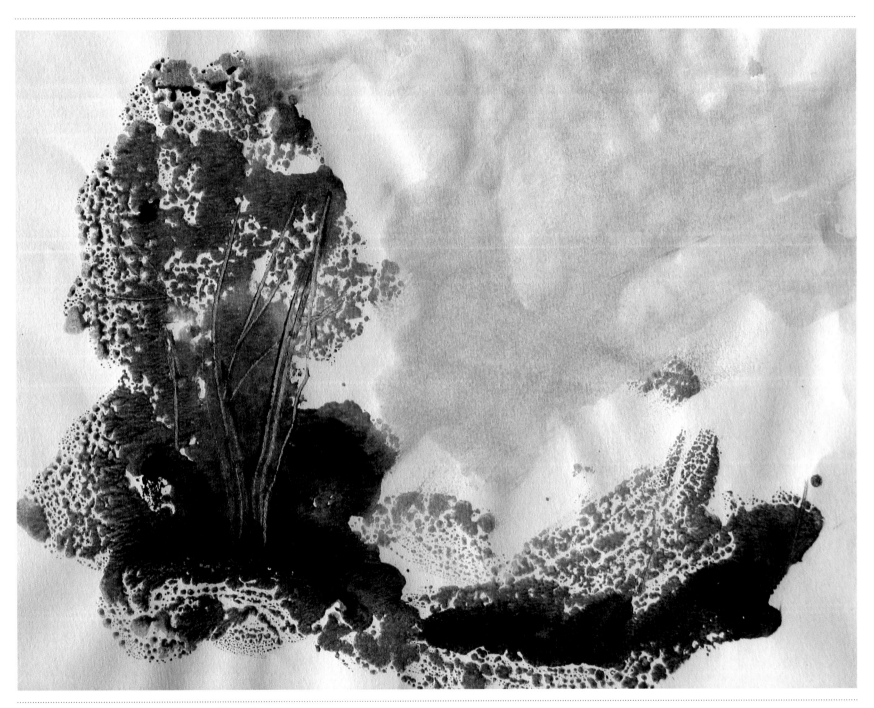

Watercolour monoprint from glass onto dry paper with scraping out.
Genuinely abstract blots can be made using almost anything to press
and smear paint. The next stage of finishing might involve using a fine
brush to add details, such as a bird to bring a touch of life to the landscape.

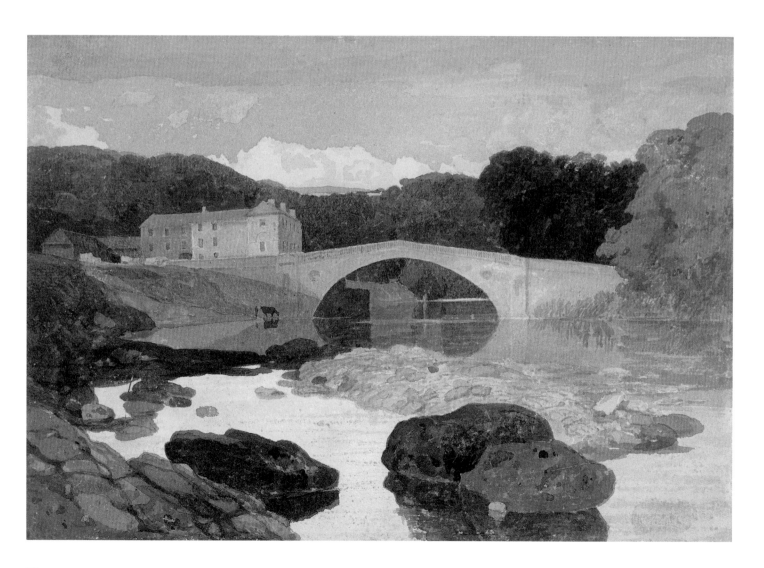

John Sell Cotman: line and wash

Opposite: John Sell Cotman, *Greta Bridge* c.1807,
Watercolour over graphite, 22.7 x 32.9, British Museum, London.
Above: John Sell Cotman, *Durham* c.1805,
Watercolour and graphite on paper, 23.5 x 25.4, Tate N03634.

J.S. Cotman (1782–1842) was born in Norwich, England and is recognised as one of the most original landscape watercolourists of the nineteenth century. He had little formal training and was initially intended for a career in the family haberdashery business, but in 1798 he left home to further his artistic education in London, where he attended the informal 'Academy' of Dr Thomas Monro, a wealthy physician who had accumulated a significant collection of contemporary British watercolours. Monro encouraged young artists, including Cotman, and the youthful Turner and Thomas Girtin, to study and copy from works in his collection, paying them two shillings and sixpence (which would not have been a good sale price to a professional artist), and a supper of oysters. In 1800, while still in his teens, Cotman exhibited several works at the Royal Academy. Like Turner, Cotman derived much of his inspiration for landscape from travelling. He toured Britain, and later France, but his most famous trip was to Yorkshire in 1805, where he focused particularly on the River Greta, producing some of the finest and most original watercolours of the period. His distinctive early style is characterised by flat, muted colours and simplified, pattern-like forms, and he exemplified an approach to watercolour based upon beautifully observed and careful drawings subtly washed in between the lines – an evolution of the traditional eighteenth-century stained drawing. In later life his art evolved to use richer colours and more textural washes, reputedly by using paint thickened with flour paste. In 1823 Cotman returned to Norwich, where he became a leading member of the Norwich school of artists (the group included two of his sons who also became artists). He also taught drawing, and ran a 'library' of watercolours for his pupils to borrow and study. Later he became drawing master of the prestigious King's College school in London, but never attained wealth.

Cotman appears to have used a selection of earth colours on both laid and wove papers with quite a coarse texture, but no scientific analysis has been carried out on his works.

Some years ago, armed with a reproduction, a painting group I was leading set out in search of the exact location from which Cotman had painted – or at least drawn and planned – his most famous masterwork, *Greta Bridge*. After making their way down from the bridge and along an old cow path and through the deepest rural mud, they found they could look back to the same view that Cotman had enjoyed nearly two hundred years earlier. As it turned out, it was a spot on the bank now exactly underneath a modern overpass. So accurate was Cotman's drawing that they could still line up rocks he had drawn in the foreground. Then, to complete the picture, a dairy cow came down the path to drink at exactly the same place as its ancestor had in a previous century.

Cotman exemplified an approach to watercolour based on beautifully observed and careful drawings subtly washed in between the lines – an evolution of traditional stained drawing. In Cotman's case this led to some of the most considered works ever created in watercolour, a consequence of his intense and painstaking observation of nature. When compared with the directness of Constable or the great colour harmonies found in Turner, his works may seem

rather more restrained. Yet, like fine wine, they may be best sampled when there is time to consider fully the rich subtleties contained within.

Arguably the best-known example of 'early' Cotman is *Greta Bridge*, painted in 1807. Here, in beautifully rendered lines and mostly flat washes, we see a master designer at work, and the careful hand of a great draughtsman.

Cotman's approach is still regarded by many as the classical 'English watercolour' method. A fine exponent from the modern era was William Heaton Cooper (1903–95) who lived and worked in the Lake District in the north of England.

Today, countless painters in watercolour still make line and wash the basis of their craft and many have published wonderful manuals to explain it in detail. Our exercise, however, reduces it to a very achievable study for those who haven't painted before, based on a tiny work by Cotman.

It will require a certain amount of accuracy in drawing and a modicum of skill in laying wash, since this is the only way to experience *the basic method*. Like many demonstrations in this manual, it was painted onto available cartridge sketching paper within a sketchbook. You can expect to achieve far better results (a more 'even' wash, for example) if you work on less absorbent, *sized* watercolour paper.

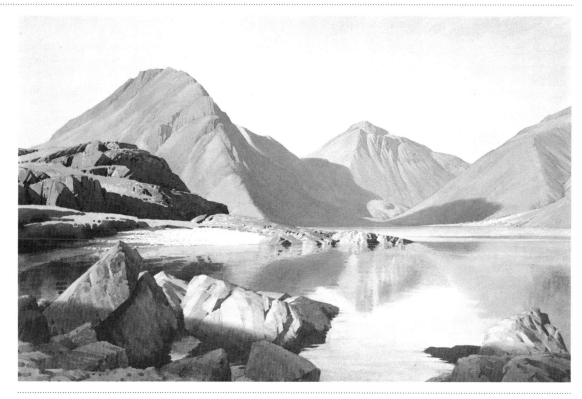

William Heaton Cooper R.I., *Clear Evening, Wastwater* 1967, Watercolour on paper, 76.2 x 50.8, Heaton Cooper Studio, Grasmere.

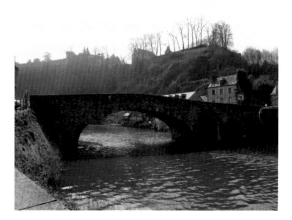

As initially photographed this view would be quite a complex subject to paint. But it can be simplified by cropping, reduction to monochrome (that is, a single colour) and the strengthening of tonal values into light, mid and dark tones. This is the sort of process an artist like Cotman might mentally apply to a subject prior to commencing work. In Cotman's case, though he drew with great accuracy, he was also a master at arranging any subject into a coherent design.

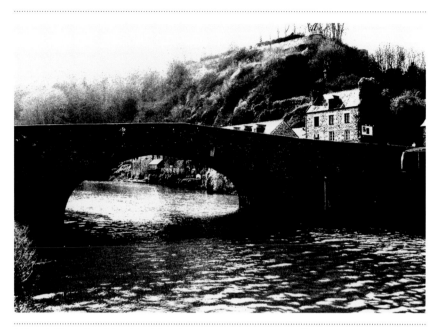

Although this version of the original photo has greatly simplified the subject, the following exercise will reduce it to almost block-like simplicity. (Try to imagine Cotman himself setting you a simplified task so that, armed with experience, you can then move towards more detailed and coloured works in future.)

Start by washing a very pale toning over the entire picture, except for the surface of the lake that will be seen through the archway. Reserve this as white.

This drawing reduces the view even further and gives the basis for a study in tonal values.

After the first wash has dried, wash in the area from the top of the mountain with a mid-tone of the same colour. Continue to reserve the white seen through the arch. If you are working on sketchbook cartridge (as here) you may find irregularities occurring on the surface as you lay one wash over the other. Don't fight it – rather, coax it to suggest local texture.

When this mid-tone wash is completely dry, wash in the bridge with the darkest tone, including the shadow underneath it and a suggestion of ripples on the surface of the water. When all of this has dried, use the darkest tone again to darken the curved shadow under the arch and a shadow falling onto the bridge (cast by something outside the field of view).

Use the edge of a knife or blade to create crisp highlights in the water.

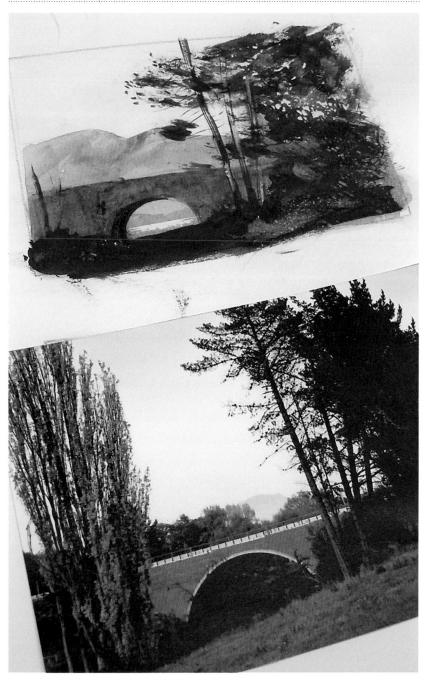

In this extension of the initial exercise, a photograph is the starting point for a more detailed picture based on the previous exercise – to render a solid bridge using flat wash and tonal values but then combined with the blotting approach to trees learned by working from Claude, Corot and Cozens.

Later Cotman

Although in later life Cotman made greater use of vibrant warm/cool contrasts and experimented with adding gouache, his compositions remained largely dependent on beautifully drawn details – as seen below in the windmill, foreground and figure, beautifully complementing the subtlety and freedom of his washes.

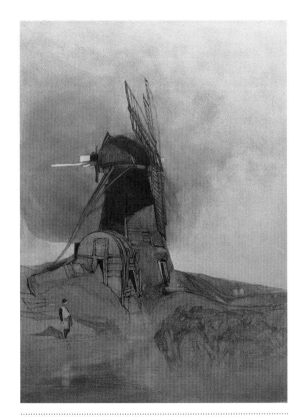

John Sell Cotman, *A Windmill* c.1828, Watercolour, pen and brown ink, 52.7 x 38.1, The Hickman Bacon Collection, Raveningham.

Tony Smibert, *Meeting* 2004, Watercolour on paper, 19 x 14.5. In this study based on Cotman's later approach, the sky and land were painted wet-in-wet, then after drying the shape of the rock was carefully drawn and washed in with warm colours, great care being taken with the edges and line-work. This was blended into the land, deeply shadowed with darker tones, and the shadows enlivened with passages of cool colour reflected from the sky. Finally the tiny figure was carefully drawn and washed in.

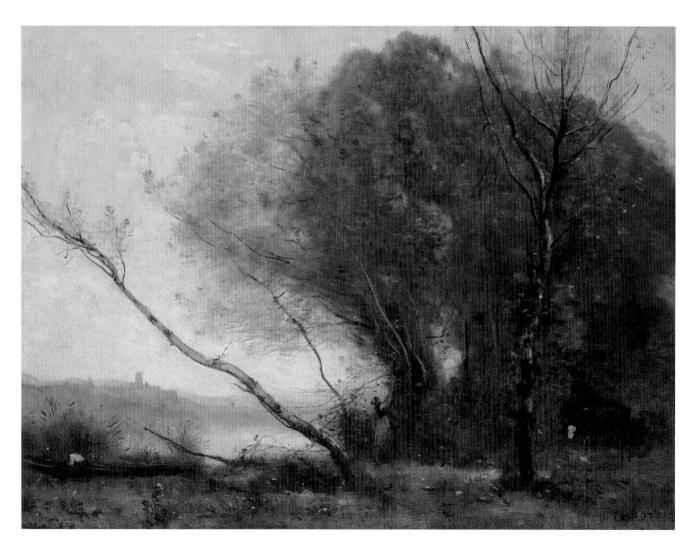

84

Jean-Baptiste-Camille Corot: balance of light and dark elements

Opposite: Jean-Baptiste-Camille Corot, *The Bent Tree* c.1855–60, Oil paint on canvas, 44.3 x 58.5, National Gallery of Victoria, Melbourne.
Above: Variations on the Taoist symbol popularly known as *yin-yang* – representing 'the balance and harmony of opposites'.

The French painter Jean-Baptiste-Camille Corot (1796–1875) was born into a family which owned a small business, and initially was apprenticed to a draper, not an artist. However, the trade did not suit him and in his mid-twenties his family gave him the financial independence to travel and paint. He studied in a number of French studios under well-known artists, and spent a highly formative period in Italy, painting landscapes in oils inspired by the country's scenery and classic heritage. From 1831 Corot exhibited at the Salon in Paris but his work was not well received (at a time when a less than positive reception by the Salon would have been far more damaging to an artist's reputation and sales than rejection by the Royal Academy in London). However, by the 1850s his position as a leading landscape artist had been established and by the end of his life 'Père Corot', as he became known, exerted a profound influence on many younger painters, including the up-and-coming Impressionists. In later life he often worked from the motif, using natural scenes directly to inspire his soft and atmospheric compositions.

Examination of Corot's oil paintings suggests that he used a wide range of earth colours, and mixed greens derived from blue and brown. In combination, these colours readily harmonise, and they also form the typical and traditional watercolour palette.

In *The Bent Tree* Corot has arrived at a very balanced composition that directly reflects the influence of Claude. It's an approach to composition that, perhaps coincidentally, also seems to echo the Chinese Taoist ideal of 'balance' – in art, life and nature.

The Taoist notion that all things exist within a harmony and balance of opposites – such as light and dark – is conveyed by the yin-yang symbol. Perhaps unexpectedly, this may help us to see the compositional principles applied by Corot in a new way. Next to the first graphic is a more developed symbol of yin-yang – having an area of dark within the light portion and of light within the dark. In the first symbol we have already seen that when light and dark are placed next to each other they not only *contrast* but help us to visually *appreciate* what we see – both light and dark. But here, in the second, because the light portion has a darker element within and the dark a lighter element, the visual statement is even stronger.

Now, having seen this, if we look once more at the Corot and turn it upside-down we can see that the light and dark areas almost perfectly reverse, and the similarity to the Taoist symbol is obvious. Looking closer, we can also see that Corot has helped the viewer to appreciate the dark mass of foliage by leaving a gap through which we see the light. He has then angled his bent tree to cut a diagonal straight through the open area to the left of the foliage. As a consequence, its serpentine shape is crisply silhouetted against sky. It is great design and, whether contrived or achieved unconsciously, was also applied in other works by Corot, as seen overleaf in another version of the bent tree.

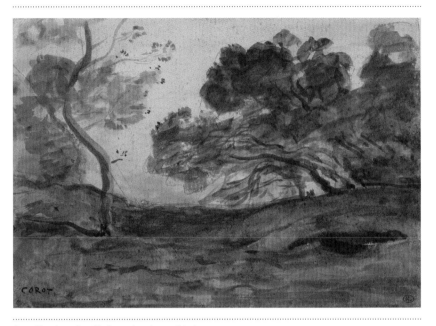

Jean-Baptiste-Camille Corot, *Landscape Study*
c.1870, Watercolour and black pencil, 14.9 x 21.1,
D.A.G., Musée du Louvre, Paris.

This exercise builds on what you learned from Alexander Cozens, except that there is now an emphasis on 'composition'. Start simply, with very solid shapes, placed according to the planned design. Leave lighter areas within the darker masses and try painting a single tree-trunk within the reserved white of the sky.

Here's how you can apply Corot's design into a simplified but classical method for compositional sketching in watercolour, then evolve that into a variety of creative approaches based upon it. You may find it useful to start by sketching the basic composition in pencil, then placing the foliage masses within the guide lines.

Use solid slabs of dark to build up a much larger copse of trees next to a smaller area of clear sky. Make sure there are plenty of sky-holes within the foliage and cut a single branch across the area of clear sky.

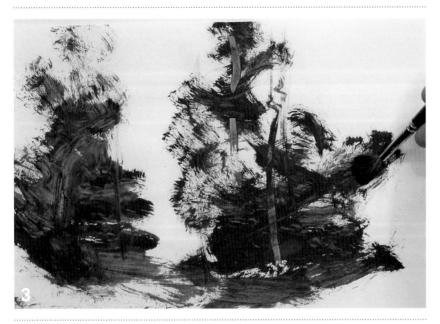

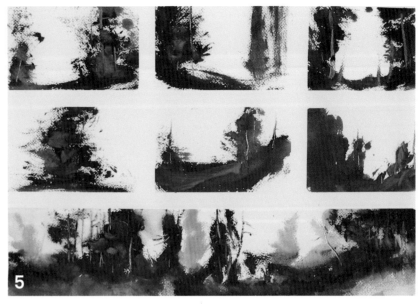

Follow this with a number of rapid studies. Just as Corot did with his smaller watercolour, you should feel free to stretch and adapt the composition. The idea is to build your own composition inspired by the clarity of design in the Corot. Then, when you feel comfortable in monochrome, move on to colour studies.

Consider using charts to experiment with ways to vary the light and dark balance. Here, each tiny study was created very rapidly, a conscious variant on what had gone before.

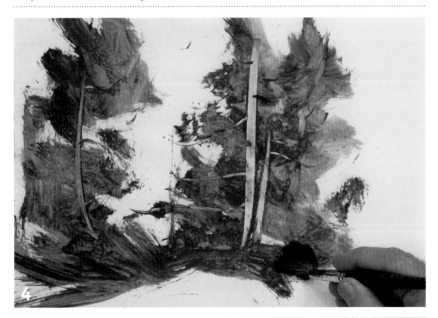

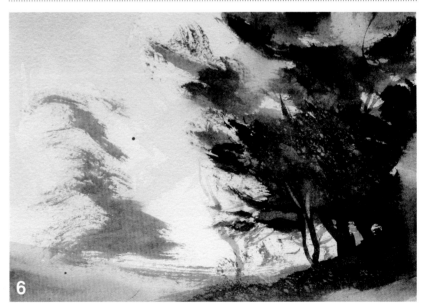

The only colours used here were yellow ochre (lightest), raw umber and burnt umber (mid-tones) and a rich grey mixed from cobalt blue and light red (darkest, shadow tones). The process is from light to dark – with a few crisp details in dark added with a fine brush or scraped out while wet with a knife-tip. Note the addition of a bird in flight to bring 'life' to the scene.

Finally, make some creative studies: simplifying and experimenting, but always retaining the core principles. The key purpose of learning 'from the masters' is to come to a working understanding that you can apply in your own way with your own art.

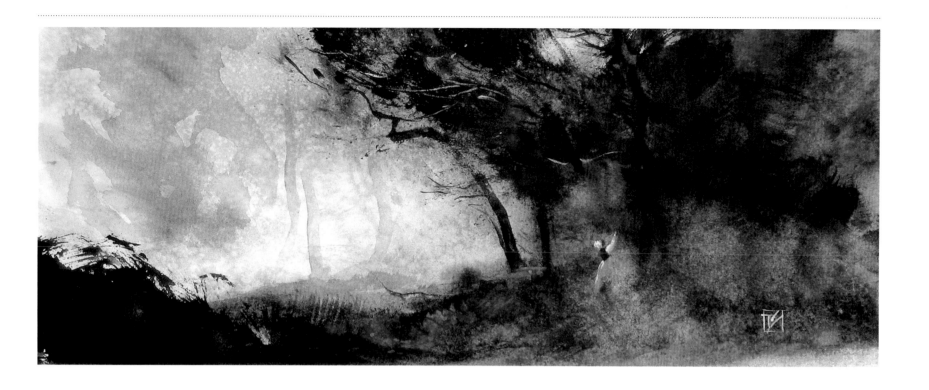

Tony Smibert, *After Corot* 2005, Watercolour on paper, 38 x 14.5. Never be afraid to emulate, copy, 'steal from' or make use of the techniques of masters you admire. Then do feel free to vary their approach once your own picture starts to develop. Here, the greatest variant might seem to be that the composition has been elongated, but in reality, while the composition is based on Corot, the technical approach (wet-in-wet with charging, etc.) is very different throughout. At the same time, the addition of a female figure clearly references Corot's own *Bent Tree* as the primary source of the composition.

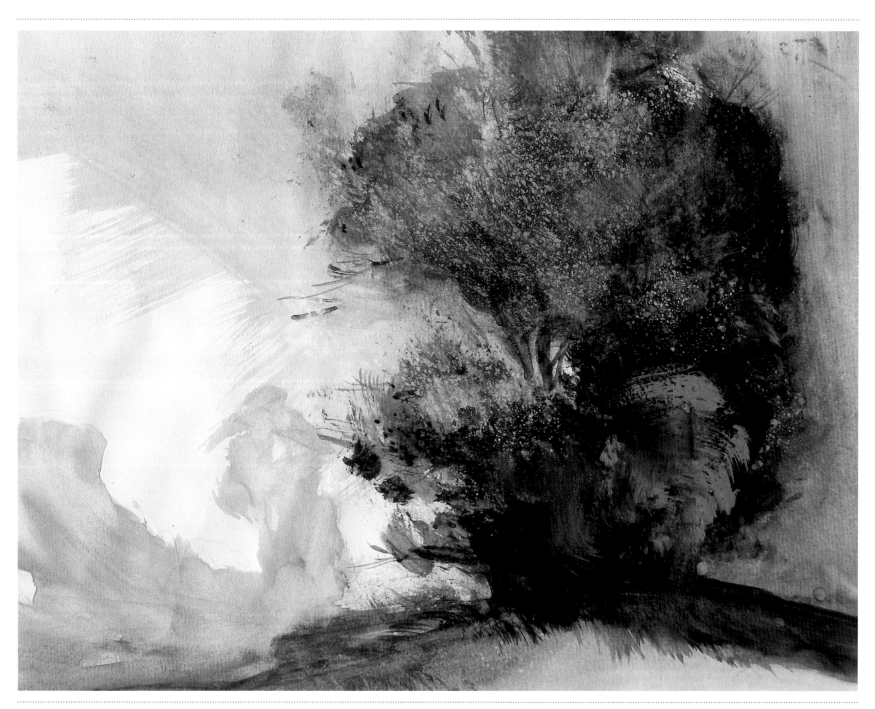

Tony Smibert, *After Corot II* 2009, Watercolour on paper, 38 x 29.
In this example, reference to Corot's painting may be less obvious,
because subject is now a single tree, placed so as to balance with
the composition, but still in a free-standing and dominant position.

This is more of a tree-portrait than a landscape, with the emphasis
now on the intensity of wash, colour and detail achievable in simple
passages of watercolour within that tree. And just as important as
placement and tone is the counter-balancing of strong elements of

warm and cool colour. This is also the subject of the next section,
which introduces the painter thought by many to be the greatest
master of watercolour, J.M.W. Turner.

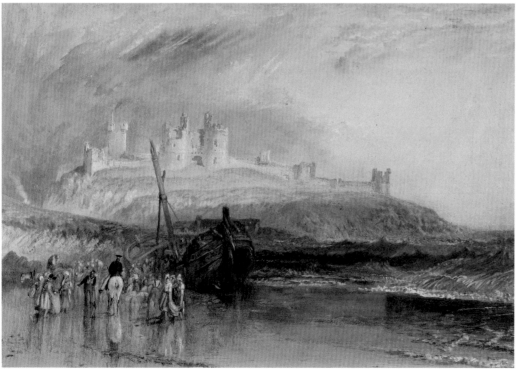

Top: J.M.W. Turner, *Dunstanburgh Castle from the South: Chiaroscuro Study* c.1797–8, Graphite, brush and ink, watercolour and gouache on paper, 26.1 x 33.7, Tate D01113.
Bottom: J.M.W. Turner, *Dunstanburgh Castle, Northumberland* c.1828, Watercolour and bodycolour on paper, 29.1 x 41.9, Collection Manchester City Galleries.

Joseph Mallord William Turner: colour harmony

A powerful contrast occurs if you place black alongside white. Turner's system made use of a similar effect, which can be seen if you place a cool colour next to a field of warm colour.

J.M.W. Turner (1775–1851) was born in London into modest circumstances (his father was a barber). From an early age he showed promising artistic talent, even in simple and lowly tasks like supplying landscape and weather effects for studies of great houses by architectural draughtsmen. He was articled to Thomas Malton, an architectural draughtsman whose teaching Turner openly acknowledged. Aged fourteen he gained admittance to the schools of the Royal Academy, the most prestigious art school in the country, where he studied drawing from plaster casts of classical sculptures and from live models, and in addition, a thirst for self-directed learning led him to copy watercolours at Dr Monro's 'academy' at the same time as his friend and rival Thomas Girtin. Turner was successful as a professional artist from the very beginning, teaching, drawing and making sketching tours around Britain for wealthy patrons. He became an Associate, and then full Member, of the Royal Academy while still in his twenties, and in 1807 was appointed as the institution's Professor of Perspective, which involved sporadic lectures and more practical tuition of students. His life's quest was the pursuit of landscape and a desire to raise the genre to new academic and expressive heights. Turner coupled artistic genius and an extremely high level of practical skills with astute entrepreneurial ideas, and derived a handsome income from the sale of paintings, particularly his works on paper. He also forged new creative ground in engraving rights and illustrations for mass-market topographical publications aimed at 'armchair' travellers. His father became part of the family enterprise, managing the studio and his son's various homes for many decades. Turner worked obsessively, and throughout his life travelled extensively throughout Britain and Europe, continuing the habit until his seventieth year. In later life his oil paintings were frequently criticised for their increasingly experimental nature, but his late style was defended and praised by the influential critic John Ruskin.

Of all the artists discussed in this book, Turner was the most adventurous user of materials and many of his materials have been scientifically analysed. It is known that he tried out practically every coloured pigment that became available during his lifetime. He disliked some of them but did adopt most newly invented colours: Mars orange and red (brighter, manufactured versions of the traditional earth colours), a series of newly available yellows (this became his signature colour), red lake pigments (which over his lifetime became available in shades from brownish red to bluish red), blues such as cobalt blue, and even pure greens, in an era when it was conventional to mix greens from blue and yellow when working in watercolour. He kept his past favourites to hand in his studio – he appears to have thrown out nothing – but increasingly he used the newer materials. He used many pigments intended for oil painting in his watercolours: vermilion, smalt, expensive natural ultramarine and Prussian blue, for example, as well as the red and yellow lakes, indigo blue and earth colours (yellow ochre, siennas, umbers) that had been used by all the watercolourists who came before him. As time went on, Turner made particularly striking use of newer, intensely opaque

colours such as chrome yellow (produced in shades ranging from pale yellow through orange to scarlet during his lifetime) and emerald green. They can be seen most often in watercolours for which he selected a blue paper rather than an off-white one, and in such compositions he used opaque white highlights made from chalk, dolomite or even lead white, and mixed these materials with yellows or reds to make gouache (opaque, water-based paint) for dramatic sunsets. The use of gouache would be adopted increasingly by nineteenth-century watercolour artists who were accurately illustrating plants and flowers.

His surviving paintbox includes many bottles of dry pigment for use in either oil or watercolour. The cross-over in pigment use, and the contrast of opaque gouache and more traditional washes – a device employed by oil painters – are the main reasons why Turner's watercolours appear today to be so innovative.

Many of the paper formats which Turner used derive from standard sizes of paper, neatly torn down to half, quarter or an eighth of the original sheet, which was a common and efficient practice. His sketchbooks came in a variety of sizes, and he used them somewhat randomly, generally from both ends on different occasions. But he rarely ran a sketch over the double page of an opened sketchbook, or made multiple sketches on a single page. When travelling and running out of materials, he was good at improvising on the day.

Turner's watercolours were not only the products of talent but also evolved from his drive to experiment with all that it was possible to do with the medium. While of course no individual could ever expect to master the full potential breadth of watercolour as a medium, Turner perhaps came the closest, and it is hard to imagine that he did not reach the highest possible levels of attainment with the materials of his era. He was at one and the same time capable of producing finely detailed, jewel-like miniatures and studies that, like *The Challenge* by David Cox, feel as if they were painted with raw earth rather than 'real' paint. Turner could capture the fleeting effects of nature in a few brushstrokes, or portray the scale and detail of a full-sized battleship in a painting the size of a dinner plate.

The view that Turner rose to a point where he no longer needed technique, but could rely on instinct and inspiration alone, is only partly true, but might be explained in terms of the *shu-ha-ri* principle (discussed in an earlier section). He trained himself well, acquiring a high level of skills early through dutiful study and perseverance.

Among the most important characteristics of Turner's development as an artist was his personal transition from the classical approach of the late eighteenth century – based on muted tonal values of light and dark – to a glowing palette based on colour harmonies primarily built around the use of warm and cool colours. This can be seen by comparing studies of *Dunstanburgh Castle from the South*, painted in 1797–8 when he was twenty-two, and *Dunstanburgh Castle, Northumberland* of some twenty-five years later.

Historical link for blotting

A colour sketch or colour beginning by Turner can be regarded as a kind of creative blot – conceivably owing a great deal to his study of Cozens – and partly representing what the artist may have seen, partly experimenting with colour and composition, and sometimes acting as a preparatory start from which a finished painting might be built. Such studies, while complete in themselves, represented a crucial stage in Turner's ongoing creative process.

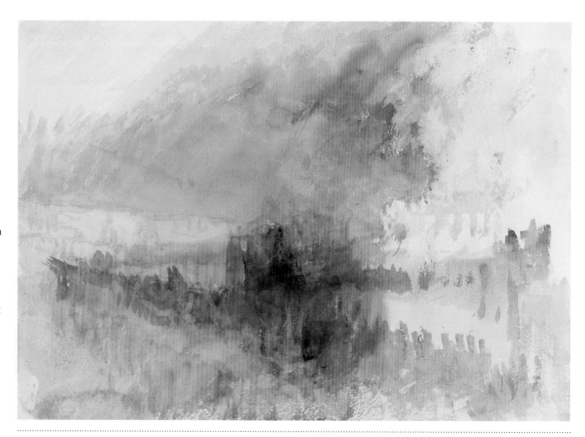

J.M.W. Turner, *Fire at the Grand Storehouse of the Tower of London* 1841, Watercolour on paper, 23.5 x 32.5, Tate D27851. These two colour studies (from a group of nine) show Turner experimenting with variations on the same subject – burning buildings, reflected in water. Here his composition is basically an area of cool blue surrounded by warmer colours.

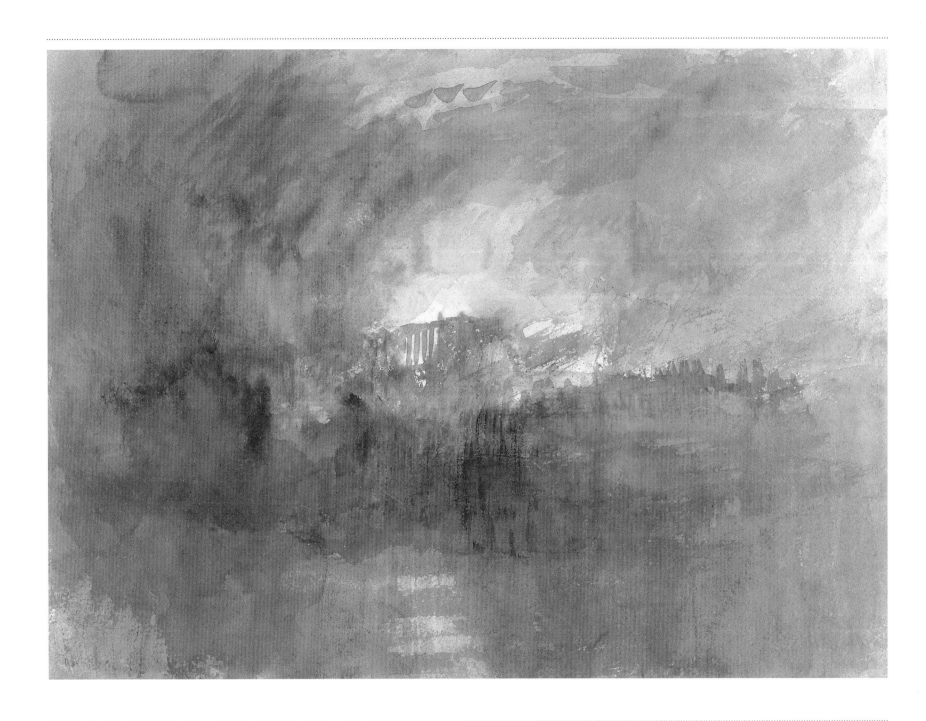

J.M.W. Turner, *Fire at the Grand Storehouse of the Tower of London* 1841, Watercolour on paper, 23.5 x 32.5, Tate D27846. This composition is based around a glowing central area of warm colour, echoed by its reflection from the river, and surrounded by much cooler (and darker) hues. Where the previous example was based on *warm-within-cool* and *dark-within-light*, this example draws its compositional strength from *warm-within-cool* and *light-within-dark*.

Contrasting warm and cool

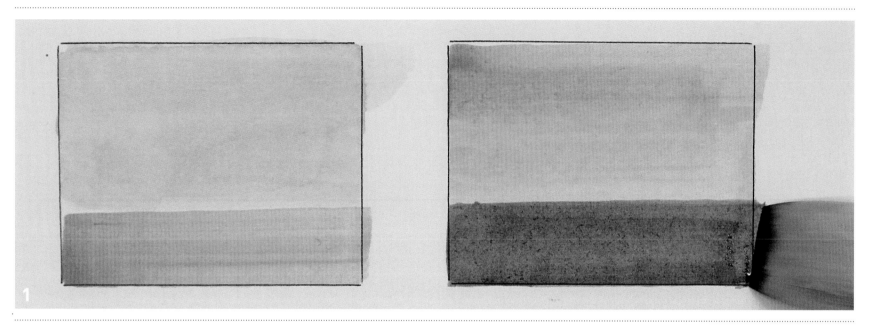

1

Turner understood how a passage of cool blue laid above an area of warm yellow could provide him with the basic colouring for a glowing landscape under a cool sky. Then, if reversed (as on the right), it could provide the basic colouring for a warm sunset over a cool sea.

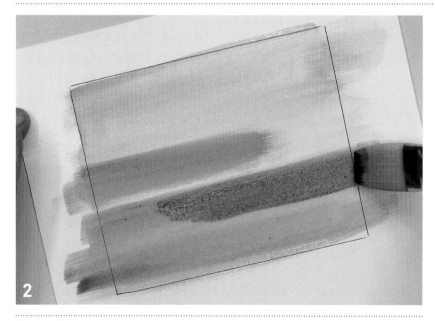

2

3

These bands can then be strengthened with deeper values and finally brought into a colour harmony through the addition of passages of cooled warmth into the upper band and warmed cool into the lower band. Turner built on such principles to great effect.

Such harmonies were only a beginning. Here, in a greatly simplified illustration, a band of warm/cool mix has also been swept along the far horizon – another device sometimes used by Turner when painting a distant city over water at sunset (Venice, for example, as on the right).

The next exercise will give you the opportunity to put Turner's approach into practice by creating a sunset study in full colour, but from your imagination. Like Constable, Turner observed the sky and never tired of making studies of it. His sketchbooks are full of them, giving him an endless resource for creating amazing effects from his imagination, whether working in watercolour on paper or oil paint on canvas. His method enabled him to rapidly capture both the broad colour balance of a sky, and more specific details, on one sheet of paper before he moved onto another study. The following exercises are *not* about creating something that necessarily looks like a Turner watercolour, but they make use of a Turnerian approach based upon the juxtaposition of warm and cool colours.

A good example is *Venice: Looking across the Lagoon at Sunset*, no doubt based on observations at sunset. While his actual processes and brushwork are quite complex, the principles applied are not. It seems likely that the artist soaked the paper sheet and simply smoothed it out onto a flat surface – a board perhaps. He then washed in the lightest warm colours over the entire surface and charged the upper sky with patches of deeper wash while it was still damp (to suggest soft clouds), before allowing the sheet to dry. Later, he added the darker blues of the lagoon and finally the crisp, darker details of the posts and wharf.

Firstly, Turner ensured that the warm glow of evening envelops the entire painting (even as if from within the ocean) by washing his initial warm colours over the whole sheet so that they can be seen through the later washes of cool colour.

Next, the clouds in the upper sky were charged using a red to which blue was added (in other words, a *cooled warm*), while the darkest details in the foreground were actually created with a *warmed cool* (possibly a blue/black to which red had been added). These touches give the sheet the profound sense of colour harmony associated with sunset. Finally, the distant city at the horizon was created using a colour made up of warm and cool, not mixed together but painted as a strip. They simply overlap where they meet. In the same way that both the Taoist yin-yang symbol *and* Corot's *The Bent Tree* seem to 'connect' or 'unify' otherwise strongly contrasting passages of light and dark (by the graphic device of including a *touch of light within the darker mass*

and *dark within the lighter mass*), Turner has achieved the same thing in colour by introducing a touch of *cool into the warmer mass* of the sky and a touch of *warmer colour into the cooler* foreground. This subtle effect can be seen repeated in various ways in many Turner paintings, and from a practical painters' point of view is a very powerful lesson we can learn from him.

To illustrate the point, the charts on the left page have been reduced to simple blocks of colour. In the third one, broad areas of colour were strengthened with deeper values (a warm sky might be strengthened with a passage of a darker, stronger or more radiant warm hue, and a cool ocean strengthened with a deeper or more intense passage of a cool hue).

Finally, in the fourth one, these are linked visually into a powerful harmony through the addition of passages of cooled warmth into the upper band (commonly as wisps of high cloud in a sunset) and warmer cool in the lower band (often a detail such as a boat). Here, you may also notice that a band of warm/cool mix has also been swept along the far horizon .

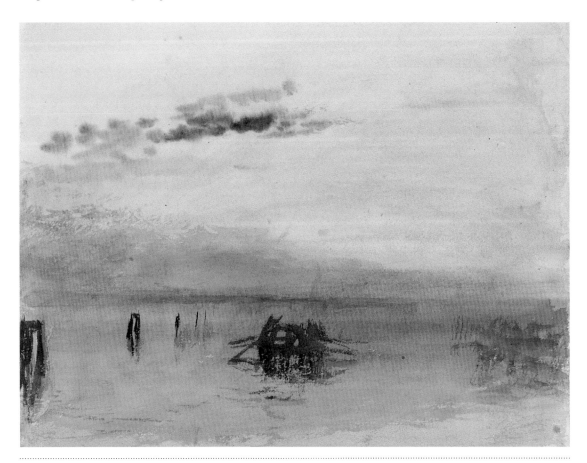

J.M.W. Turner, *Venice: Looking across the Lagoon at Sunset* 1840, Watercolour on paper, 24.4 x 30.4, Tate D32162. Consider this masterpiece by Turner in terms of the powerful colour formula he seems to have used. Though system and technique are only the beginning where great art is concerned, the fact is that any painter can learn to improve his or her own works by studying, analysing and applying the principles revealed in masterworks.

A sunset study using warm and cool colours

This exercise is a much-simplified version of a Turner colour formula, though not necessarily his painting technique, in order to create an achievable small study of a harbour at sunset. The aim is not to attempt the full subtleties of a Turner original, but simply to achieve harmony by applying the core elements of warm and cool contrasts. It is recommended that you try this more than once and keep the studies small and simplified at first. Later, see what else you can acquire from Turner by applying more subtle washes and enlivening the surface with more delicate brushwork. The key is to *eliminate* from the exercise *everything you don't need to learn at this point*. The key to understanding and working with colour harmony lies in remembering what happens naturally when watercolours mingle.

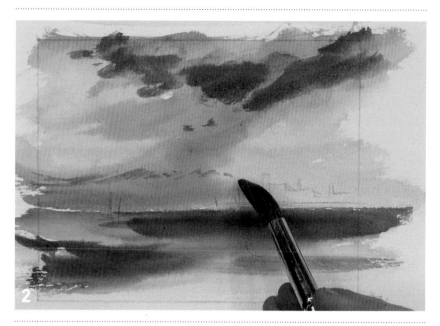

When the first washes have dried, take a deeper red (we used cadmium red, which looks quite like Turner's vermilion) and slightly 'cool' it by adding a touch of cobalt blue, then use the side or tip of your brush to drag in a few clouds scattered across the upper reaches of the sky and receding near the distant horizon.

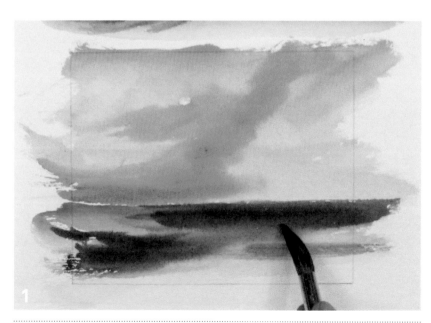

Start with a warm sky in yellow ochre and cool sea in cobalt blue, then strengthen the warm/cool values by adding deeper (darker) values in light red and indigo.

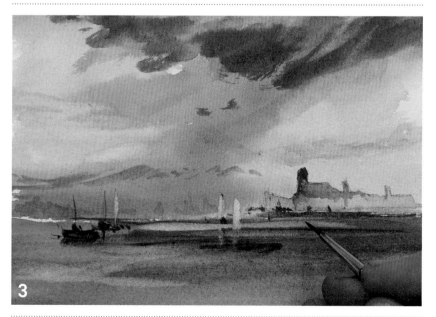

Lightly wash in the simplified shapes of distant buildings with a much paler wash of the same cloud colour, and some even paler distant ones (so they seem to be fading away). The darkest details can then be suggested with a stronger mix of the blues, slightly warmed with red. Finally, lift out by lightly applying clean water then wiping with a dry tissue to create sails and reflections.

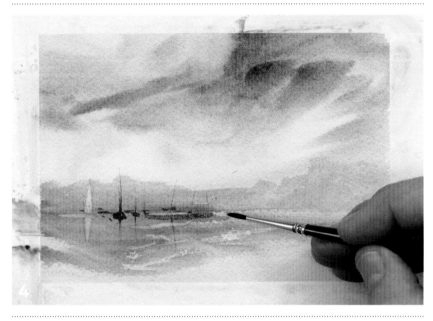

Putting the lesson to use

A sky like the one photographed below might seem an incredibly complex subject to paint. However, armed with techniques from the introductory course and a little knowledge of Turner, you may be able to paint a realistic impression. Start by laying a flat wash in pale blue over the entire sheet, but reserving a few streaks of blank white paper in the upper right (if paint has covered this area, lift or soften it by dabbing the damp pigment with an absorbent cloth or tissue). Now charge this with a little warm yellow to create the sun, glowing near the horizon, then teasing a little out to the sides with the tip of the brush to show the light touching clouds in the far distance. Let this almost dry before loading the brush with a light grey. Squeeze most of it out of the brush and then use the side dragged across the surface to paint in the darker clouds rapidly.

Here are two more versions, each on different papers. The first was painted all over with a warm wash before the cooler values were added (as Turner did) and the sky was largely completed while the first wash was still wet.

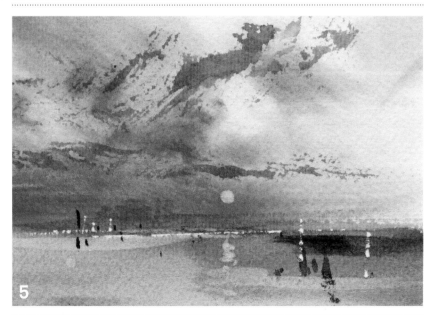

In the second, the sky was finished last of all, when the rest of the picture had dried, and with lighter touches of the side of the brush skipped over the surface to create broken cloud. The setting sun was softened with water, then wiped away with dry tissue (along with its reflection in the water). Finally, the brightest whites were scraped out with the tip of a sharp blade.

Today, no less than in Turner's time, sunrise and sunset are a great source of inspiration and wonder to many painters. Turner's profound understanding of colour harmonies equipped him to render even the most complex of skies in watercolour.

Studies from an original

There are great differences between: copying an original watercolour in modern materials; making a historically accurate reconstruction that takes into account fading or other changes in appearance; and working from the original in order to develop skill (whether painting studies based on it, or producing original works inspired by it). For example, a copy may well look just like the original up to a certain distance, but it need not have been painted using the same processes, still less historically accurate materials. In order to get to the heart of how a master like Turner painted, you will need knowledge of his methods, materials, interests and approaches as a craftsperson, combined with a close examination of the original.

When looking at original works of art the average eye can often discern which layers of paint have been washed in first. A watercolour artist – or a reader of this book – can also observe which areas were applied to soaking wet paper and which to dry paper (the former of these coming first, because soaking would soften the edges of a detail applied with strong rich paint to dry paper). An artist like Turner who used many processes in one work sequenced them almost instinctively.

The next study shown here involved painting the first stage only in the first rectangle, the first two stages in the second, the first three in the next and all of the stages in the fourth. Short written notes support the visual reference and the Tate accession number was noted at lower left (this number can be used to search for an image of any work in Tate's collection on the website, www.tate.org.uk). This is a simplified professional system that any private researcher can easily use.

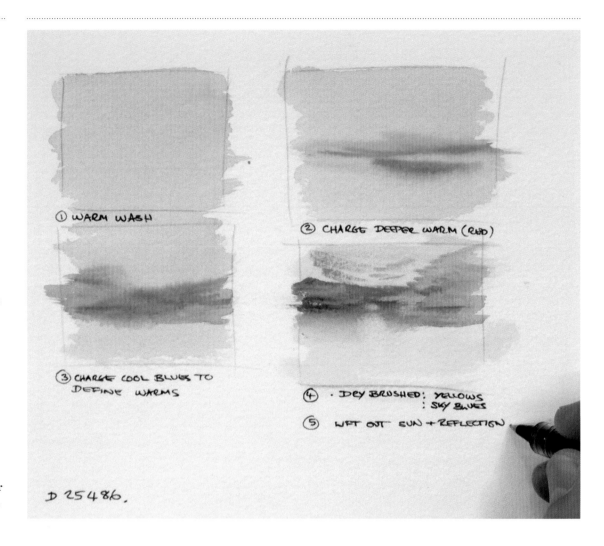

① WARM WASH

② CHARGE DEEPER WARM (RED)

③ CHARGE COOL BLUES TO DEFINE WARMS

④ • DRY BRUSHED: YELLOWS : SKY BLUES

⑤ LEFT OUT SUN + REFLECTION

D 25486.

Memorandum from *A Sunset Sky* by J.M.W. Turner. Time taken for such studies is well spent, and provides the practical painter/ researcher with a working record of how he or she *believes* (from close observation) an original masterpiece was created.

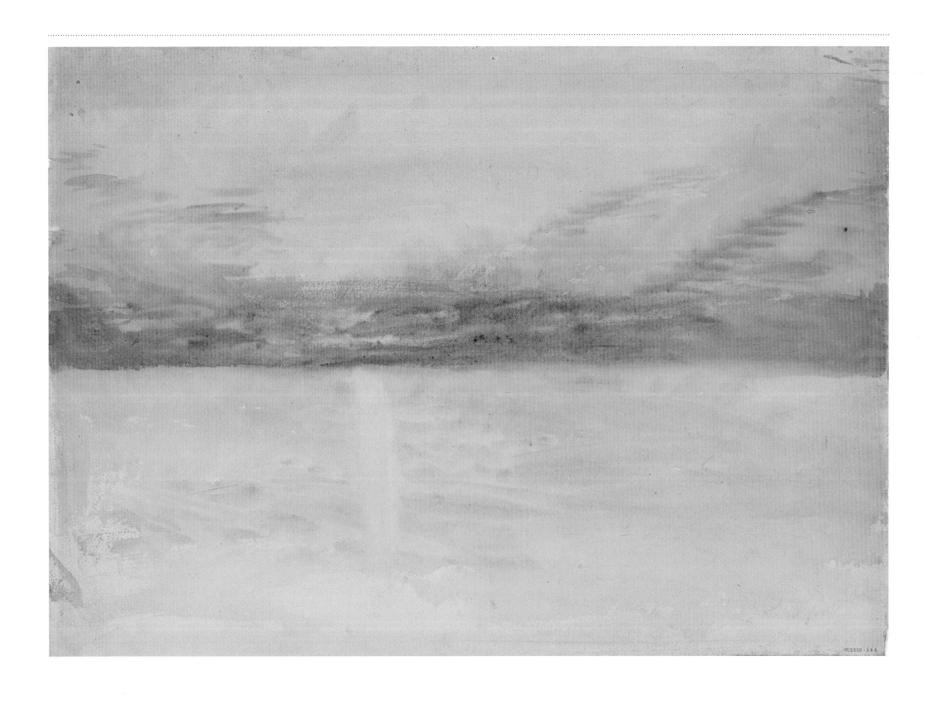

J.M.W. Turner, *A Sunset Sky* c.1825–30, Watercolour and gouache on paper, 34.5 x 48.6, Tate D25486.
Here, reproduced almost full-scale, Turner's own observation of a sunset is clearly revealed. Given the focus on grand 'finished' art in most reproductions of the great masters, it is worth noting how casual yet careful his work is here. This is Turner the observer, patient craftsman and student of nature at work, using a personal sketchbook and painting for his own reference.

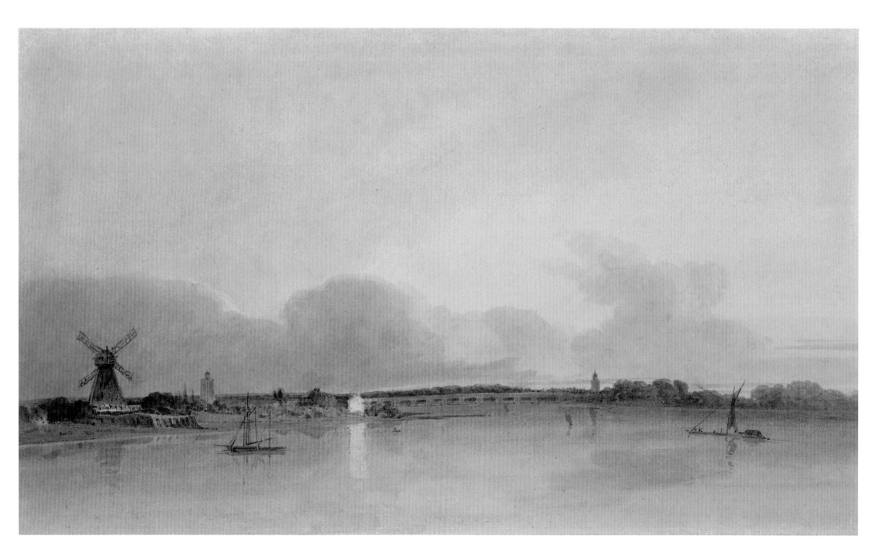

Thomas Girtin: the power of white

Thomas Girtin (1775–1802) was an exact contemporary and friendly rival of Turner. With his teenage companion, he spent evenings at Dr Monro's 'academy' studying, copying and thereby learning from masterworks (and in fact his style and talents at this time were very similar to Turner's). Unlike Turner, however, he did not study at the Royal Academy schools but took lessons from the topographical master Thomas Malton the Younger (1748–1804), and was additionally apprenticed to the watercolourist Edward Dayes (1763–1804). To begin with, Girtin made watercolours based upon drawings by other artists, but in 1794 he undertook the first of his annual summer tours around Britain, sketching and gathering material to use for original landscape compositions. This was a pattern of working which continued throughout his (short) life. As well as scenes of countryside he frequently painted cities such as London and Paris, and in 1802 he exhibited a huge panorama in oils, the 'Eidometropolis' of London. He supplemented his income from selling finished works by teaching drawing to the families of some of his patrons. His early death deprived British art of a significant artist of Turner's stature. Turner himself is reputed to have said later, 'If Tom Girtin had lived, I should have starved.'

Unusually for the period, we know from notes made by another artist exactly which fifteen pigments Girtin preferred and recommended. Nine of these had been used by his master, Dayes. Girtin's palette consisted of the earth pigments Roman (yellow) ochre, Vandyke brown, burnt sienna, light red, Indian red and Venetian red; yellow, transparent gamboge; yellow lake and a similar-looking material called 'brown pink' (confusing to the modern reader because 'pink' once meant yellow, not a diluted red as it does today); madder brown, which is a dull orange shade; madder, a fairly permanent red lake; indigo, Prussian blue and natural ultramarine for blues; and presumably a black such as lamp black. He bought his paper in large batches, often choosing Dutch cartridge paper which was a laid paper, generally off-white, with a coarse and readily visible texture.

It was just this type of paper that Girtin used for his most famous work, *The White House at Chelsea*, a beautiful English watercolour that demonstrates the stunning visual impact achievable by the use of reserved whites. Girtin 'reserved' the titular white house, leaving the detail virtually unpainted and preventing it from being touched by the build-up of wash elsewhere. The result is highly effective and the house seems to glow with its own light. Although it looks to be brilliant and pristine, in fact, the artist lightly coloured the house with yellow so that it is not entirely white. But from a distance it seems to shine out over the water, where an area has also been reserved unpainted to convey its reflection. Especially when viewed in the original the motif seems to focus the attention as powerfully as it dominates the picture's composition. This is the power of white. Yet this magical effect was not achieved by painting the house.

There are many different ways to replicate the effect of the 'white house'. The simplest way to reserve such whites has already been described in the introductory course and merely involves painting around the area, but another traditional method is that of 'stopping out', in which the artist treats the chosen area with a wash of gum Arabic so that the paint can't reach it.

When the painting has dried, the gum is washed off with a brushload of water. A modern rubber solution can also be used in the same way (this is called a 'resist' technique), with the rubber simply being peeled off at the end to reveal the paper beneath. Other more innovative contemporary methods might include laying down a piece of removable Magic® tape in the shape required and then peeling it off later. Even if the space has already been painted (and depending on paper choice and the staining qualities of the paint used) you might also re-wet within the shape and lift it out by blotting with tissue, or scrape the paint away within the building until the white surface has been redeemed.

The White House at Chelsea is a perfect synthesis of the right subject and technique with the right location and time of day. The lighthouse in the modern photograph here would make a wonderful example of this if it were photographed later in the day – and especially if the water were throwing its reflection as in the river scene on the right. Girtin's management of this effect was not accidental, but it was original in its profound simplicity. It has inspired generations of artists.

Like Girtin's *White House*, this estuary lighthouse glows almost as brightly during the day as it does at night. White gives it a visual authority which contrasts strongly with deeply shadowed rocks in the foreground.

In this photograph the power of 'white' itself is as much the subject as the buildings are. The effect is greatly enhanced by the glowing reflection on the surface of dark waters below (just like Girtin's subject). Turner made use of the reflected glow of the burning Houses of Parliament in a comparable way (see page 93).

Lightly sketch a very simplified building on a shoreline, complete with reflection.

Using grey, create an expressive sky painted right up to (and defining) the building and land.

Paint in the water using the same wash, but a little darker and leaving the reflection unpainted.

Using a mix of cobalt blue and yellow ochre, sweep in the land.

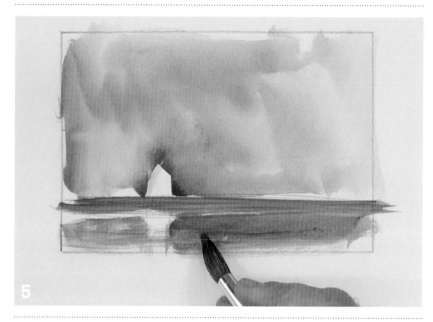

When this has dried, paint a very light touch of yellow ochre onto the face of the building and show this broken up and echoed in the reflection below. Then pass a damp, clean brush *horizontally* across the foreground water to soften and drag some darker wash out of *part* of the surface of the lake and over *part* of the surface of the reflection.

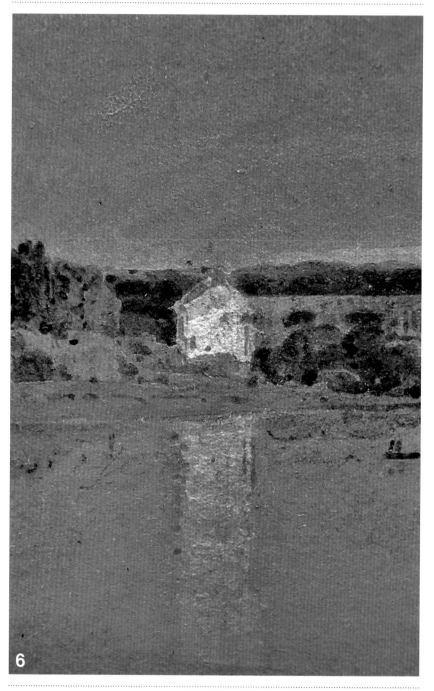

This detail of Girtin's *White House* has been enhanced digitally to exaggerate colour and highlight his process. It reveals the role that the surface of the paper plays in creating a vibrant reflection, as well as casting a spotlight on the added details within the 'white' wall, and the subtlety of washes over the reflection.

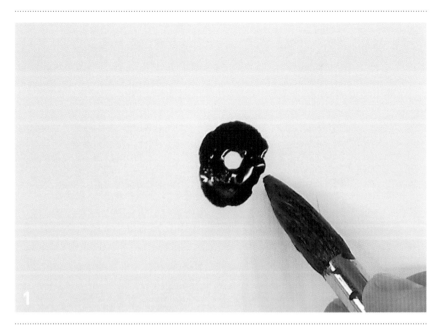

1

For this next exercise the subject is bright moonlight over a snowy landscape. Start by painting around the shape of a tiny moon. The easiest way to do this is to keep turning the board and working up to the edge with the tip of the brush.

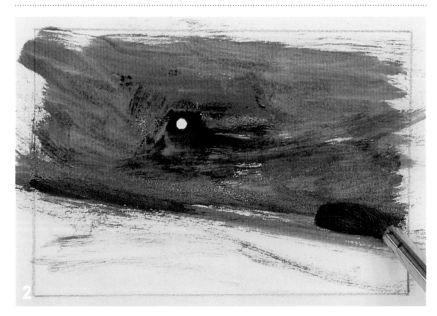

3

Rinse your brush and load it with a little blue tinged with the grey to suggest softer, broken shadows scattered across the snowy landscape. As a last touch, add a stronger, darker slope as a focal point.

2

Wash in the rest of a night sky, down to the upper edge of a snowy slope. Then use an almost completely dry brush to drag some of this wash down and across the foreground slope, to suggest tracks or uneven light on the surface of the snow.

4

Here, the moon over water was reserved by masking the surface with a removable sticker, then painting it over. (Remove the sticker when the paint is dry.) The reflection was simply painted around, and the light on the horizon was scraped away with a blade while the paint was wet.

Experiments with the power of white

Tony Smibert, *Castle-Moon* 2001, Watercolour on paper, 9.5 x 7.2. Here, the moon and moonlight over a dark lake were painted in white gouache as the last brushstrokes were added to the work.

Zen calligraphy attaches great meaning to brush-painted circles called *enso*, in which the white inside space makes a powerful statement entirely created by a black shape. The white centre speaks to the eye even across a room. This shows clearly that the lesson from *The White House at Chelsea* can be applied in non-traditional and figurative ways.

Tony Smibert, *Energy* 1999, Watercolour on paper, 36 x 51. Here again, a reserved white sings out. It was created by painting a blue band around each edge, then over-painting with black to cut straight across the reserved white. Before it was dry the left side was sprayed with water to partially wash away the paint on that side, allowing it to run down the page before being laid flat to dry.

Graham Sutherland, *Devastation, 1941: An East End Street* 1941,
Watercolour, crayon, gouache, ink and graphite on paper on
hardboard, 64.8 x 110.4, Tate N05736.
A twentieth-century example of white used with great impact.

John Constable: 'natural' sky paintings

John Constable (1776–1837) was born and raised in East Bergholt, a village in the county of Suffolk, and throughout his life his art was so deeply rooted in the local countryside that the area is known to this day as 'Constable country'. His father was a successful corn merchant and the owner of Flatford Mill – the subject of many later sketches and paintings. He had intended his son to take over the family business, and consequently Constable began his artistic training later than many, in his twenties. Like his close contemporary, Turner, he studied at the Royal Academy schools and also undertook sketching tours around central and northern England. He drew his inspiration from the agricultural landscape around the River Stour, an area of flat fields and open skies, and he repeatedly painted the same buildings and vistas, aiming to replicate the freshness and vitality observed in nature. He felt he could best achieve this in locations he knew and loved. Constable never achieved the same level of success as Turner, selling only a small handful of paintings in England during his lifetime. He moved his large family to Hampstead, London, for the sake of his wife's health, and there made an intensive study of the sky and cloud formations, as well as many pictures of Hampstead Heath. Constable was finally elected as a full Royal Academician at the rather mature age of fifty-three. His work was held in particular esteem in France, where it influenced Eugène Delacroix and the painters of the Barbizon school.

One of the most radical aspects of Constable's career was his insistence on observing and painting nature directly from the motif and consequently he was well organised for sketching outdoors in oil, as well as the more typical watercolour. He prepared paper for oil sketches with a range of coloured oil washes including warm and cool ones, cutting it to fit inside his sketching box for easy transport of the wet paint, then using the closed box on his knees as a working surface. His pigments were based on a limited selection of opaque and transparent primary colours, augmented with Mars earth colours, black and white. Less is known about his watercolour materials, but he could well have taken the same approach. His surviving painting boxes include bottles of dry pigment in many colours. He was not quite such an earlier adopter of new materials as Turner, though he used chrome yellow a couple of years after its invention, and he habitually mixed his greens from blue and yellow, and his greyish purples from red, blue and black. Like Turner, he tore down sheets of paper into quarters and eighths, but unlike his fellow landscapist, Constable's ideas often outgrew his format. When working on canvas, he often resorted to straightening out the turnover edges tacked around the stretcher, and then painting right up to the edge. As he evolved each large oil painting from first a small oil sketch or a group of oil sketches, then a full-sized oil sketch, he juggled and improved the composition, and altered the 'crop', to borrow a term from contemporary digital imaging. Sometimes if he ran out of paper for cloud studies he used millboard (a thin paper-based solid support) for sketches.

No other artist from the golden age of British watercolour better represents the aspiration to use the medium to further their observations of natural

John Constable, *Between Folkestone and Sandgate* 1833, Watercolour and graphite on paper, 11.6 x 18.2, Tate T08750.

To many artists, the sky is a primary source of drama in landscape. This break in a stormy sky reveals an enormous range of tonal values from light to dark, through which a pure blue can be glimpsed.

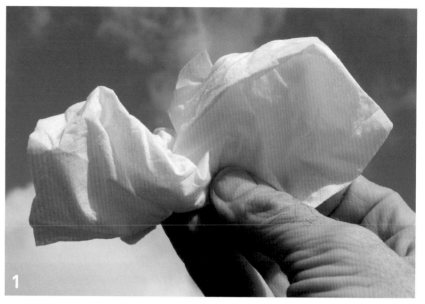

Here's a way to study the play of light, reputed to have been used by Constable. Scrunch up a tissue or thin handkerchief and hold it to sunlight, noting how the light shines brilliantly on the upper surface, filters through in varying degrees and results in shadows on the underside.

The effect of light and shadow within the clouds above will always affect the landscape below.

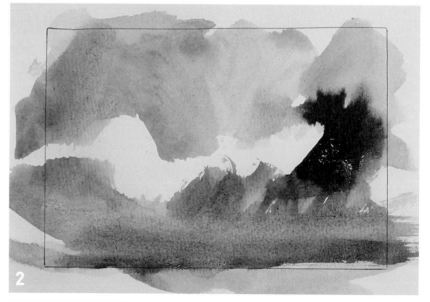

Watercolour remains an almost perfect medium for sketching the rapidly changing nature of clouds. Here, cloud shapes are delineated by shadow tones, blue sky and *reserved white*.

phenomena. Constable's cloud studies in particular seem to be a direct response by his hand and brush to what his eye was seeing. They can truly be described as 'natural', due to the lack of complex finish and the absence of complicated processes used for the painting. The artist aspired to portray nature as it actually is, and he filled his sketchbooks and studio with countless studies in watercolour and oil. Constable's directness somehow speaks to our own real impressions of nature in a way that a beautifully designed and idealised sky might not, and so his work is often hailed as a precursor to following generations of painters in watercolour and oils who also desired to paint the real world in terms that would do it justice.

Constable once noted that the sky is the 'chief organ of sentiment' in a painting, and indeed this is a very important observation. Obviously the sky above us provides the light that plays across the surface of the earth, and where there are clouds, they screen, soften and diffuse that light. In the case of a watercolour, the impression of light in a painted skyscape comes from the paper itself, reflecting light *back through the layers of transparent watercolour* laid down by the artist. In a similar fashion to a real sky, the light seems to come through and from *behind* the painted clouds. Perhaps this is why sketches of clouds in watercolour can sometimes seem so true to nature. Constable was a master of this, and any watercolourist with a desire to paint light will learn a great deal from his cloud studies. Although Constable might not have been comfortable with the idea of a fixed technique for watercolour, we can nonetheless point to certain methods that do recur in his works.

Study the sky and start to learn its moods. Many dramatic cloud effects occur when they are deeply shadowed, so that light is only seen on the upper levels of cloud. What you observe (and may want to record in sketches) will also depend on which way you are looking: for example, directly up at a break in the clouds above your head or towards the horizon. Note how the light falls on top of the clouds in the photographs on the opposite page, while underneath is shadowed. Also note how cloud cover casts strong shadows on the land below. These are the sorts of things you can expect to see acutely observed and represented in studies by Constable himself.

Direct brushwork

Most of the brushwork in the methods that follow involves the side of the brush (see earlier exercises on brushwork).

Blue sky first, shadows second

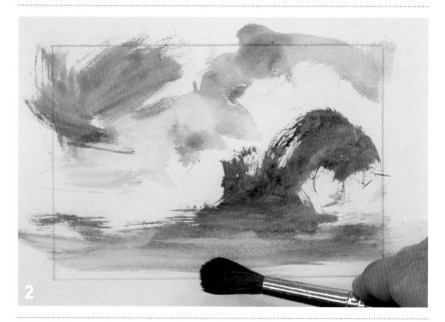

Start by sketching in the blue sky so that the white shapes of clouds are created in reserved white.

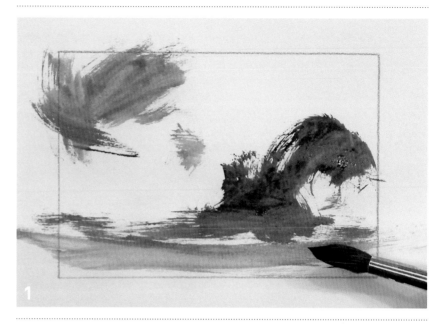

Sketch in the shadow areas on the underside of the cloud, the side (for example, on the left of the cloud if the light is from the right) and cast by the cloud (on the land or other clouds below).

Keep it simple and direct. There is time enough for complex studies later, once you learn the general system.

Grey shadows first, blue sky second

Try to see the shadowed areas as abstract shapes and form them with the side of the brush.

Rinse and reload your brush with blue before forming the blue shapes around the clouds.

A more subtle and complex sky

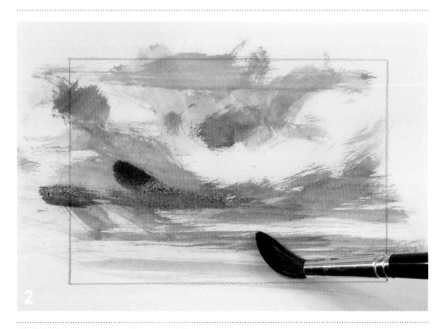

1

This time the initial grey and blue washes are more subtle, so that tonal values can be built up stage by stage (from light to dark).

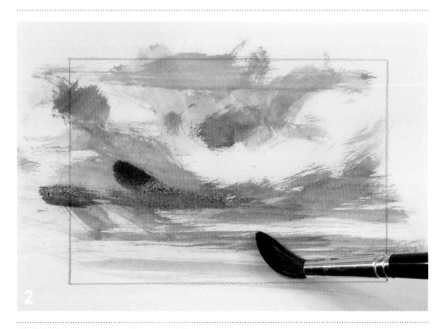

2

The finishing touches come when you add the darkest shadows.

Working over with water

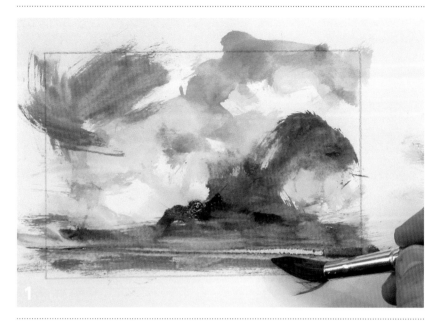

1

Any previous method can be taken further by simply wetting your brush with water and working back over the finished study after it has dried (or while still damp), softening and blending edges.

2

This will enable you to carry subtle tones from one area to another (for example, very pale greys over the top of crisp whites) and gives you further options to continue adding tone or even a glaze of warm wash over the entire sky to emulate the glow of sunset.

Studies and sketches

Studies and sketches from nature lie at the heart of Constable's art. The processes shown here, and those you discover by examining his originals, are simply the beginning. In order to truly emulate him you will have to go outside. The key to his approach was a commitment to close observation of the real world, resulting in works which were a direct response to that observation. Many, indeed *most*, of his sky studies actually began with a very light, preliminary pencil sketch, perhaps to freeze the shapes as he saw them, followed by the painting strategies you have just learned.

We advise that you try this approach too – although *not if it makes you fuss about the exact shapes* at the expense of letting your clouds take form naturally – so that you can almost *feel* the clouds on the page.

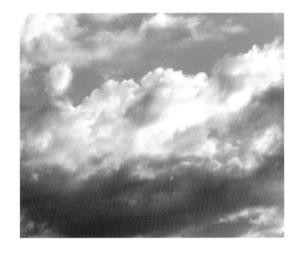

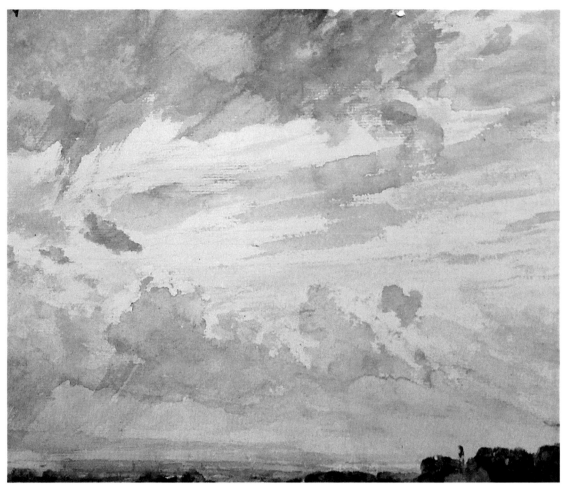

Left: Photograph of clouds above a wide landscape in Tasmania.
Right: John Constable, *Study of Clouds Above a Wide Landscape*
1830, Watercolour and graphite on paper, 18.9 x 22.7, Victoria and Albert Museum, London.

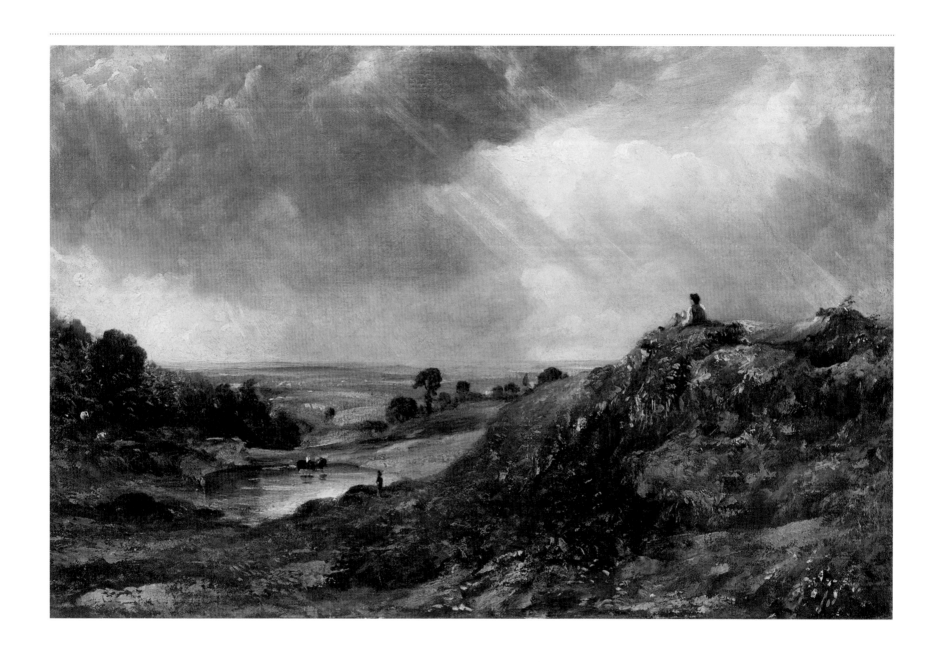

John Constable, *Branch Hill Pond, Hampstead Heath, with a Boy Sitting on a Bank* c.1825, Oil paint on canvas, 33.3 x 50.2, Tate N01813.

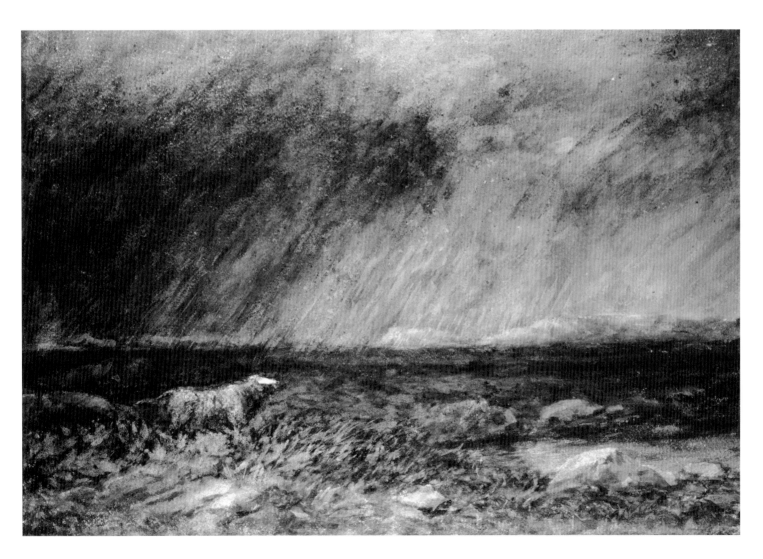

David Cox: painting the elements

David Cox (1783–1859) was born in Deritend, Birmingham, the son of a blacksmith. Aged fifteen he was apprenticed to a miniature painter and he later worked as a theatrical scene-painter, which gave him experience of working rapidly on a large scale and creating broad effects which could be appreciated from a distance. He studied with John Varley (1778–1842) and eventually became one of the most celebrated practitioners of the day. He regularly exhibited and sold pictures at the Royal Academy but, never making much money, he supplemented his income by teaching drawing. He also went on to produce several instruction manuals for amateur artists, with well-illustrated landscape subjects described in prescriptive stages, including instructions on the precise colours to be mixed for each area. These went through many editions, and one is a classic manual even today, since it has been regularly reprinted in the twentieth century (see the list for further reading).

In his watercolour manuals, Cox recommended using rather traditional colours: blue indigo and Indian red or light red ochre to make a grey for skies, yellow ochre, gamboge for a transparent yellow, burnt sienna, Vandyke brown, red lake, yellow lake called 'brown pink' (which Girtin used too), and black. He mixed blue and brown to make a dull green, and red and yellow to make orange, and recommended touches or glazes (thin, transparent washes) of brown pink or Vandyke brown to make colours locally warmer. All of these colours are transparent, even when applied as a strong wash. He often used a coarsely textured off-white paper. Some of his papers had coarse brown fibres visibly incorporated within them. Cox would work these into the composition, or anchor tiny details by or on top of them, if they stood out too much as the composition developed.

Cox often painted scenes featuring strong winds and rain. In this dramatic painting, *The Challenge*, he seems to break all the formal guidelines of his era, yet still demonstrates his own mastery and the full potential of watercolour as an expressive art form. Perhaps no picture better demonstrates how the medium can be used to portray the elemental forces of nature. As demonstrated earlier 'in the jar', watercolour is only, after all, coloured sediment settling in water. If you stir these sediments together the outcome is a muddy *absence* of colour. Worked with at its thickest the result is something like painting with mud, and it is the antithesis of the beautiful colouring that we might have expected from Cox. Yet, as demonstrated here, it is precisely when painting with 'mud' that the medium may most surprise us with its expressive potential.

Just as in the 'natural painting' of Constable, we can easily identify Cox's creative processes as he stages the drama of a shaggy bull facing up in defiance to an oncoming storm. The rough play of light is fully captured in a sky worked hard by the artist with energetic diagonal brushstrokes, while the soggy ground has been scratched and worked, mostly while still damp, in a seeming frenzy of marks made with a knife-edge, stick or fingernail. An observer who witnessed Turner at work described the 'chaos', with the artist pouring, scratching and scrubbing at the paper in a frenzy, so it is easy to imagine the sort of energy with which Cox must also have attacked *The Challenge*.

David Cox, *The Challenge: A Bull in a Storm on a Moor* 1853, Watercolour and gouache on paper, 45.5 x 66.6, Victoria and Albert Museum, London.

Perhaps the physicality of this approach is best described as something that goes beyond mere technique. *The Challenge* seems to reflect complete abandonment of the traditional, careful processes of watercolour. Yet it is imbued with the spirit of watercolour as a creative medium. While Cox was widely regarded for his portrayal of the drama of weather, we also find embodied in *The Challenge* his raw *experience* of nature. He is often quoted as observing that, if no excitement is felt *while* painting, there should be no surprise if it is missing from the finished work. This may well explain the fascination that artists and lovers of watercolour continue to have for this particular painting. Passion and enthusiasm will always play a part in the creation of great works. Cox reminds us to challenge our own preconceptions about watercolour, even when painting traditional landscape. Great paintings don't have to be pretty or cleverly done. Sometimes they simply have to be felt.

Rapid study of an elemental storm

Let the sense of the wind blowing guide your brush ... Go with the forces unleashed ... Scrape back wet paint ... Smear and wipe to create effect. Paper: sketchbook, cartridge or watercolour paper. Colours: raw umber and grey (the grey you mixed earlier from cobalt blue and light red will be fine).

Rapid storm study

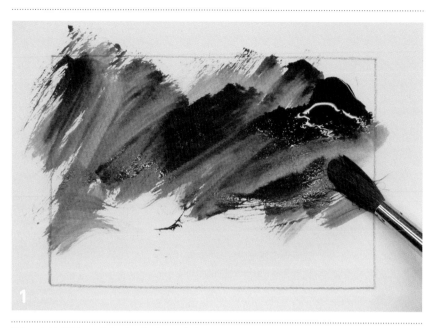

Using a fairly thick grey (mixed earlier from cobalt blue and light red), build the sky with rapidly executed sweeps, allowing it to sit heavily in areas to build the drama of gathering windswept clouds.

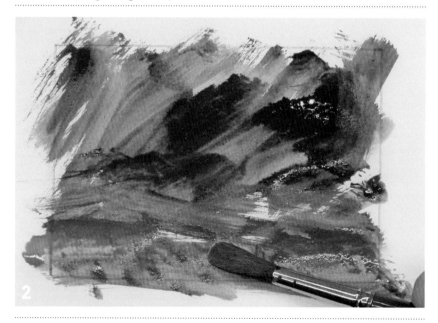

Load your brush with raw umber and establish the land below, allowing it to mingle with the sky and charging it here and there with darker values.

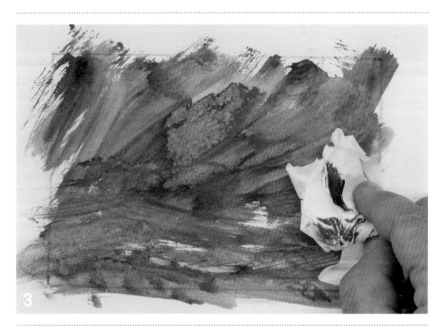

As the sky dries, choose to leave the darker values or alternatively, as they are probably the wettest areas and consequently the last to dry (as in this example), wipe them away to create interest in the sky. You can also start working at the rough ground below, scraping with a knife edge.

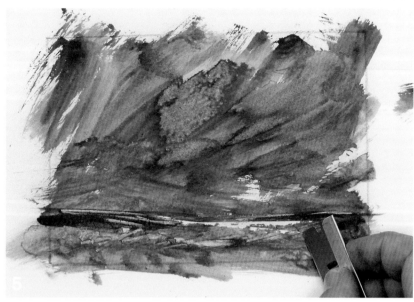

Finally, use a sharp blade to scrape away a distant lake catching the light from the sky (notice that in this case it takes advantage of the reserved white 'light' already in the sky). You have now created a small, though dramatic setting for a bull, a tree, birds in flight, a cottage or whatever.

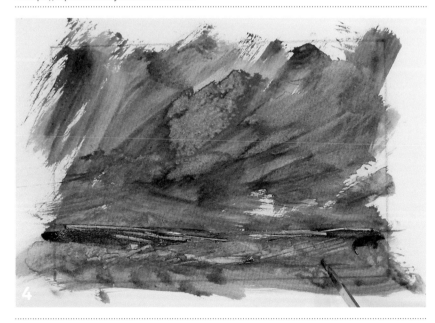

The far horizon has been darkened here and there while the scraping continues, suggesting distance and fields.

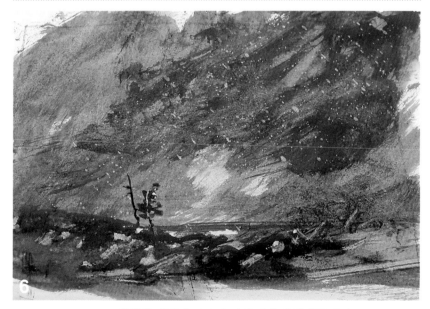

Such studies are little more than 'thumbnail-studies', and take little time. Here is a variation, but with a pair of trees suggested, as if challenging the incoming storm clouds.

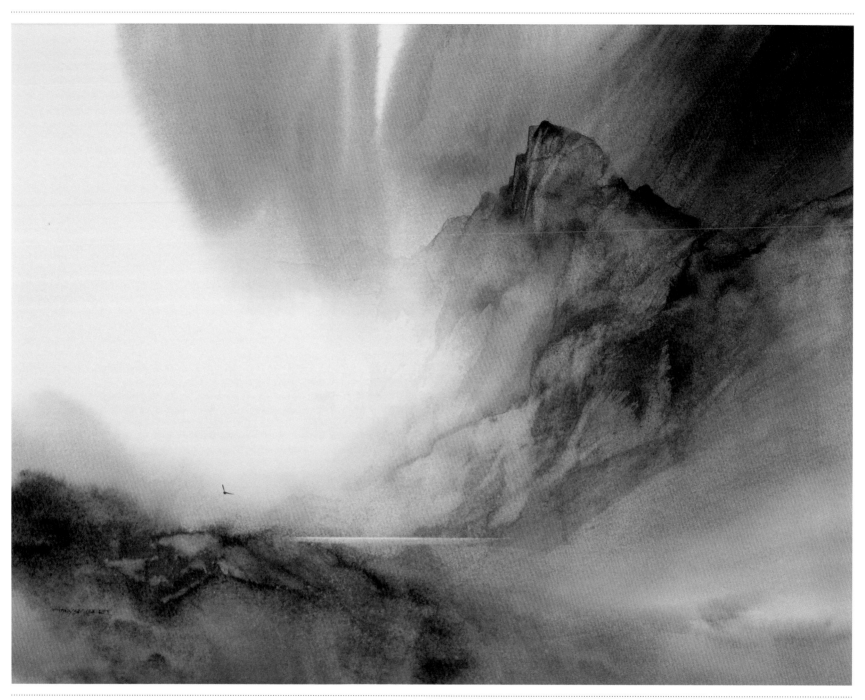

Tony Smibert, *Riding the Wind* 2008, Watercolour on paper, 38 x 29. This finished watercolour also references Cox, but in a much more atmospheric way. The overall drama was established with a wet-in-wet sky and charging of raw and burnt umber into the foreground, some wiped away while still wet to create the suggestion of rocks and broken ground. The most important element is the balance of shadowed sky and reserved white haze. The towering bluff was added later, after drying, with areas removed by wetting with clean water and then wiping out. Finally, a single bird was added in reference to Cox's bull – though more as a symbol of 'harmony' than 'challenge'.

Tony Smibert, *Sanctuary* 2013, Watercolour on paper, 38 x 20. The same approach can be used to work wet-in-wet or in colour. Here in a larger study, in the spirit of Cox's *The Challenge*, the same speed, processes and composition have been applied, but executed entirely with a very coarse and long-bristled glue brush. Painted onto very soft etching paper, the same processes can be used to provide the basis for exploring not only the drama of the elements, but also the possibilities for a little detailed work to enhance the drama (for example the bird at lower left which brings life to the sky near the tree).

John Ruskin, *Study of a Spray of Dead Oak Leaves* c.1879,
Watercolour anbd bodycolour on paper, 14.4 x 18.18, Collection
of the Guild of St George, Museums Sheffield.

John Ruskin: on learning to see

John Ruskin (1819–1900) had the good fortune to be born into a middle-class, art-loving and supportive household, which furnished him with independent means and an excellent background for his chosen career as critic, art expert and artist. He travelled widely with his family, particularly in Switzerland and Italy, which he would revisit many times during his lifetime. Ruskin was never a teacher of practical art, but his extensive writings, particularly his five-volume *magnum opus* titled *Modern Painters* (published 1843–60), were hugely influential on the appreciation of art and its history during the second half of the nineteenth century and beyond. Most importantly, he championed Turner at a time when many critics were deriding his paintings for their lack of finish. Ruskin argued that Turner's genius lay in his close observation and corresponding creative interpretation of the natural world, an approach which Ruskin described as 'truth to nature'. Ruskin spent his mature and final years at Brantwood, his home in the dramatically beautiful landscape of the Lake District in north-west England. Always interested in social improvement, he devoted much time and energy to the creation of educational and employment opportunities for the 'labouring classes', not necessarily to train artists, but as a way to help people to see with moral clarity. He wrote, 'The greatest thing a human soul ever does in this world is to see something, and tell what it saw in a plain way. Hundreds of people can talk for one who can think, but thousands can think for one who can see. To see clearly is poetry, prophecy, and religion – all in one.'

Ruskin had a profound influence on the next generation of watercolourists, particularly through his belief in the importance of close observation which helped to elevate watercolour as an art form. He said that if any two people were to pass down a country lane together and only one of them was an experienced sketcher, the sketcher would see and remember much more of the glories of nature there than would the companion. (Anyone who sketches or paints from nature will not be too surprised by this, for those who attend art classes often comment on the fact that they see 'so much more on the way home' as a result of heightened sensibility.) He was himself a highly skilled painter, making exquisite, highly detailed sketches of flora and fauna, rocks, landscapes and architectural subjects. He once observed that almost any rock picked up from the path at our feet might be found to represent a mountain in miniature. This reveals the harmony that underlies the natural world and, like a blot by Cozens, the rock can also be a starting point for creativity. Based on *clarity of seeing*, looking hard at the rock leads to *seeing creatively*. This is a very practical way to find mountains to paint, even in the city.

Ruskin followed Turner's example, and used a very wide range of coloured pigments in watercolour, including the opaque greens and reds Turner had been criticised for using two or more decades earlier. His many studies of plants and flowers render them in all their natural colours and often in full sunlight, which suggests he adopted newly invented colours readily, just like Turner. His works have not been scientifically analysed to verify this, however.

Ruskin's work contains a number of techniques that will increase your skills as a watercolourist.

Ruskin exercises

These might include: a study of the way different shadows are cast as light plays over mountains; an imagined landscape whereby the rock provides not only distant mountains but also the foreground below; a study in pencil and wash from various angles; or a detailed leaf study such as Ruskin himself might have created.

Even in reproduction this Ruskin study from nature clearly reveals his painting technique. He began with a detailed drawing based upon very careful observation, cross-referencing back and forth from the subject to the image. This was a process which would take some time. The next step was to wash in the mid-tones, then probably the darker shadow tones, before lifting out the lighter areas and adding the finer details. This is a classic approach, which he enhanced by heightening with opaque white pigment added to his paint – usually referred to as *gouache* or *body-colour* today – for the final play of light.

Remember, this manual aims at readily achievable exercises, rather than the sort of near-perfection that Ruskin aspired to in his own work. We won't proceed to the body-colour stage either. Learn the basic method *then* move on to detailed studies later. Try to complete the first study in 20–30 minutes. Allow five minutes for the drawing. We can only guess how long Ruskin himself may have taken with his own leaf study – possibly hours for it is most beautifully rendered – so perhaps his approach may lead you towards making far more careful and detailed studies of your own.

If you want to learn more, repeat the same technique with other found objects from nature – with perhaps some really detailed studies – or keep researching Ruskin's methods by examining some of his other works.

A small stone picked up from almost anywhere (this one came from a path near Brantwood) does indeed look like a vast mountain in miniature, providing the basis for creative landscape sketches, and with more stones, a mountainous landscape.

Leaf study

First you will need a dried leaf to draw. Don't worry about getting it exactly right; that's a challenge for another day. Simply block the shapes in to establish the main forms (i.e. those which cast the shadows).

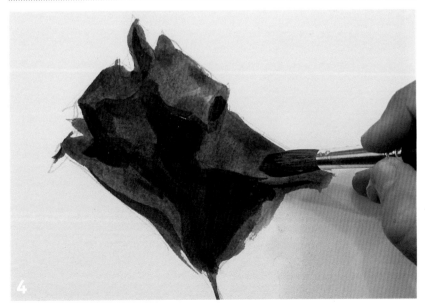

Ruskin wrote at length about the challenging difficulties of leaf studies so don't be surprised if your drawing only roughly resembles the motif (after all, no one will be comparing your efforts to the actual leaf).

Now wash over the entire leaf with a medium toning of colour. This demonstration was painted entirely in tonal values of burnt umber. It won't require a perfectly flat wash – gradation may even be better – just keep the wash moving.

When the first wash has dried, paint in the shadowed areas using a darker toning of the same colour.

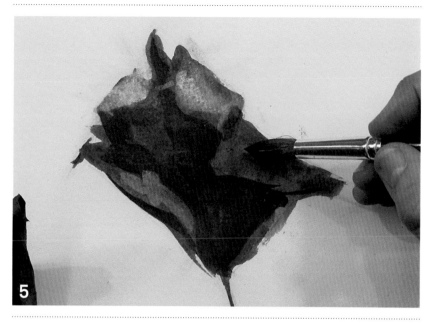

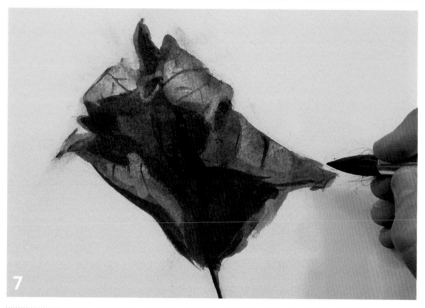

When the second wash has dried *completely*, sweep clean water over the areas where light is striking the leaf. This will soften and start to remove the paint, creating highlights.

After the previous stage is dry, use the tip of your brush to add a few crisp details. This leaves you free to finish, as we have, or go on as Ruskin did with body-colouring – by mixing a little Chinese white and adding a very small amount of the original burnt umber.

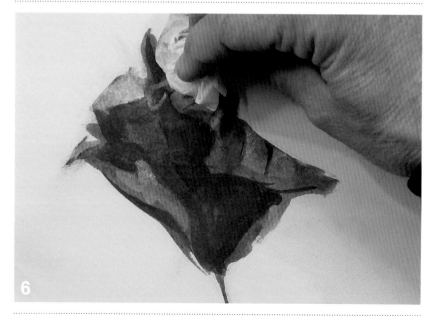

While these areas are still damp, take a clean, dry tissue or rag and wipe the softened paint away. Take care to roll the tissue as you do this so as to pick up rather than smear the paint.

Whether to use body-colour is now your choice. Crisply applied and with Ruskin's lively brushwork following and almost *sculpting* the form, it is a profoundly effective device in his hands which, being opaque, seems to sit on the *surface* of the leaf. (The next section is devoted to body-colour.)

Painting onto coloured paper: watercolour heightened with gouache

Many artists painted onto coloured paper from time to time. One commonly used method was to work with opaque colour (gouache or body-colour) and finish by heightening with completely opaque white paint (rather than reserving areas of white or scraping back to white, as could be done when working on white paper).

Turner often used blue paper to establish a basic mid-tone for sky or water. The Turner-esque study discussed next was painted onto 'Turner Blue' paper (a historically accurate reconstruction of a gelatine-sized cotton/linen paper with blue fibres among the white), commissioned by Tate Enterprises. Although the only true opaque colour suggested for the exercise is Chinese white (zinc white), you will find that yellow ochre, cobalt blue and light red (within the mixed grey) all appear somewhat opaque against the blue paper, and will seem to sit on its surface.

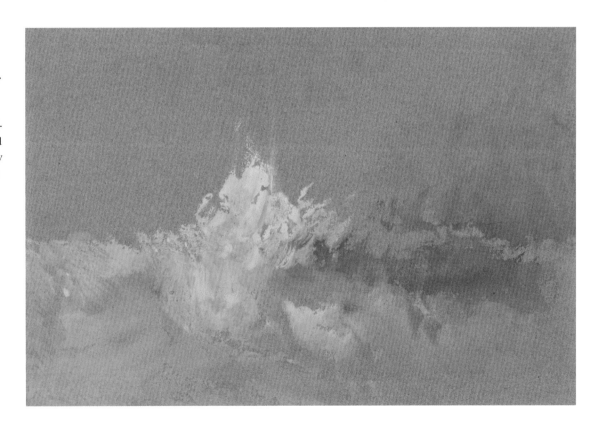

J.M.W. Turner, *The Breaking Wave* c.1832, Watercolour and gouache on paper, 19.2 x 27.9, Tate D36285.

Start by thoroughly brushing both sides of blue watercolour paper with a large brush full of water. Smooth it out on a tabletop or board. A sheet of glass or hard plastic would also do.

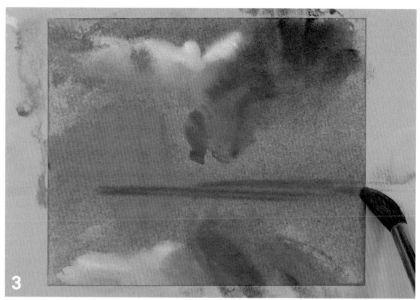

Strengthen the composition by bringing in some darker clouds tapering away towards the horizon and also reflected in the lake. This will help to establish a sense of recession.

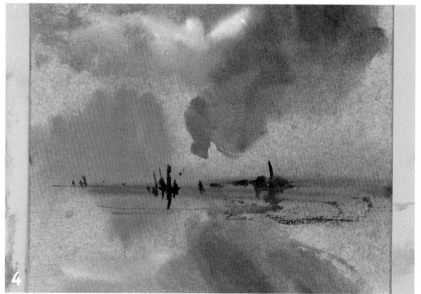

While the paper is still wet, use yellow ochre to establish the general shape of a distant headland, with its reflection in a lake below. Repeat this with a toning of deeper-blue sky above and then some clouds in Chinese white. Suggest the reflection of these in the lake at the bottom of the picture.

After the painting has dried a little (notice the edges starting to lift away from the board here – typical behaviour for gelatine-sized paper), suggest a few boats, their reflections and ripples on the surface.

There are countless ways to work on coloured paper. This first experiment may give you a starting point for further exploration. Following up on your own ideas and discovering ways to build onto the classical techniques shown here would be in line with the traditional way of developing skills and creativity.

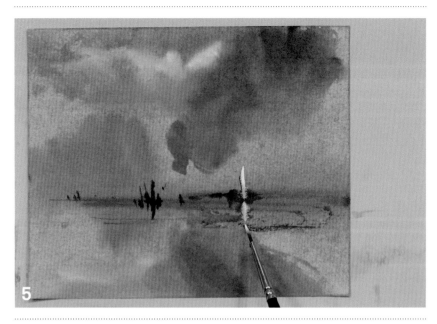

Remembering the power of white in Girtin's *White House at Chelsea*, use Chinese white and a very fine brush to suggest a single vertical sail as a bright accent, with its reflection below.

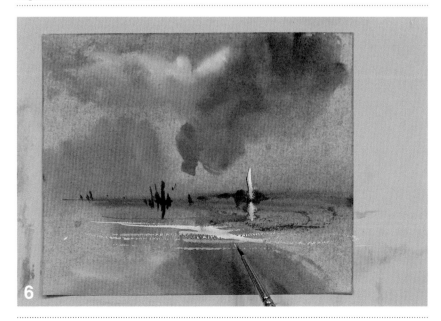

Finally, suggest a few bright reflections here and there on the surface of the water.

Ways to work from originals

There is a big difference between *copying* a masterwork and working *from* it, just as an artwork *inspired* by an original is also very different from one *influenced* by it. Artists have been affected by other artists' work throughout history, so that there is no need to feel hesitant about copying, learning and acquiring whatever experience and ideas you can from any source.

While still a very important drill, copying can only take you some of the way. The learning experience will require a deeper engagement than the eye-to-hand co-ordination of mere imitation. Try to glimpse and analyse the original artist's *way of thinking*: how they expressed their interests, creativity and emotions through their medium and, because high-level watercolour also requires high-level mind/body co-ordination, you probably can see this reflected in his or her method of working.

There are lots of ways to proceed, but once again, the key is to ensure that whatever you do is part of your own learning process; towards inspiration, acquiring of technique or simply understanding more about the artist *as an artist*. You will then gain an insight that can never come from merely looking at their work. Also try not to worry if your sketches or studies seem amateurish in the face of the original that has inspired you. That's why it's called a masterwork. This process is not about impressing others with how good your copies are.

Access to originals and reproductions

Public galleries are full of original artworks from which you can work directly. Tate, for example, has a vast collection of works on paper (over 50,000, more than half by Turner), including outstanding examples of most of the artists in this book. Appointments can usually be made to view works not currently on display, in an institution's *study room* or *Prints and Drawings department*. Additionally most public collections now offer online images and some have detailed online catalogues (Tate's catalogue of all Turner's works on paper is now available online though incomplete, with more works regularly added to it) as well as information as to what is currently on display. So the best way to access specific artworks is likely to be to contact the gallery directly. Ask if it is possible to view works on paper privately in a Print Room and whether it is permissible to make pencil studies, take photographic images, or even to work with watercolour paints (which can be done at Tate).

If you do not live close to an art gallery, or find that the nearest does not have examples of the artist you are interested in, reproductions still provide a wonderful resource. Art books are a ready reference and provide a practical way to work at home. However, it is always preferable to link your studies to in-person examination of originals. This will help you to overcome one of the major drawbacks of working solely from reproductions: they may look similar but the colour and scale is usually different and you can't read the surface layers of paint to deduce the processes (which layer of wash was laid first) in the way that you can when examining an original. On the other hand, galleries often produce large-format high-quality prints of their works on demand, or have in their shops large exhibition posters of much smaller original watercolours. This can be a great way to study details up close. Pilot projects to make high-resolution research images of paintings already exist online, but have not yet been extended to watercolours.

Pencil studies

A pencil and sketchbook make perfect companions for a gallery visit. Should you find yourself without, you'll usually find them on sale in the gallery shop. Indeed, Tate wants you to sketch (although some galleries may not). Sketches can be tiny or much larger. They are a record of your observations and a means of noting your ideas. They can also remind you of the things that most interested you and can be a way of undertaking visual analysis of the work you are looking at. You can simplify or render details, alter the composition, try out experiments and work with line, tone or colour – all in pencil and very conveniently within the gallery space. Today, most people carry a camera or smartphone and many want to take images in galleries (if allowed), but in the past making a sketch was practised by many people as the best way to inform their visual memory.

Colour studies

Not all public galleries permit the use of liquid paint or coloured marker pens near their collections. But as already noted, you can work in coloured pencil and this means colour *watercolour* pencil too, to be washed over later with water. Another alternative may be to bring a small receptacle brush (with a chamber of water like a fountain pen), which might be permitted. As with flash photography, permission for this should be sought first.

Probably the best approach is to take a leaf out of Turner's book and make pencil sketches on location, then follow up with watercolour studies later at home or in the studio (and with the assistance of reproductions).

Brush studies

Since most watercolours are created with a brush, brush studies remain one of the most important ways to work from originals. Given all of the above, when working from an original or its reproduction, a brush study will give you the chance to mimic the physical processes, to work expressively, to create your own dynamism and to learn a lot along the way. As demonstrated in previous chapters, brushes are much more than mere receptacles for conveying paint to paper. They are unique entities each equipped with a thousand different ways to carry, deposit and manipulate the surface of watercolour. It is not hard to imagine that Alexander Cozens, for example, might have recommended working with blots in order to render a broad compositional possibility in tone and mark, while Constable might have suggested a direct study, allowing your hand to sublimate its movements to the observations of your eye. Turner's advice might have been to try a free and broad experiment with colour to see what comes of it, and so on. The great masters are always there as a reference, ensuring no shortage of approaches.

Make use of the composition

As was illustrated with Claude, there are many examples of compositions repeated by artists through generations. In *A History of Art*, H.W. Janson showed how the composition of Manet's *Le déjeuner sur l'herbe* of 1863 (Musée d'Orsay, Paris) can be sourced back through a succession of painters including Albrecht Dürer and Andrea Mantegna to a Roman frieze of the third century CE. He also showed a photograph of Picasso making his own sketches after Manet in 1954. Plagiarism is not an issue here: learning is the object.

If you love the way a landscape composition works, then perhaps one way to reuse it might be through tonal value studies – as blots, perhaps – but used as the basis for a very different scene. For example, a close study of Turner's colour beginnings linked to Alexander Cozens' creative blots might help you to devise your own approach.

Rhythm studies

Among the many attributes of watercolour is the opportunity it offers to establish large areas of colour in wash while also rendering tiny details. Because of the nature of the medium, a painter wanting to use both broad and detailed effects on the same sheet of paper has to choose a way of working that will ensure that one process does not cancel out the other. Turner is an outstanding example of this, commonly beginning with broad under-washes over much of the sheet and then finishing with fine details. While laying down the colour harmony in those first washes he also established the dynamic rhythm that would govern the work. This is nowhere more obvious than in the studies of waves and of weather effects over the ocean. Looking for the underlying rhythm makes a great exercise: brief studies can be sketched in pencil from the originals or might be dashed down in watercolour from reproductions at home. Remember, just as there are broad rhythms in the under-wash, there will be rhythms amidst minute details. The speed and direction of a brush directly reflects 'the dance' of the artist's hand.

In the footsteps of the master

Perhaps the most profound way to learn the methods of a past master is to apprentice yourself to his/her way of working. This may mean going to the places s/he worked and comparing their views to the place that inspired them. Although you won't have their originals with you, you will be able to take reproductions and may well discover the exact spot on which s/he worked. In making your own sketches, you will be addressing the same issues and may find it invaluable to be able to see how s/he dealt with them in the first instance. On a certain level this affords you access to their way of thinking (see section on *en plein air*) and you may even feel that you come to 'understand' how they developed an idea. You can then go back to their originals, make your colour studies and even work through to finished art as the original artist did.

Working from a masterpiece is something you can do in isolation, a single picture at a time. Or it can be part of a whole programme of study and practice-led research that leads towards a deeper understanding of, not only technical processes, but also when, how and *why* these were applied. In the contemporary jargon of lateral thinking, looking for a master's 'software' and using it in your own brain is simply a way to apply the close focus expected of the traditional apprentice in a master–pupil relationship.

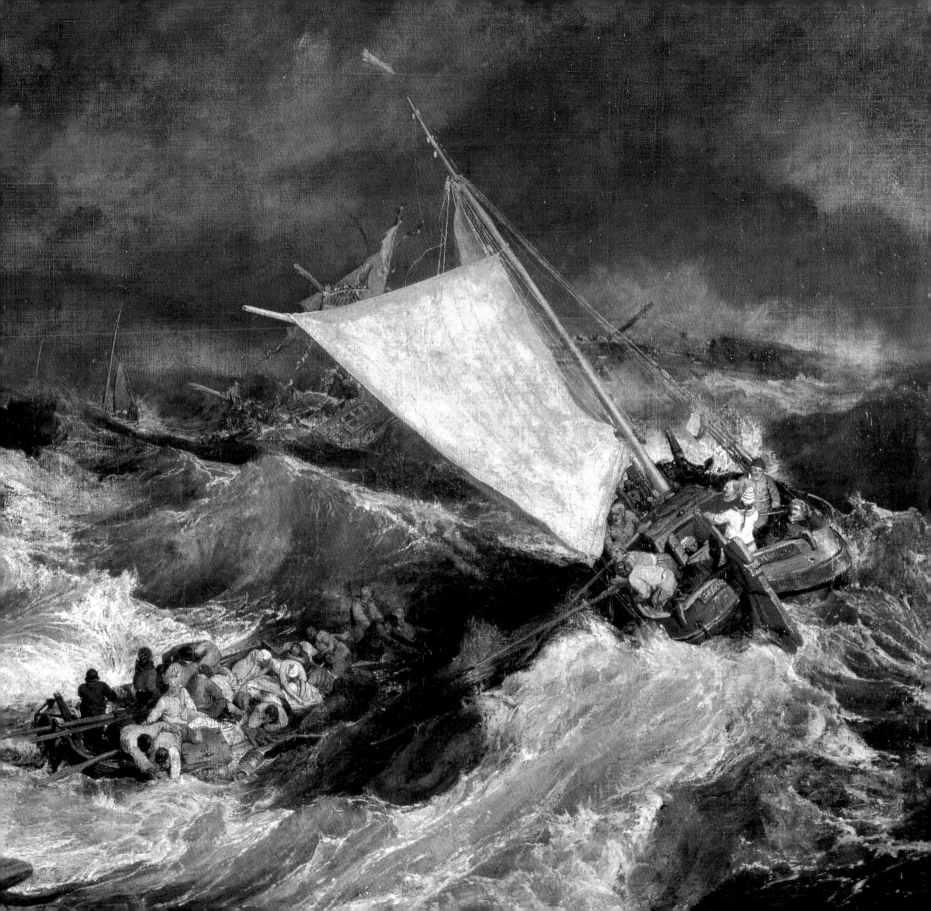

Taking inspiration from an oil painting: rapid studies in pencil and watercolour

This very large oil painting on canvas by Turner is a complex masterpiece, but it is also a good example of his capacity for dramatic portrayal of the ocean and man's relationship with the elemental forces of nature. He studied the sea throughout his life and knew it well. Here he conveys the great swell of the waves and the aesthetic integration of sea and sky.

The page opposite shows a detail of the whole canvas, which is 170 cm high and 242 cm wide. It is possible to look at a 'crop' from virtually any portion of a Turner oil or watercolour, and discover a marvellous balance of light versus dark, and cool versus warm colours, the whole composition made more dramatic by a small, strategically placed area of the very opposite colour.

Making studies based upon an oil painting enables you virtually to participate in the masterworks you admire. Far removed from merely 'copying', this is an invaluable way to come to a deeper understanding of the potential of watercolour as a highly responsive and expressive medium. This is a vital key to success when you start your own work with rapid pencil sketches while actually standing in front of an original masterpiece such as *The Shipwreck* or, if working at home, from a reproduction or print.

J.M.W. Turner, *The Shipwreck* (detail) exh. 1805, Oil paint on canvas, 170.5 x 241.6, Tate N00476.

Rapid pencil sketch

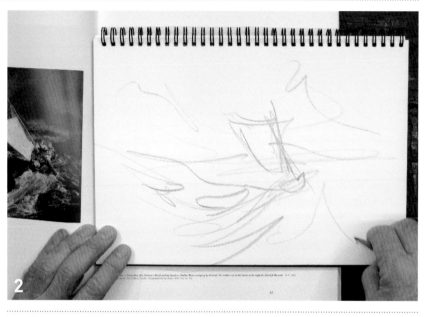

J.M.W. Turner, *The Shipwreck* exh. 1805,
Tate N00476.

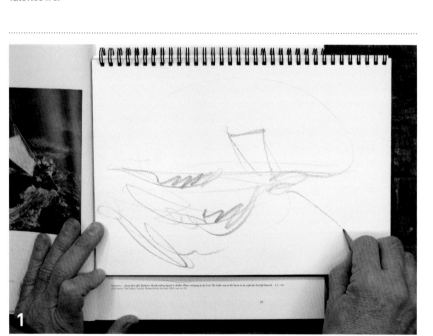

2

Speed is key here. Move as fast as the waves you are portraying might rise and sink, and as if your pencil is skimming across the ocean's surface. When you dash down the boat, let it be part of the scene. Don't try to get it 'right' by fussing.

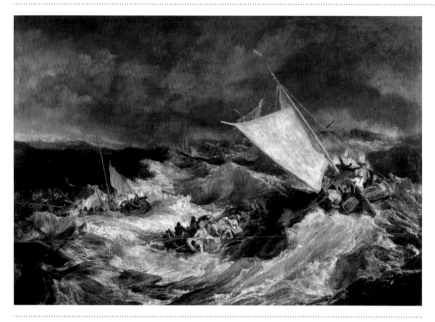

1

The aim is to work fast and try to let the feeling of the ocean drive your pencil. Allow it to fly over the page as if riding or tossed by the waves, and simply rely on it leaving an appropriate mark.

When you have finished, go straight on to further variations of the same subject and the result will be a series of gestural drawings – perhaps only a few lines each.

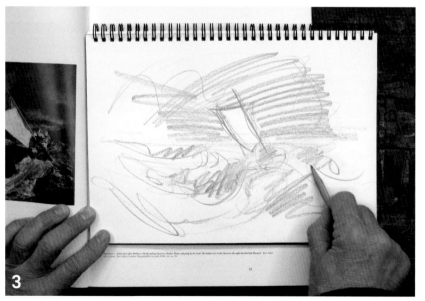

3

Shade rapidly, using the pencil to suggest tonal values by sweeping it back and forth to build the darkest areas. Try to respond directly to the observations of your eye. This process builds skills in draughtsmanship and is a far cry from the careful drawings you might make elsewhere. This was a two or three minute sketch.

Turner's profound understanding of the sea came from watching real waves and making thousands of his own studies on paper, particularly in watercolour. Here we can see the informality of his approach. He almost certainly began with a sheet thoroughly wetted and then established the warmest and lightest of colour values. The darker and cooler values would have been completed while the paper was still damp and then finally also after it had dried. His brushmarks reveal the movements of his hand.

Take a clean, dry brush and try to trace the direction and energy of Turner's hand on the actual surface of this reproduction. Rather like dancing to the same music he danced to, this can really help you to arrive at *and internalise* an understanding of how the work was crafted.

Finally, take up your watercolours and try a rapid study or two at home, based on this or another oil painting. You won't be allowed to do this in a gallery and nor should you be, because paint will fly!

Don't attempt to match Turner's colours. Here, the lightest tones (including the sail) were laid first, onto a slightly damp sheet, in yellow ochre and cobalt blue and using a very broad brush. Next, the darker values were dashed down in grey (made from light red mixed with cobalt blue), by which time the sheet was drying rapidly. Then came the crisp details and accents, with the corner of a hog's-hair, fan-shaped brush. Finally, opaque Chinese white was swept in to suggest white foam – *not* in a tight reproduction of the Turner but to convey the furious energy of real waves tossing boats about.

The final orchestration included strengthening the deepest shadows (for example, in the deep trough beside the largest boat) and a few coloured accents.

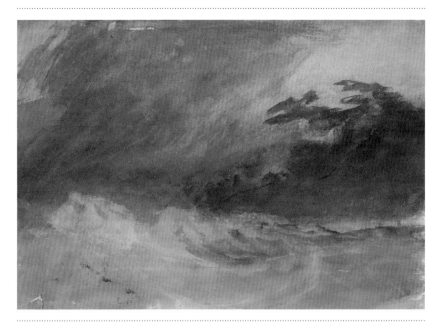

J.M.W. Turner, ?*Study for Eddystone Lighthouse*
c.1817, Watercolour and graphite on paper,
25.4 x 38.3, Tate D17172.

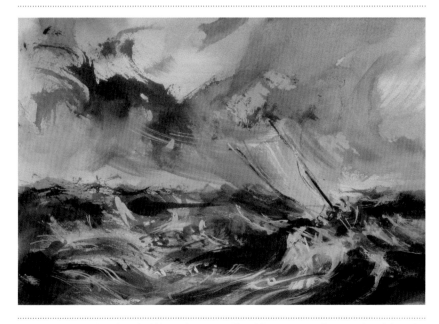

Watercolour sketch based on *The Shipwreck*.
Rapid studies should be just that – rapid.
Allow your brush to fly across the page, in
immediate response to your observations.

The trick to success and progress is to do lots of
them without trying to create 'art'.

En plein air

Most watercolourists find they need to have different systems for painting in their usual studio or workplace, and when working out of doors (also known as working *en plein air* –which is the French for 'in the open air'). Our short introductory course is based on what might be called studio watercolour – using individual dishes to mix pools of wash, for example. Painting *en plein air* presents different challenges, requiring a paring down of equipment and process. In this case semi-moist blocks of watercolour and washes mixed on a single portable palette are generally going to be a better choice than tube paints mixed in dishes. Additionally there are all sorts of other ways to simplify your painting paraphernalia so that you can work to whatever degree of finish you want.

Watercolour is among the most convenient and portable of painting mediums, ideal for the rambler, explorer, tourist and botanist. It is also a pleasant adjunct to travel, entitling you to sit for hours beneath a shady tree (while capturing the sky in moments, to the envy of anyone working on the same subject in oils). We can learn so much from the history, philosophy and methods of the past that really, no watercolourist should fail at least to sample the delights of traditional methods while *en route* to their own approach *en plein air*. As the sketchbooks of some of the great masters illustrate, it is a unique experience filled with creative opportunity.

The face of nature changes by the moment and watercolour too is an organic and sometimes unpredictable force. Works in progress very often surprise with happy accidents that make for leaps of artistic expression. The challenges of working outside the studio are many, and with so many variables it

seems a shame to content oneself with merely trying to copy nature. Again, we can learn a great deal from the past, where the sketchbooks, studies, notes and finished works of the masters provide a ready reference to their explorations, note-taking, ideas and techniques. Taken together they track the creative process.

An artist's process is how s/he brings different factors together into a system that enables projects to be carried out. Even today, for many painters, there are often three clear phases of working. First: a *collection* phase where, on location, the artist gathers visual information, ideas and inspiration. This may involve a thorough exploration of the site looking for the best spot to work, or making lots of sketches for later reference. For some artists this also involves carrying a lightweight but high-quality digital camera. Next: a *creative* phase where the artist collates, makes sense of, works with and develops the material s/he has collected. This helps him/her move towards the third phase – the *production of finished artwork* arising from the first two stages. A painter may well complete and combine all of these stages into one continuous burst of creativity completed while still in the field. However, for others, location activity might only involve sketching or compiling source material towards later work in the studio. Such systems are as varied as the artists themselves.

Underpinning the technical processes of all painters is their approach to art and – where landscape is concerned – their individual engagement with nature. This may lead them like Constable to see a microcosm of the world within a much-loved area of countryside, or to seek out the wildest locations far from home, like Turner and later Ruskin. They may find the entire

world encapsulated in the minute features of a grain of sand (as William Blake famously and poetically stated) or within the sublime vastness of a mountain wilderness. In comparing the approaches of the great masters it soon becomes clear that merely knowing something of their technique will not fully explain their artistic achievements.

Turner, Cotman and Constable exemplify three very different approaches to painting *en plein air*. In working out your own way of working it may help you to consider them. Because of today's popular interest in applying wisdom from eastern approaches to water-based media to contemporary Western watercolour (as evidenced by a number of popular books on the subject) we have also suggested a fourth model but from the opposite side of the world. In this book it is called the Tao/Zen approach (already mentioned in the context of Cotman's approach to composition), but this time it is used to cast an interesting light on Turner's, Cotman's and Constable's methods of working *en plein air*.

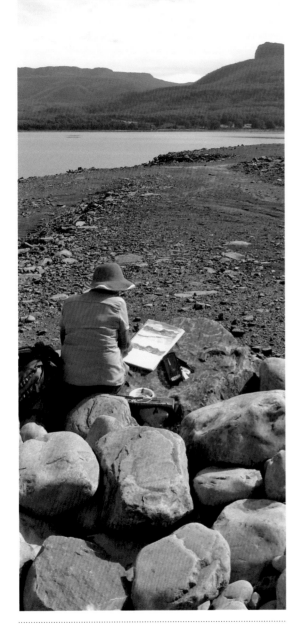

Watercolour is an ideal outdoors medium, allowing for profound communion with nature in almost any location.

Turner: Don't waste a moment

- Travel widely
- Go to your location
- Observe and absorb the moment
- Explore the site
- Make lots of sketches
- Make colour notes when you return 'to the inn' (your accommodation away from home)
- Back in the studio, thoroughly explore the options for creativity around the subject
- Finish with highly imaginative works painted in the studio

Cotman: Slow and steady

- Live at the place
- Study it
- Absorb it/become it
- Make careful drawings
- Start with a very well-considered underdrawing
- Finish with carefully-laid washes

Constable: I know this place

- Paint a place you know and love
- Study it closely
- Look carefully
- Link eye and hand
- Sketch, sketch, sketch
- Remember that a true eye and hand won't need flourishes or artifice

Tao/Zen approach

- Paint what you know rather than just what you see; therefore experience nature in order to know it.
- If you have observed carefully and have acquired the necessary skills, your paintings will truthfully portray reality.
- To paint in watercolour one must understand and work with nature's own principles.
- Tao means a way of living in accord with nature.
- By painting with sincerity, the unfamiliar will become the familiar through practice.
- Then, over time, the familiar will become as natural to you as breathing.
- Finally, what has become natural will become a part of the self (who you are) and accompany you without your having to think about it – instantly responding to your eye and inspiration, so that your paintings will be faithful to nature.
- Above all, strive to become at one with your medium and with nature at the same time.
- Attachment to trying to paint beautiful pictures will get in the way of seeing clearly and painting truthfully.
- Watercolour is nature.

Strange as it may seem, the Tao/Zen way of thinking is not entirely alien to Constable's 'natural' brushwork or Turner's remarkable ability to capture a sunlit cloud with a few sweeps of a brush. Neither is it far from the mindfulness of Cotman, who worked for months on end along a single stretch of the River Greta to render watercolours that seem as deeply invested with calm *and* energy as any Zen garden.

Tony Smibert, *Inner Calm* 1999, Watercolour on paper, 19 x 14.5. This obviously 'modern' watercolour was painted onto traditional handmade paper (Blue Lake Paper) using entirely traditional methods such as gradation, variegation, flat wash, mingling and charging processes, while reserving white as a key element in the composition. Although the image reflects our own time, the processes by which it was created are exclusively those that were used by earlier artists.

Contemporary watercolour

Why bother to look at the past? Historians generally agree that those who fail to learn from the past seem destined to repeat its mistakes. In contrast, what we learn from the past may equip us for the future. From the greatest masters we can acquire not only skills but also depths of understanding. And so we come to the future of watercolour.

To a painter (as distinct from a collector), no finished work can ever offer the same excitement of a fresh, blank sheet of paper waiting on the table, with colours ready mixed and the adventure of painting still ahead. So *real* painters, by and large, *are* forward-looking by nature. Whether the work of an artist is confined to classical subjects or to subjects that have never been attempted before, what makes a watercolour 'contemporary' is not its subject, but rather that it is painted by a twenty-first-century mind.

The boundaries between traditional and contemporary watercolour are difficult to define when so much of what makes non-figurative painting exciting today also involves techniques used in creative ways by past masters. For example, this colour study on the right, on cartridge paper, makes use of Turner methods. However, if the church, boats and birds had not been shown, it might not be recognisable as a landscape study at all, but simply as a non-figurative study in warm and cool colours (as was often the case with Turner's own private studies).

It is clearly a mistake to class watercolours by *genre*. A superb representational landscape might well be a finer example of contemporary thinking than a non-figurative abstract created without much thought about the art of painting.

Tony Smibert, *Study for Church on the Cliff* 2011, Watercolour on paper, 19 x 14.5. The paper was soaked, smoothed out onto a board, saturated with colour, removed to dry, washed out with clean water, dried again and finished with details using dry-brush technique.

Tony Smibert, *Ten Shi Jin* 2005, Watercolour on paper, 38 x 29. This was painted onto a very modern type of etching paper, using colours that were simply not available historically. Heat-dried with an electric hairdryer to achieve special surface effects, it was then finished and detailed using removable Magic® tape, scraper blades and absorbent hand tissues.

A thorough grounding in historical methods can be a great way to position oneself to paint with the complete freedom of self-expression expected today. This later twentieth-century painting by Patrick Heron makes the point with great use of the special qualities of water-based paint (gouache) *as a medium*, with fluid colour, immediacy of effect, dramatic mark-making, and so on.

Similarly *Ten Shi Jin* was inspired by an earlier era, but the painting techniques were all very contemporary.

The boundaries between traditional and contemporary watercolour techniques are difficult to define when so much of what makes non-figurative painting exciting today also involves techniques used in creative ways by past masters.

We hope that this book will help to increase both public and professional understanding of how the painting processes of the past may also be used to create modern works entirely expressive of our own era. Above all, we hope that a greater number of people will come to understand not only *how* the great masters painted, but will also sense their excitement in the *process* of painting – whether outdoors facing a stiff breeze from the sea or indoors after a day of exploration and sketching. Excitement is both a source and outcome of inspiration. Whether your own enjoyment comes from looking at watercolours or from painting them, we also hope you will find the great public collections a source of ongoing inspiration for your endeavours.

And to those with a lifelong devotion to this most special and enchanting of media: we wish you every success continuing the evolution of contemporary watercolour as an exemplary mode of self-expression.

Patrick Heron, *January 9 : 1983 II* 1983, Gouache on paper, 60 x 77.5, Lent by the Tate Gallery Foundation 1988, Tate L01427.

Further reading

Ann Bermingham. 2000. *Learning to Draw: Studies in the Cultural History of a Polite Art*, Yale University Press, New Haven and London. [See pp.134–5 on London venues for copying the works of the great masters, and pp.166–7 on drawing manuals.]

Peter Bicknell and Jane Munro. 1988. *Gilpin to Ruskin: Drawing Masters and their Manuals 1800–1860*, exh. cat., Fitzwilliam Museum, Cambridge.

John Bonehill and Stephen Daniels. 2009. *Paul Sandby: Picturing Britain*, exh. cat., Royal Academy of Arts, London.

Peter Bower. 1990. *Turner's Papers: A Study of the Manufacture, Selection and Use of his Drawing Papers 1787–1820*, exh. cat., Tate Gallery, London.

Peter Bower. 1999. *Turner's Later Papers: A Study of the Manufacture, Selection and Use of his Drawing Papers 1820–1851*, exh. cat., Tate Gallery, London.

Peter Bower. 2004. 'Catching the sky', in Frederic Bancroft (ed.), *Constable's Skies*, exh. cat., Salander-O'Reilly Galleries, New York, pp.153–79.

David Blayney Brown, Andrew Hemingway, Anne Lyles. 2000. *Romantic Landscape: the Norwich School of Painters*, exh. cat., Tate Gallery, London.

Katherine Coombs. 2012. *British Watercolours 1750–1950*, Victoria and Albert Museum, London.

Sarah Cove. 2004. 'Very great difficulty in composition and execution', in Frederic Bancroft (ed.), *Constable's Skies*, exh. cat., Salander-O'Reilly Galleries, New York, pp.123–52.

David Cox. c.1815–27. *Painting in Watercolours*, reprinted 1985 by View Productions Pty Ltd, Sydney.

Keith Hanley and Rachel Dickinson. 2008. *Journeys of a Lifetime: Ruskin's Continental Tours*, exh. cat., The Ruskin Library, Lancaster University, Lancaster.

Theresa Fairbanks Harris and Scott Wilcox. 2006. *Papermaking and the Art of Watercolor in Eighteenth-century Britain: Paul Sandby and the Whatman Paper Mill*, Yale Center for British Art in association with Yale University Press, New Haven and London.

Marjorie B. Cohn (ed.), Carlo James, Caroline Corrigan, Marie Christine Enshaian and Marie Rose Greca. 1997. *Old Master Prints and Drawings: A Guide to Preservation and Conservation*, Amsterdam University Press, Amsterdam.

H.W. Janson. 1991. *History of Art: The Western Tradition*, Abrams, New York.

John Krill. 1992. 'The drawing master's assistant: early manuals for landscape drawing in watercolour', in Sheila Fairbrass (ed.), *Conference Papers Manchester 1992*, Institute of Paper Conservation, Leigh, pp.7–10.

John Krill. 2002. *English Artists' Paper: Renaissance to Regency*, second rev. edn, Oak Knoll Press and Winterthur Museum, Delaware.

Anne Lyles and Robin Hamlyn. 1997. *British Watercolours from the Oppé Collection*, Tate Publishing, London.

Nicola Moorby and Ian Warrell (eds.), with contributions from Mike Chaplin, Tony Smibert, Jacob Thomas and Joyce H. Townsend. 2010. *How to Paint like Turner*, Tate Publishing, London.

Adolf Paul Oppé. 1952. *Alexander and John Robert Cozens: with a reprint of Alexander Cozens' A new method of assisting the invention in drawing original compositions of landscape*, Black, London.

Bronwyn A. Ormsby, Joyce H. Townsend, Brian W. Singer and John R. Dean. 2005. 'British Watercolour Cakes from the Eighteenth to the Early Twentieth Century', *Studies in Conservation* vol. 50, pp.45–66.

Henry Petroski. 1992. *The Pencil: History of Design and Circumstance*, Knopf, New York.

Michael Rosenthal with Anne Lyles, ed. Steven Parissien. 2013. *Turner and Constable: Sketching from Nature*, Tate Publishing, London.

Eric Shanes. 2000. *Turner: the Great Watercolours*, exh. cat., Royal Academy of Arts, London.

Eric Shanes. 2001. *The Golden Age of Watercolours*, exh. cat., Merrell, London. [Includes works by Cozens, Girtin, Turner, Cotman, David Cox, Peter de Wint and others.]

Tony Smibert. 1997. *Painting Landscapes From Your Imagination*, Australian Artist Publishing.

Alison Smith (ed.). 2011. *Watercolour*, exh. cat., Tate Gallery, London. [Illustrations include watercolours from the golden age to contemporary.]

Greg Smith. 2002. *Thomas Girtin: The Art of Watercolour*, exh. cat., Tate Gallery, London. [See pp.117–30 on drawing manuals by little-known artists.]

Greg Smith. 2002. *The Emergence of the Professional Watercolourist: Contentions and Alliances in the Artistic Domain, 1760–1824*, Ashgate Publishing, Farnham.

Joyce H. Townsend. 2003. *William Blake the Painter at Work*, Tate Publishing, London, pp.45–51.

Joyce H. Townsend. 2005. *Turner's Painting Techniques*, fourth edn, Tate Publishing, London.

Ian Warrell. 2013. *Turner from the Tate: the Making of a Master*, exh. cat., Tate Gallery, London.

Scott Wilcox. 2008. *David Cox: the Art of Painting in Watercolor: A Guide to his Materials and Techniques*, Yale Center for British Art/Birmingham Museums & Art Gallery, in association with Yale University Press, New Haven and London.

Andrew Wilton and Anne Lyles. 1993. *British Watercolours 1750-1880*, exh. cat., Royal Academy of Arts and Prestel Verlag, London and Munich.

Index

Acknowledgements

Tony Smibert would like to thank the following for their advice and/or assistance towards the creation of this manual:

Carmel Burns; Julia Beaumont-Jones, Curator; Vincent Miller, Art Publisher; Anne and Hugh Mackinnon, Mountford Granary Art School; Annie and Mike Swinson; David Sherbon; Jonathan Bowden; John Temple; Olivia Smibert; Grace Smibert.

Picture and copyright credits